IMAGES
of America

PATCHOGUE
VOLUME II

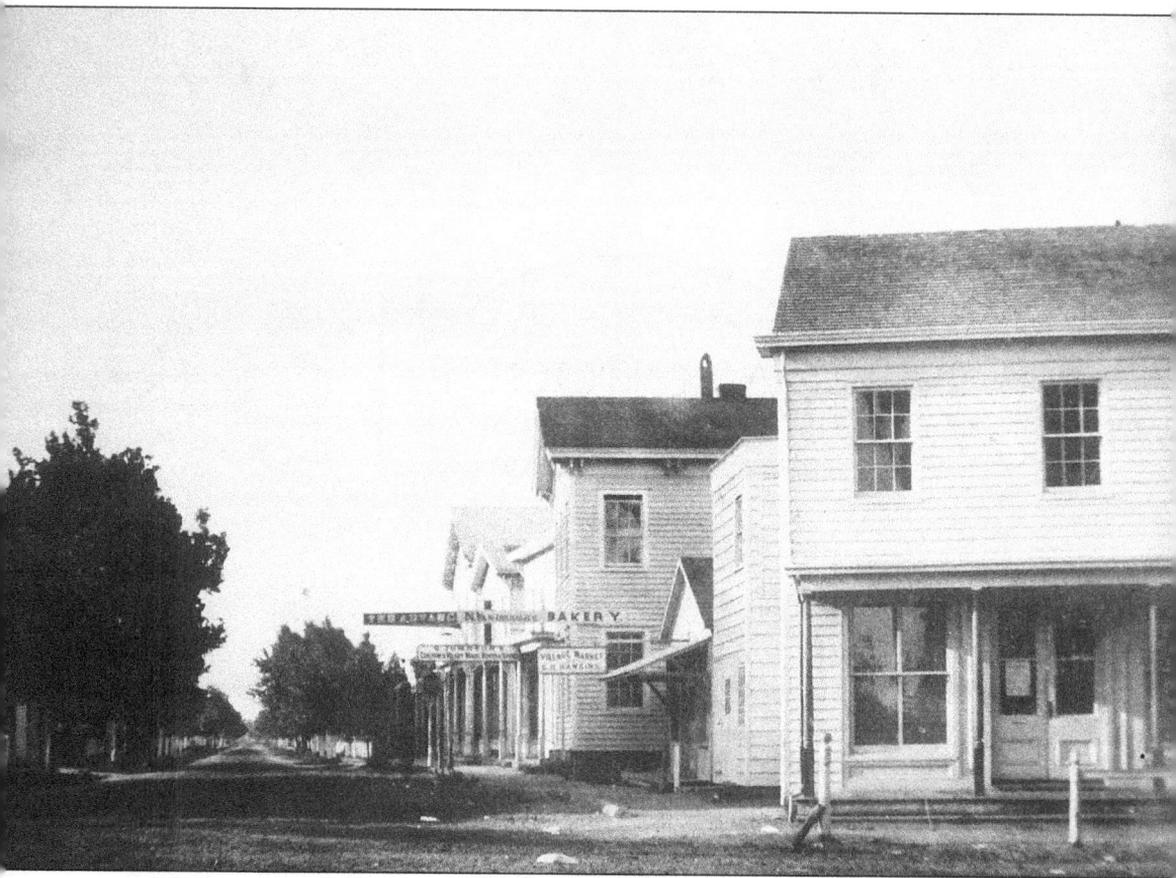

This is an early photograph of South Ocean Avenue as seen from Main Street. Nicolas Van Arsdale's Bakery is marked by the sign in front of his building. The sign protruding over the street is that of the *Advance* newspaper. This picture would have been taken in the 1870s since Van Arsdale's bakery burned on January 1, 1880.

IMAGES
of America

PATCHOGUE
VOLUME II

Hans Henke

ARCADIA
PUBLISHING

Copyright © 1998 by Hans Henke
ISBN 978-1-5316-6045-1

Published by Arcadia Publishing
Charleston, South Carolina

Library of Congress Catalog Card Number: 98-85887

For all general information contact Arcadia Publishing at:
Telephone 843-853-2070
Fax 843-853-0044
E-mail sales@arcadiapublishing.com
For customer service and orders:
Toll-Free 1-888-313-2665

Visit us on the Internet at www.arcadiapublishing.com

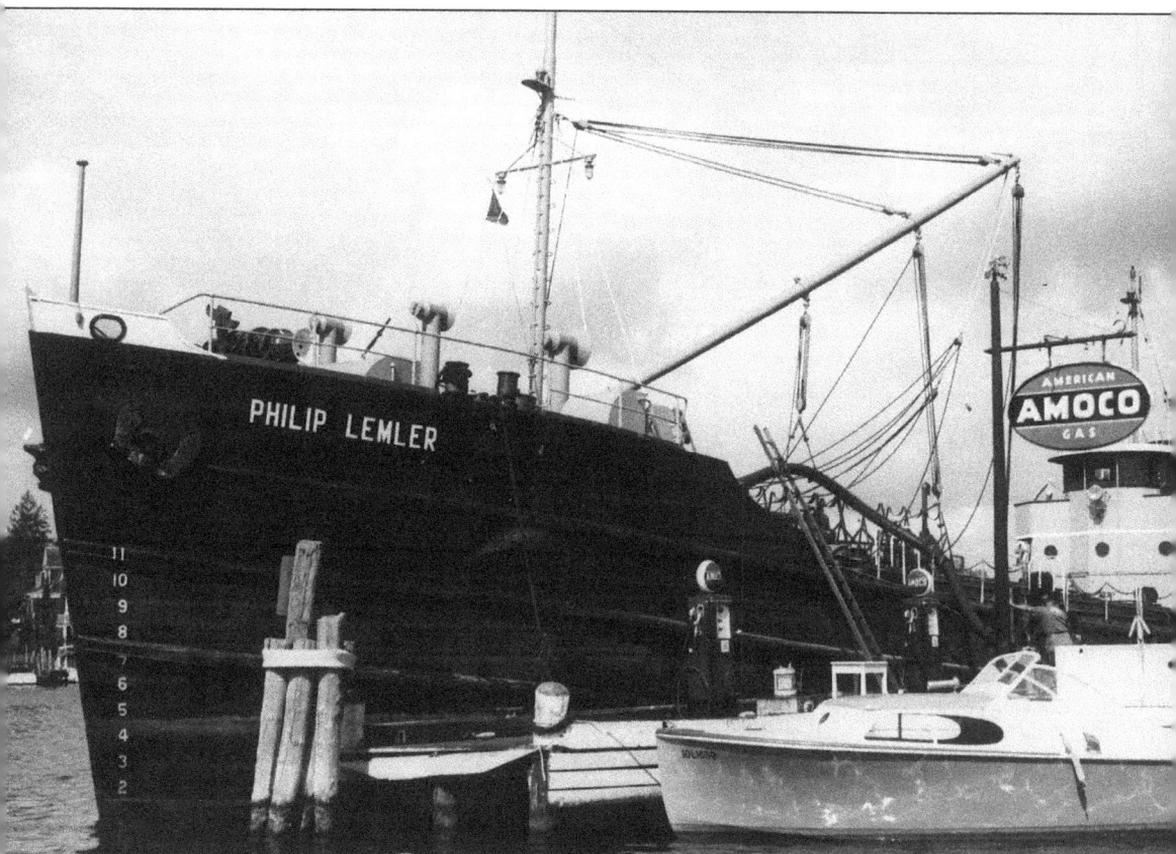

These coastal tankers were the largest ships to enter Patchogue Harbor but could only do so with reduced loads. The oil deliveries by boat stopped in the 1970s when the small tank farms on the river were discontinued.

Contents

Acknowledgments

To the Queens Borough Public Library, Long Island Division, especially Mr. Assadorian, I would like to express my sincere thanks for their assistance in making the Conklin and Chapman Collections available for this book. My appreciation and thanks to the following people who were kind enough to loan me their photographs: Donna Bodkin, Mary Blanding, Peter Barrie, the *Long Island Advance*, Lilian Priest, Don Zimmer, Postmaster John Sweeney, Lou "Dutt" Meyers, Fred Printzlau, and Adolph Morge.

Many thanks to my daughter, Susan, for completing all the computer work and to my wife, June, for helping with the difficult job of assembling this book.

Introduction

Patchogue had been a very successful little town with a tremendous growth during the fourth quarter of the last century. The hotel industry and the fishing and oyster industries created a demand for supporting business and stores which formed a solid base for Patchogue's continued success in the next century. Patchogue became the most important shopping center east of Bay Shore and Huntington. The fishing declined and the hotels gradually lost their tourists during the first three decades of the 20th century, but there never really was an economic depression because Patchogue now emerged as the place to shop on the eastern half of Long Island. A 1926 business directory of Patchogue lists over five hundred various businesses. Included in this figure are 4 banks, 18 physicians, 23 real estate and insurance offices, 12 manufacturing firms, 40 contractors and builders, 50 auto-related stores and shops, and 40 clothing and variety stores. The large variety of goods and services available made Patchogue the choice spot to shop.

The Patchogue Plymouth Lacemill and the large Bailey's Lumberyard continued their strong business performance for the larger part of the first half of this century and were the providers of many jobs.

The incorporated Village of Patchogue maintained a large modern fire department, an efficient police force, and an up-to-date street department. Water, light, and gas services were supplied by local plants with excellent service records. For a village of its size, a population of ten thousand people in 1926, the school system was unsurpassed. A $500,000 high school, a new $250,000 grade school, and two other grade schools, as well as a parochial school and a business college, provided for an impressive school system. There were ten churches in Patchogue during the 1920s, including Congregational, Episcopal, Baptist, Lutheran, Methodist, Nazarene, and Christian Science churches, two Roman Catholic churches, and a Hebrew Synagogue.

Although the tourist industry was slowly declining, there were still accommodations for 1,300 tourists available in hotels and boardinghouses at the end of the first quarter of this century. Patchogue would maintain its standing as the leading business center in the eastern half of Long Island until the arrival of more and more shopping malls and super stores.

Photo Credits

One

The First Quarter of the 20th Century

Patchogue was a very prosperous community during this time and managed a smooth transition from the fishing and tourist industries to a community that became the leading business district on eastern Long Island.

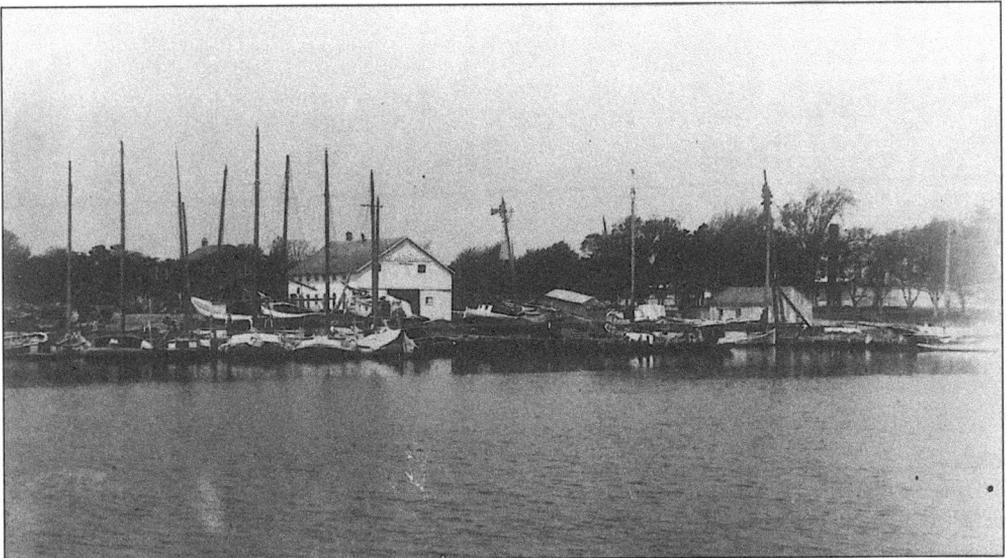

Patchogue Harbor was extremely busy in 1904. This is a picture of the Week's Boatyard on the west bank of the river.

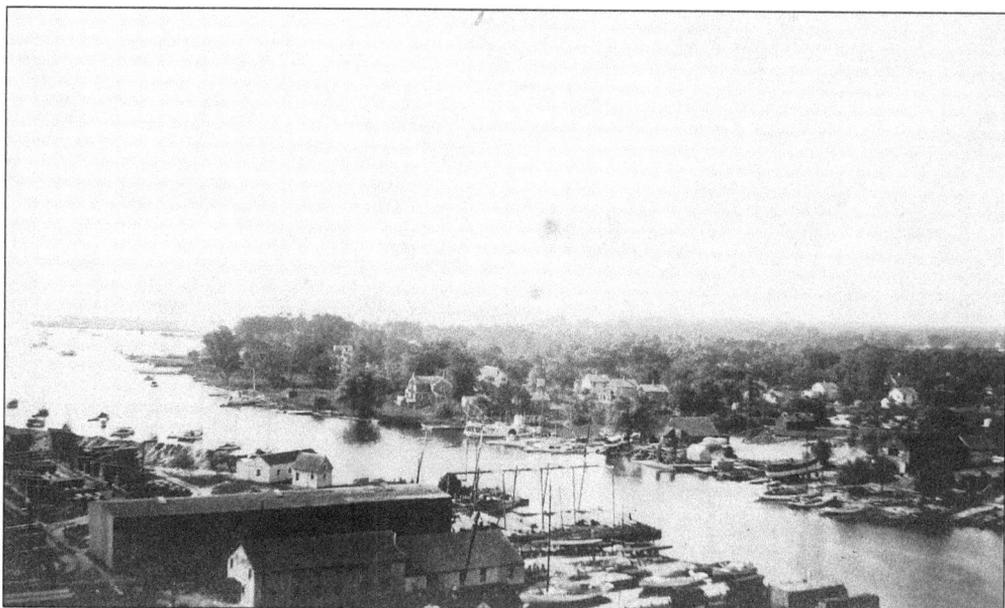

This view of the Patchogue River was apparently taken from the smokestack in Bailey's Lumberyard, looking toward the southwest. Part of Bailey's yard can be seen in the foreground and Gil Smith's Boatyard and shed are located in front of the long dark building.

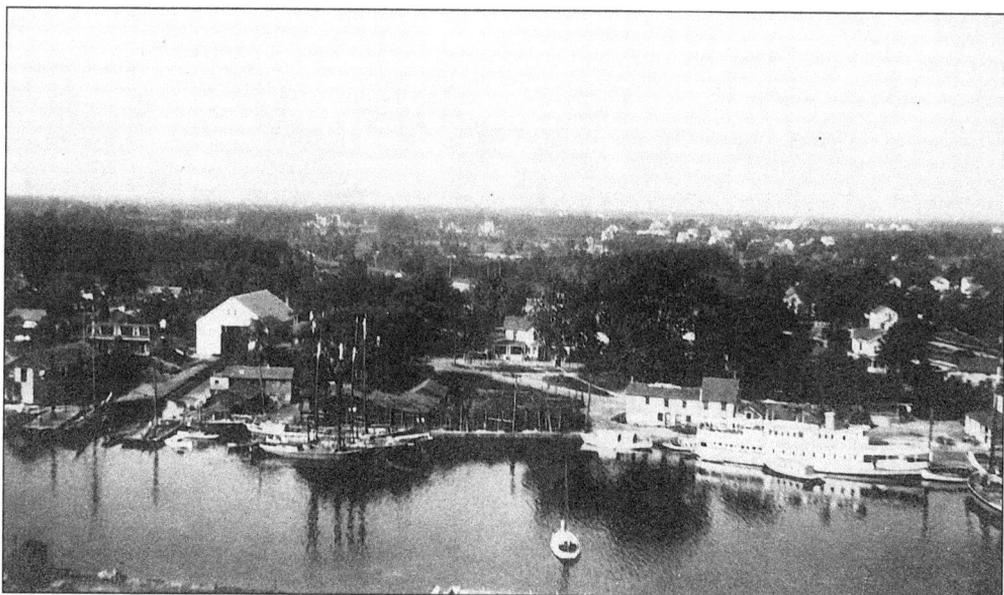

This is another photograph taken of the river, this time looking west. These pictures have no dates, but they could not have been taken later than 1914, because the ferry *Patchogue* can be seen tied up on the west bank and she was sold in 1914. The large boatyard on the left is Week's Boatyard, started in 1898 and still going strong today—it is celebrating its centennial anniversary this year!

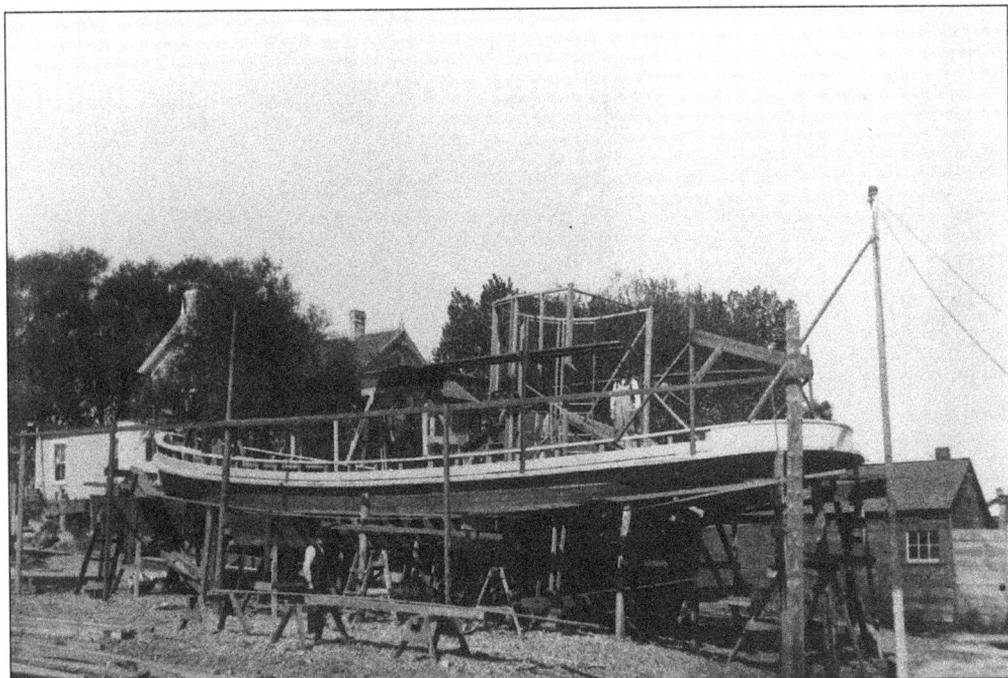

Boat building continued at a good pace on the Patchogue River after the turn of the century. We see here a large boat under construction in Furman's Boatyard in 1904.

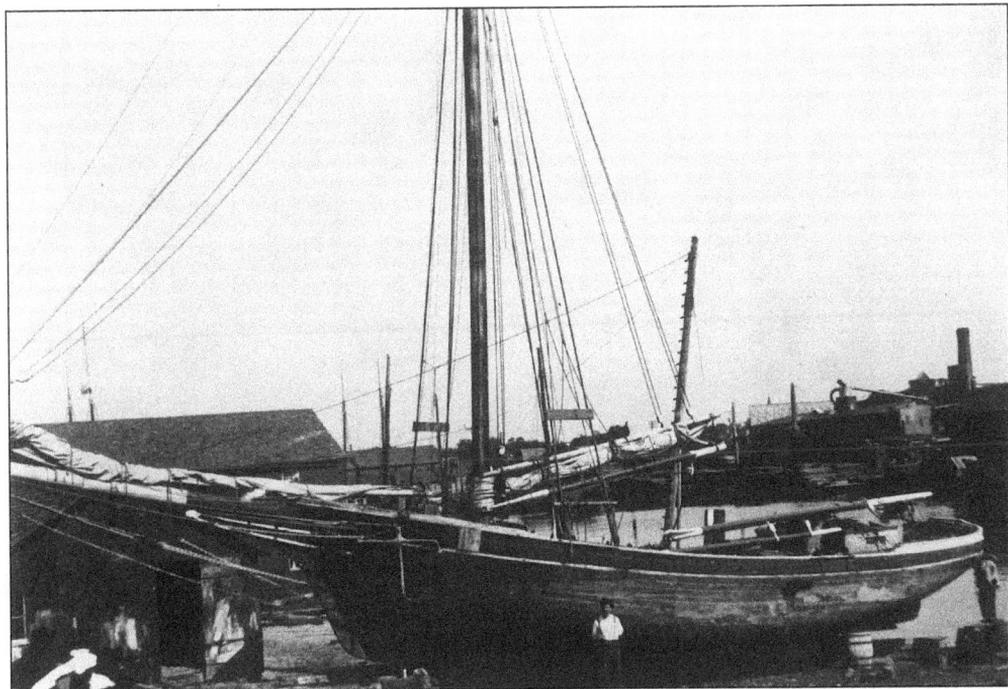

This large sloop is hauled out in Bishop's Boatyard on the west bank of the river for repair. The year was 1904.

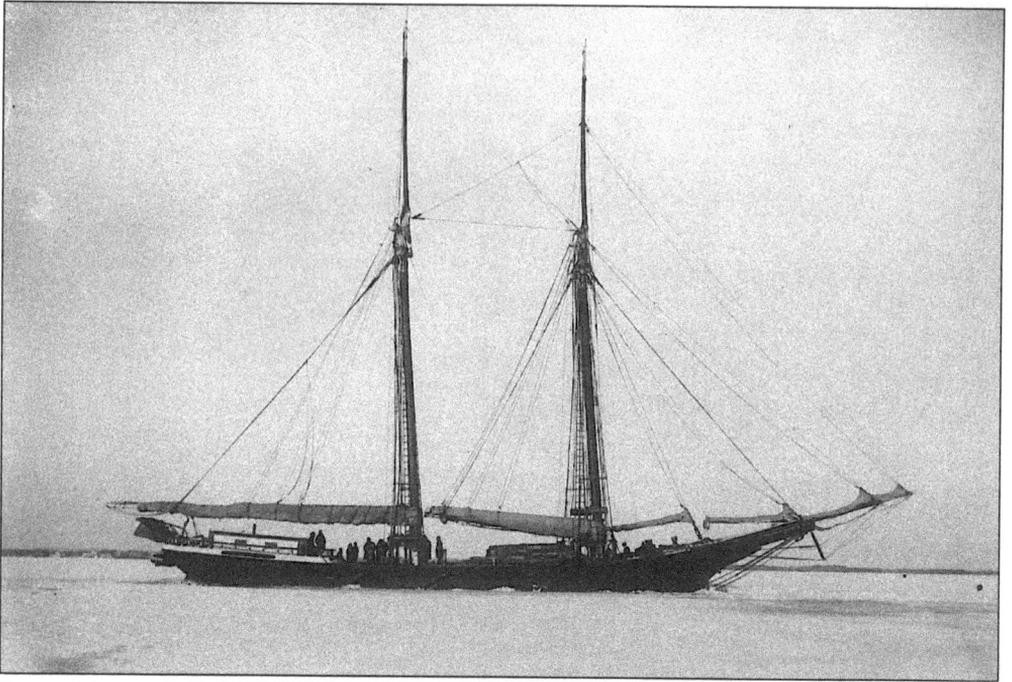

Boats delivering goods to Patchogue during the winter were at times unable to make it and found themselves frozen fast in the ice of the bay. Apparently it never created a big problem because teams of horse and wagons would go out to the boat and remove the cargo.

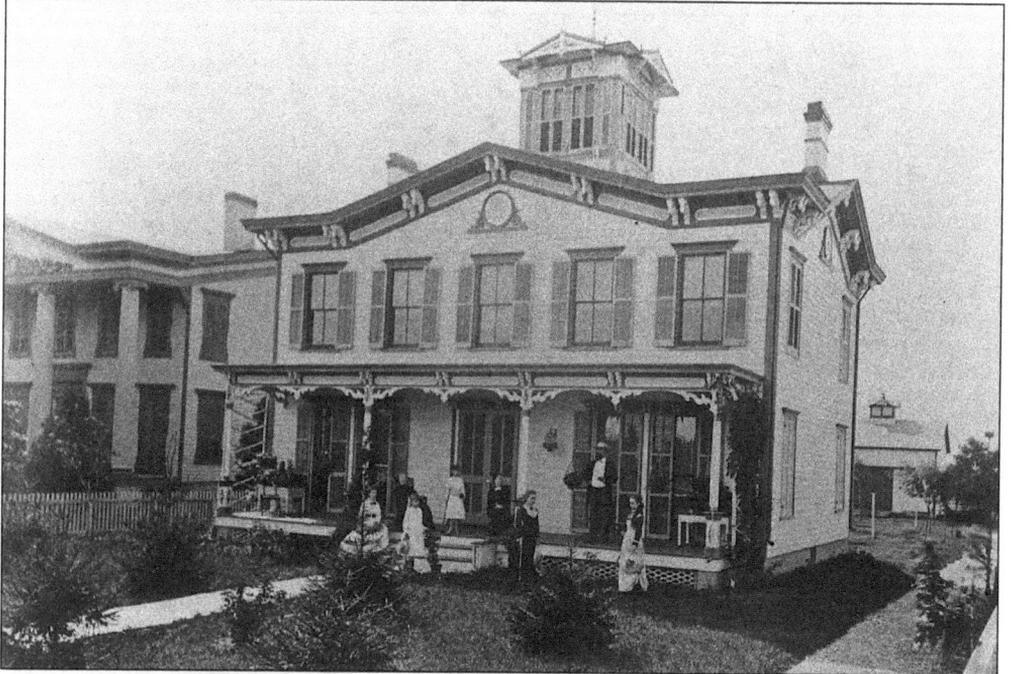

The Nettie Roe home on East Main Street is one of the few remaining old homes on Main Street. It stands just east of Rider Avenue but is much plainer in its appearance today. Mr. Conklin took this picture c. 1900.

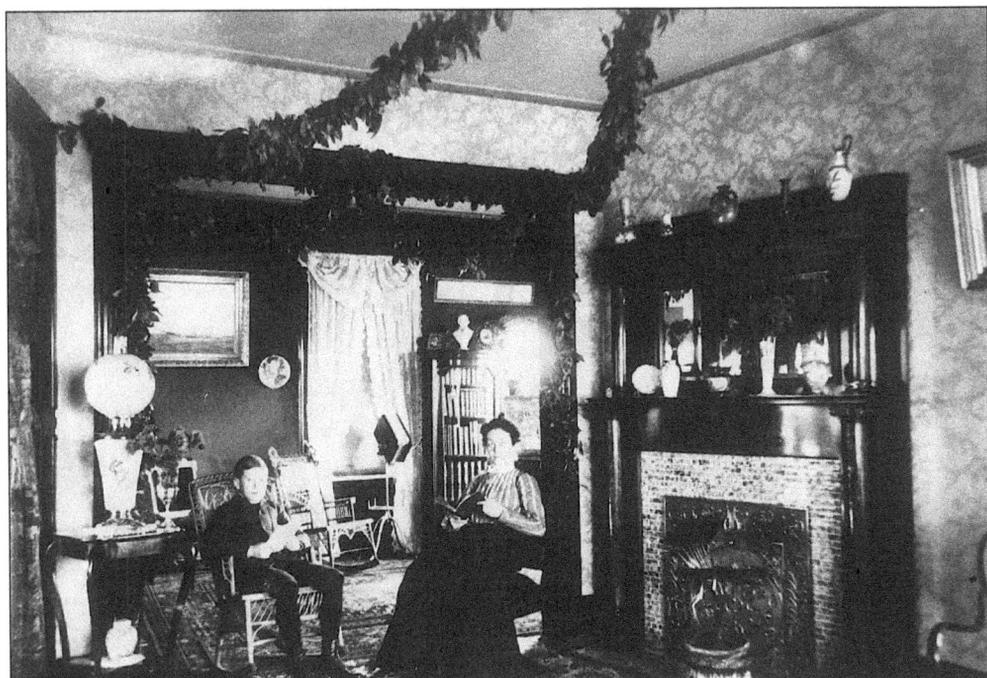

Very few pictures were taken inside of houses in the early days of photography. These beautiful views show the interior of Howard S. Conklin's home at 84 Rider Avenue. This picture was taken in their library.

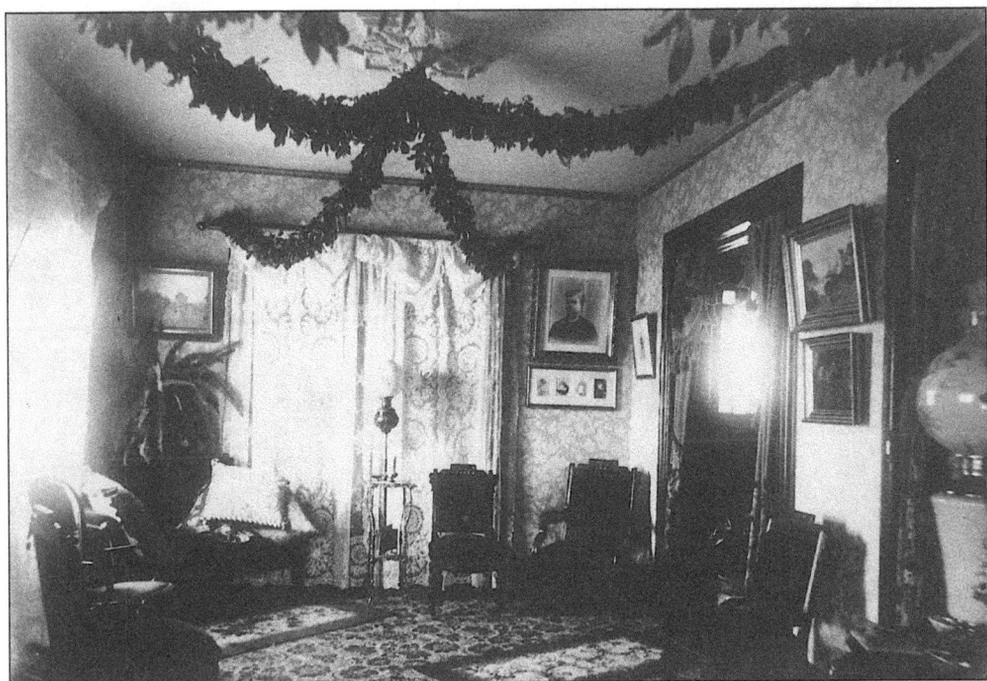

This is the parlor of the Howard S. Conklin home. Christmas decorations can be seen in these photos, although they were taken in January 1903.

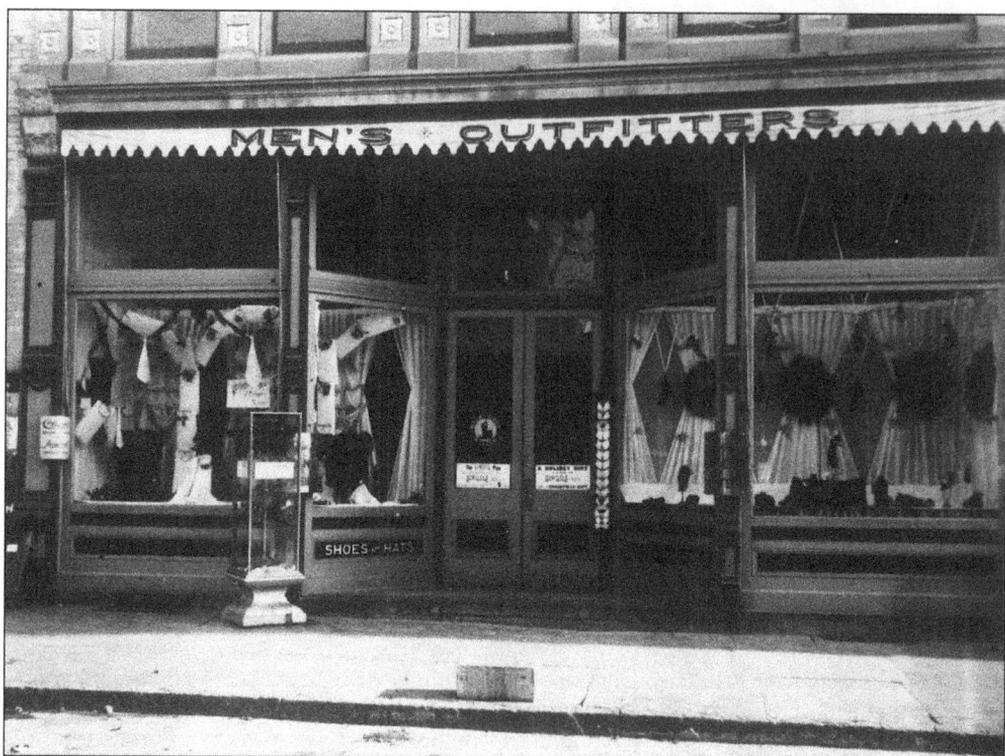

Charles Howell's store at 35 South Ocean Avenue specialized in men's furnishings. The picture of this store in the Mills building was taken in 1904.

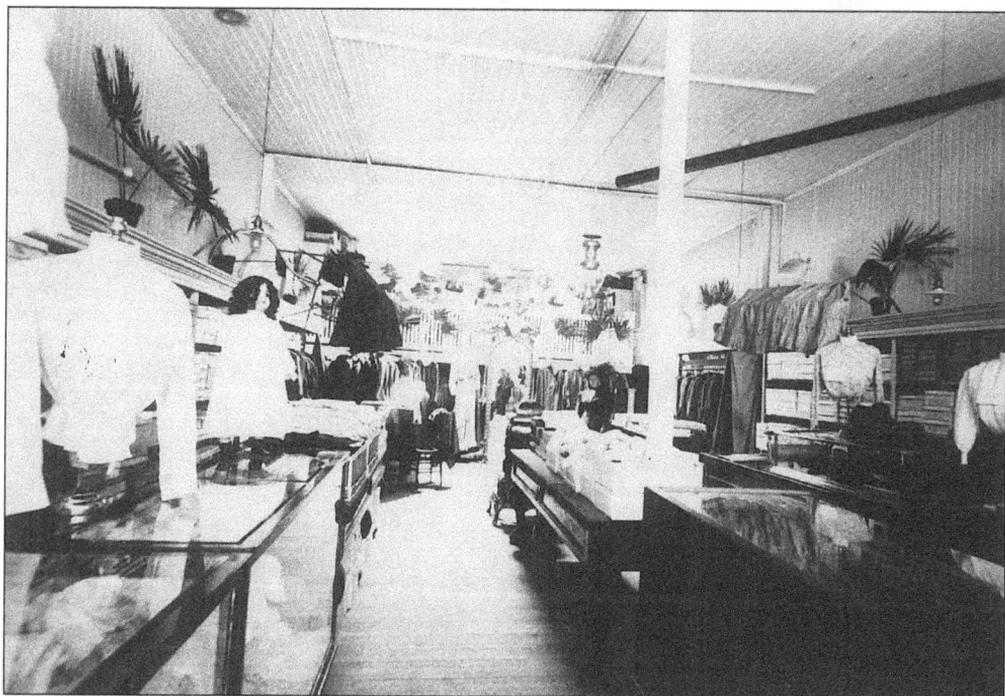

Krause's store, just two doors south of Howell's store, specialized in ladies furnishings.

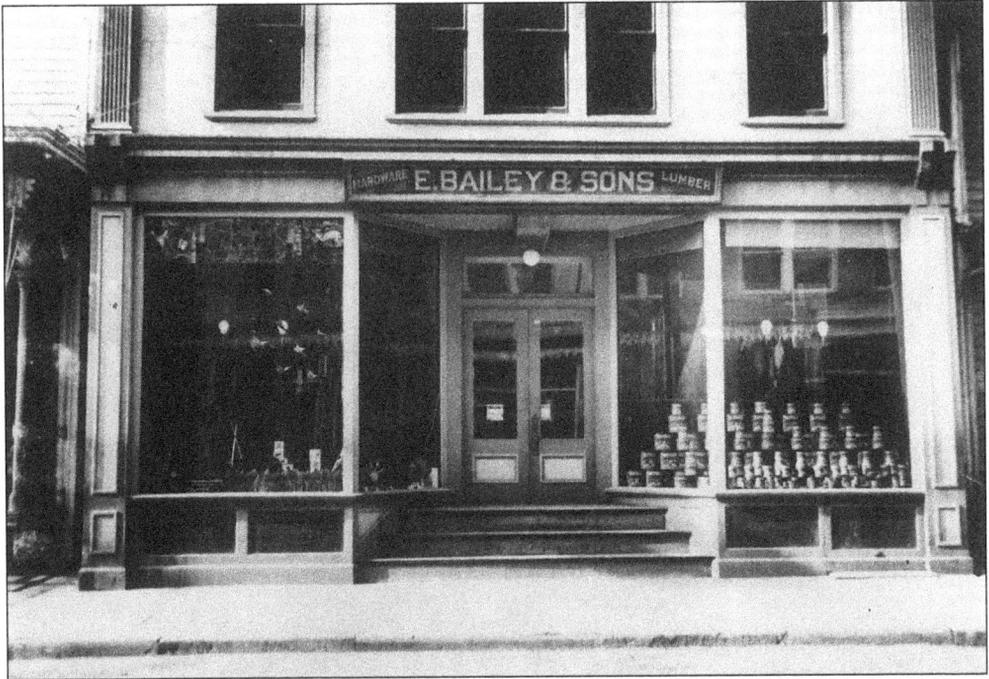

Edwin Bailey's Hardware and Paint Store on South Ocean Avenue was a part of the Bailey's Lumbermill operations.

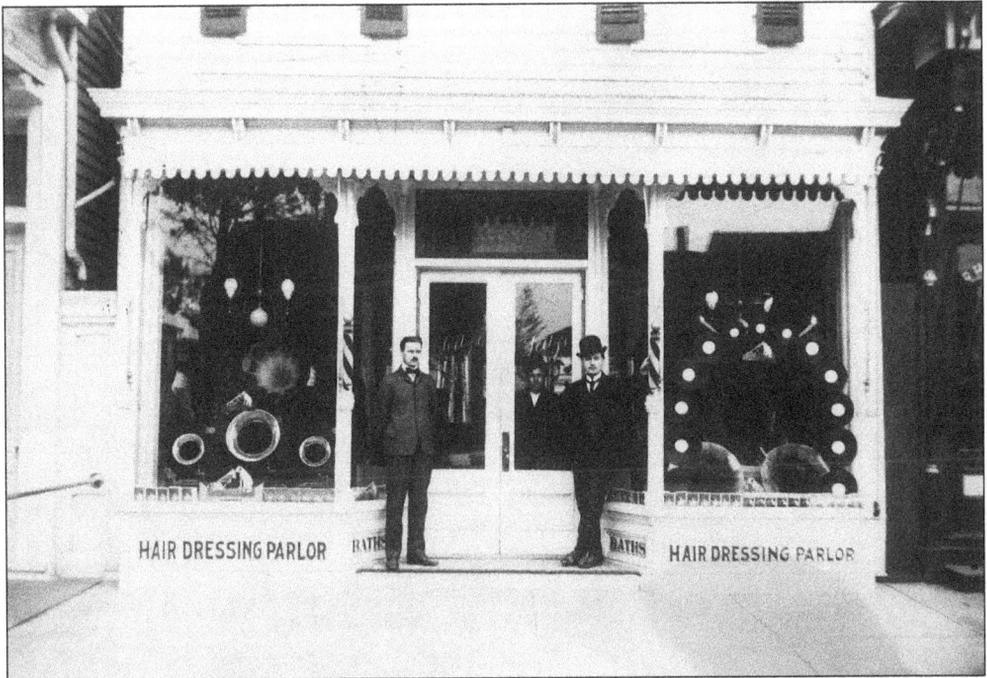

During the first two decades of this century, Al Seitz had his barber shop next to Swezey's on Main Street. As the display in the windows indicate, he also sold Victor Talking Machines, or Gramophones as they were called later.

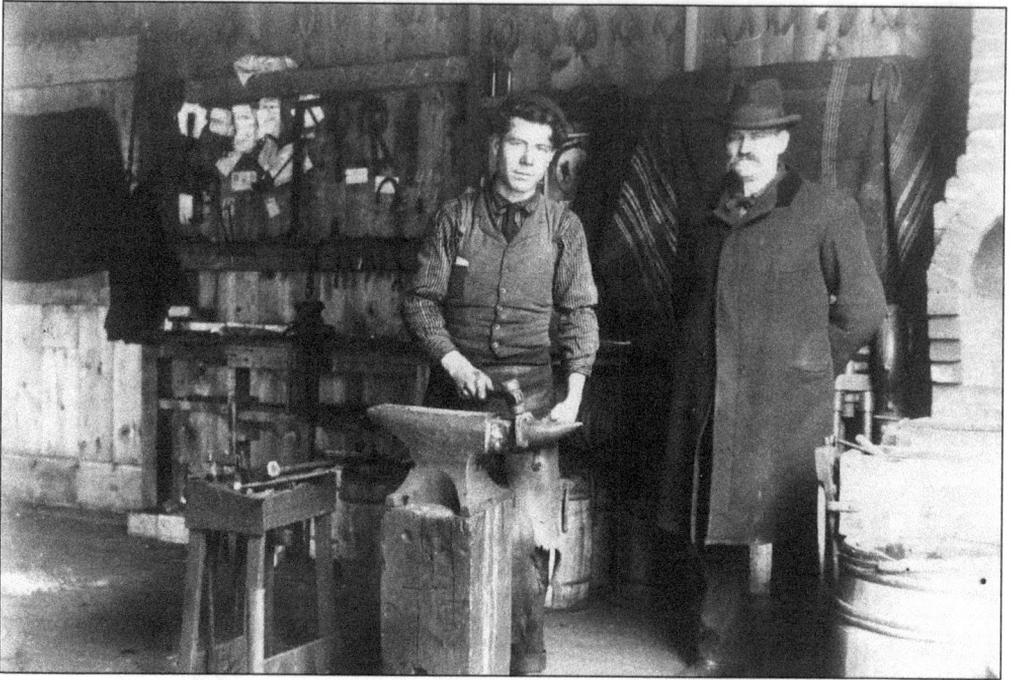

Jack McKean was one of the several blacksmiths in Patchogue at the turn of the century.

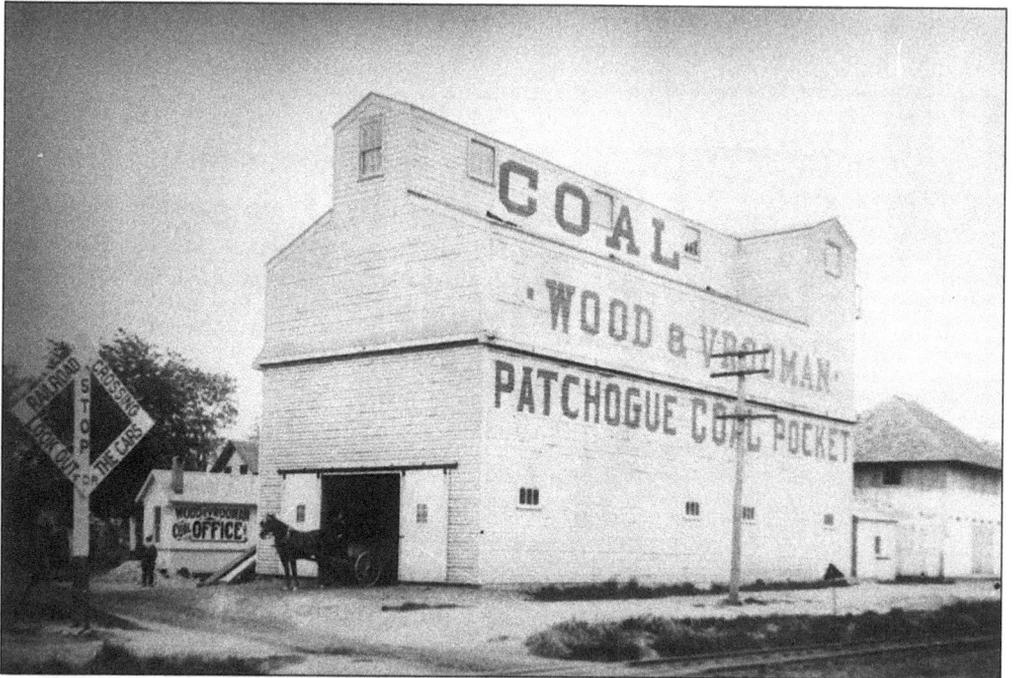

Clarence Vroomans Coal and Lumberyard was situated alongside the railroad tracks on Potter Avenue. On May 6, 1964, a fire destroyed the building.

16

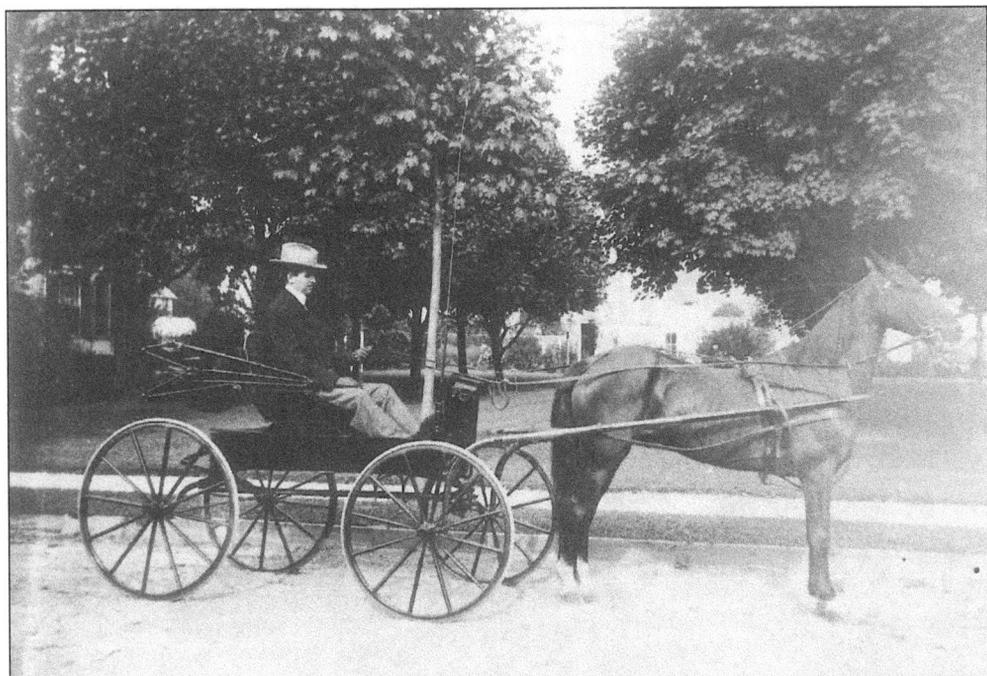

This beautiful picture of Edgar Sharp and his horse and buggy was taken c. 1903. Edgar Sharp had an insurance and real estate office in the Mills building.

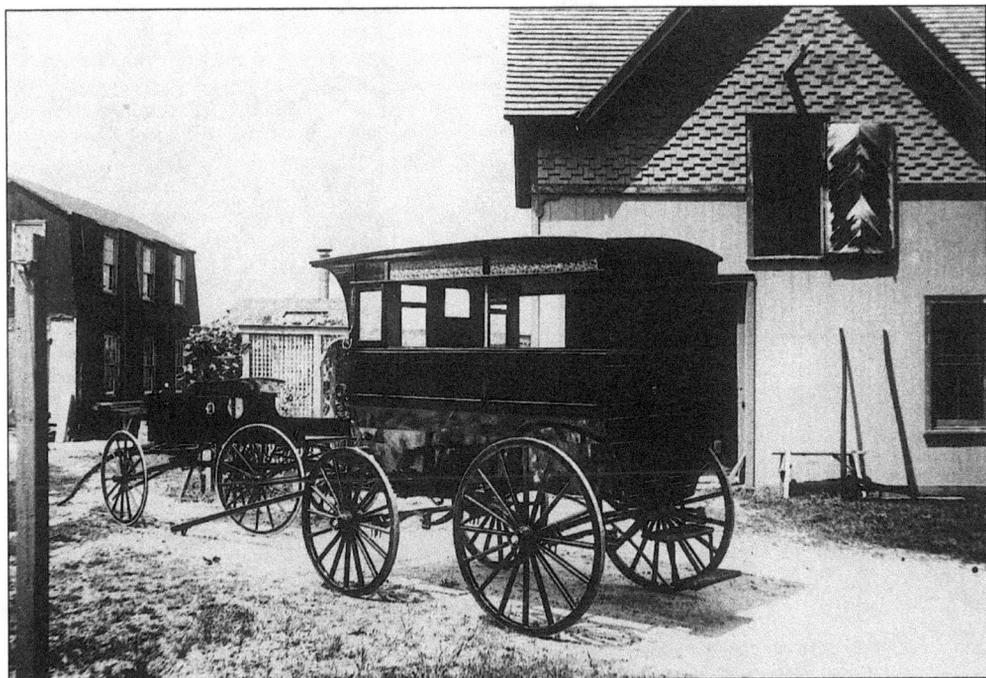

These beautiful carriages are examples of the craftsmanship of Robert M. Sharp's Carriage Works on Railroad Avenue. Mr. Homans wagon is in the foreground. Mr. Sharp also was an undertaker in partnership with Will T. Danes.

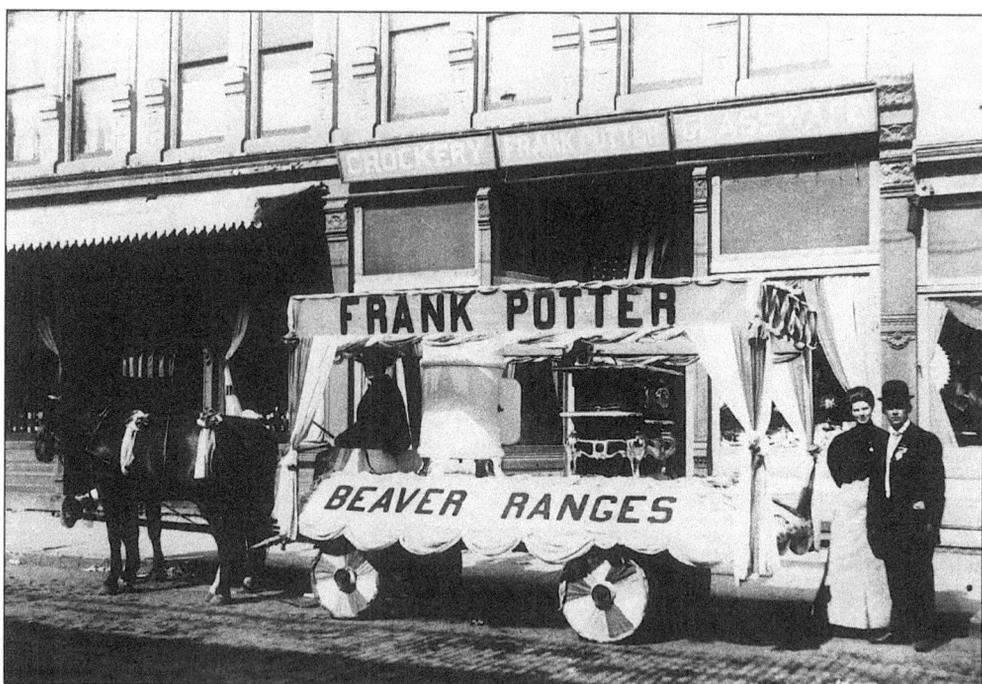

Frank Potter and his wagon are ready to take part in a 1904 parade. Frank had a glassware, crockery, and kitchen equipment store in the Mills building on East Main Street.

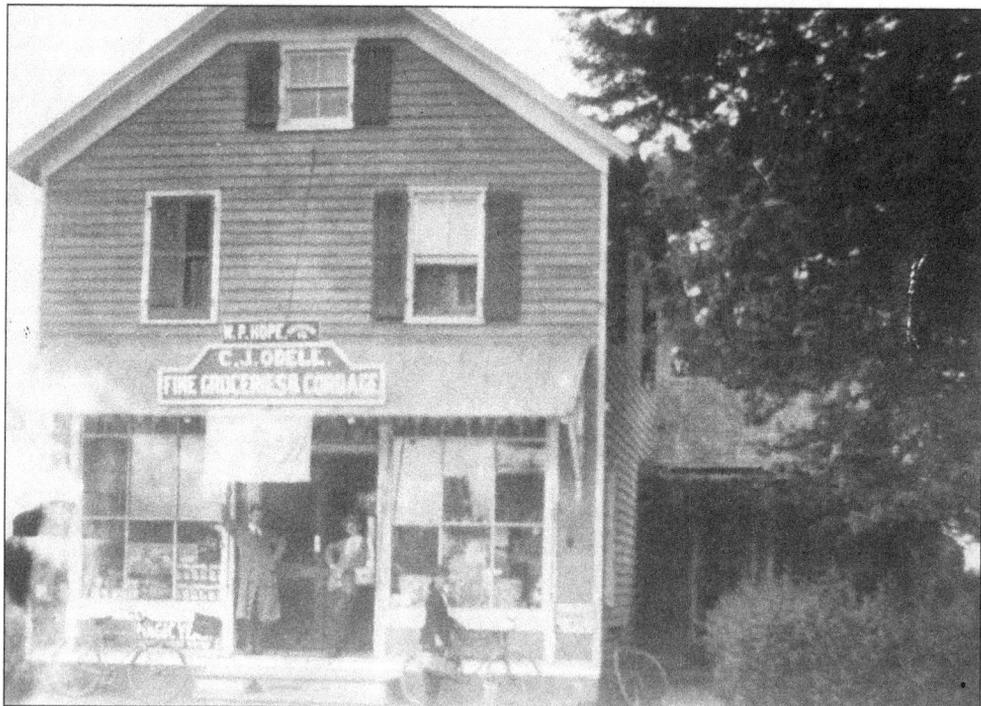

Charles J. Odell's store, 467 South Ocean Avenue, sold staple and fancy groceries, foreign and domestic fruits and vegetables, and specialized in butter and eggs at the beginning of the century.

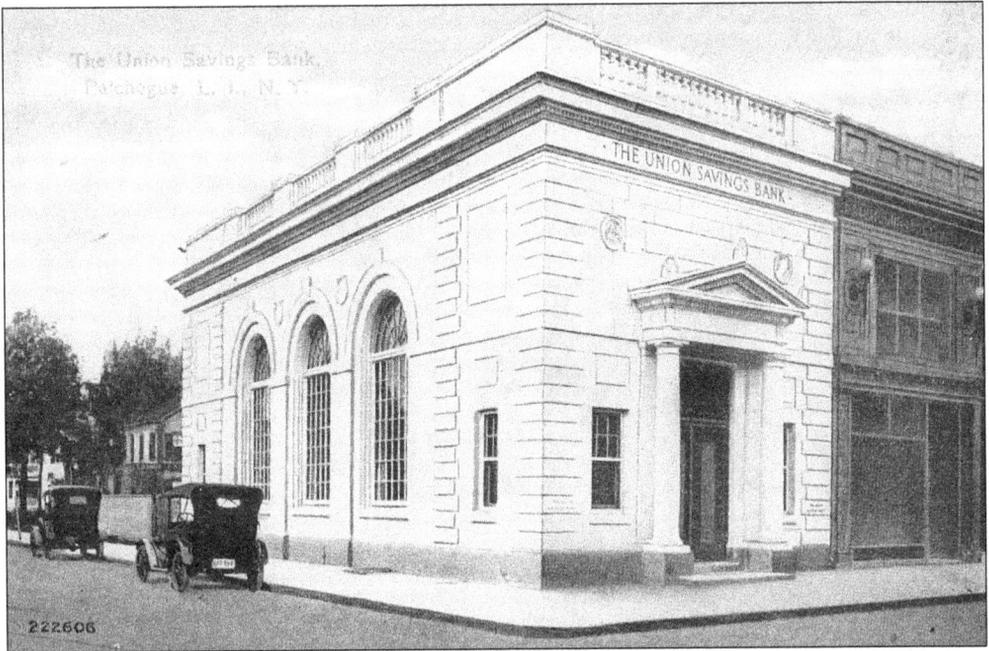

The Union Savings Bank was established in 1896 and opened on February 1, 1897, in the Tower building (today known as Swezey's). In 1912 this new bank was built on the northwest corner of South Ocean Avenue and Church Street in the style of the Georgian period of classic colonial architecture. It was faced with the whitest Vermont marble available.

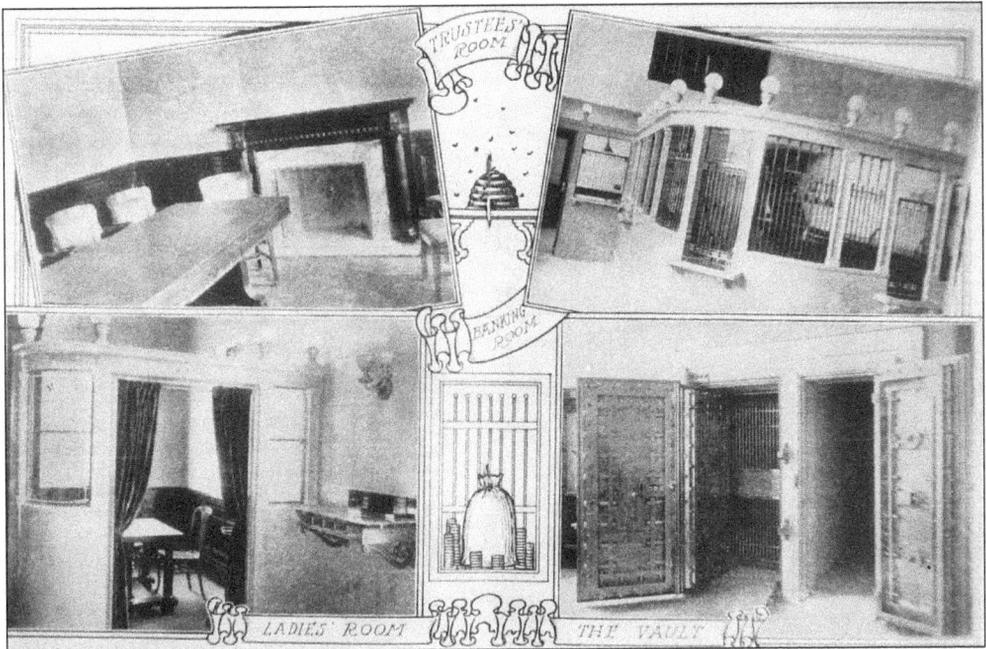

The interior of the Union Savings Bank in 1912 was 26 feet by 70 feet with a 25-foot ceiling. In later years the bank was enlarged by incorporating the Patchogue Electric Light Co. building on the north side as well as an extension on Church Street.

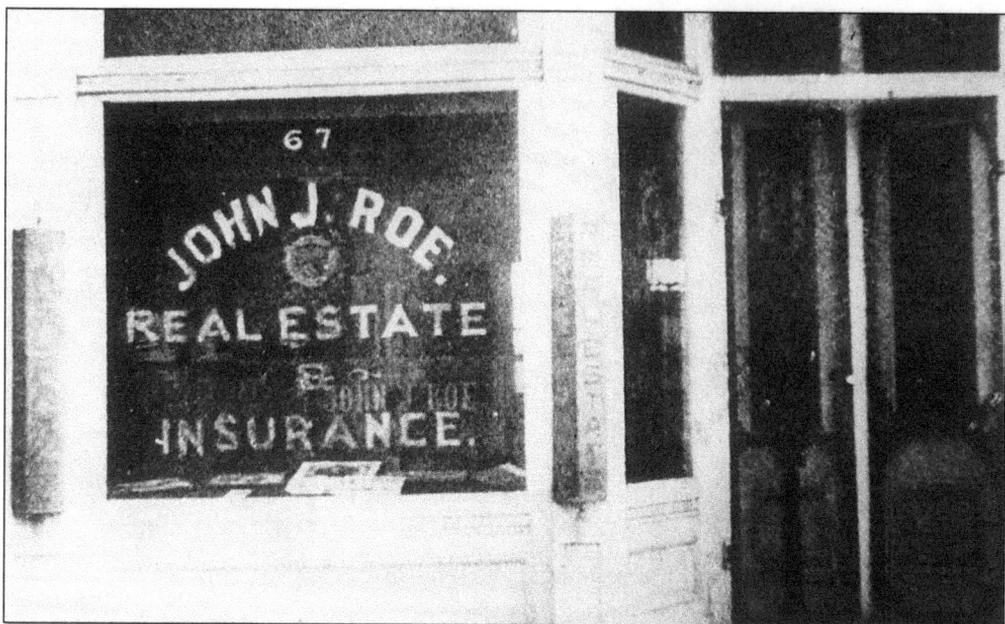

In 1904 John J. Roe's real estate and insurance office was located at 65 South Ocean Avenue approximately opposite the Union Savings Bank. The Roe Agency, established on April 5, 1898, celebrates its centennial anniversary this year.

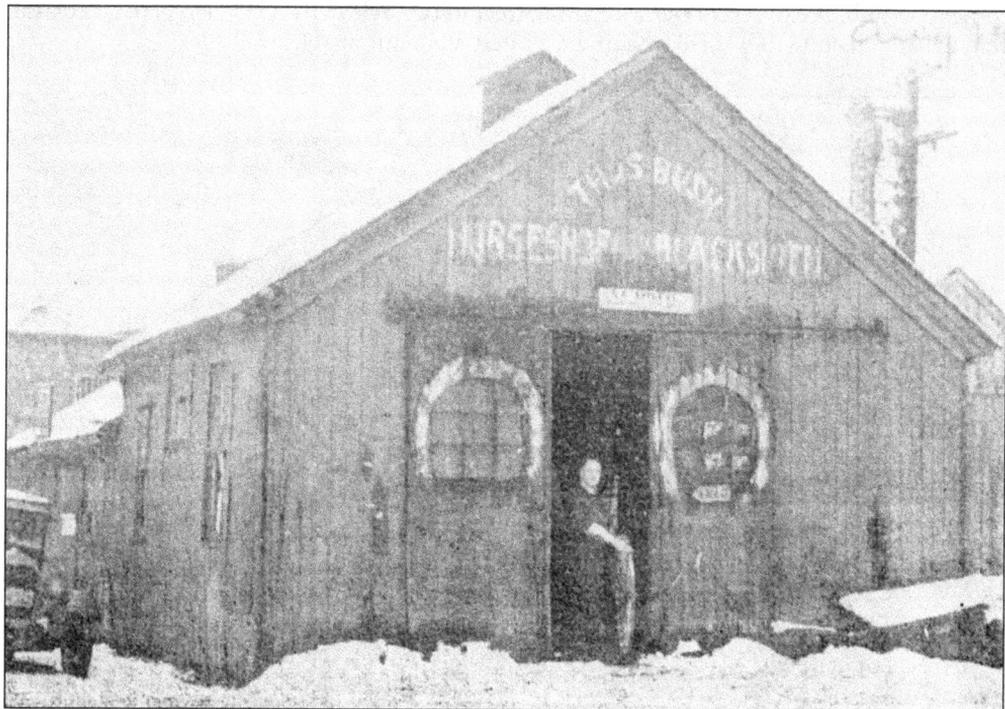

Thomas Bush, blacksmith, had his business in 1904 on East Main Street opposite the Roe Hotel. He then moved to Terry Street. This is his shop on Terry Street. Stephen S. Smith, who had his shop in Roe Court, moved his business to Thomas Bush's shop as the sign above the door indicates in this 1930s picture.

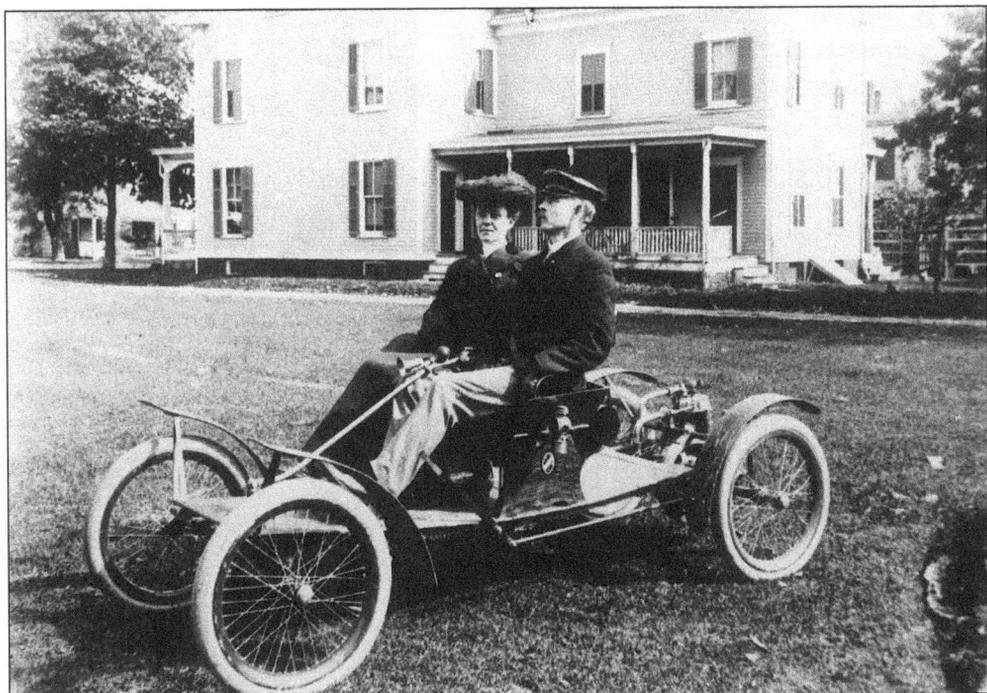

Howard S. Conklin was always fascinated with cars and made it a point to photograph every new car coming through Patchogue in the first decade of this century. Here he is with his wife and his own vehicle in October 1903.

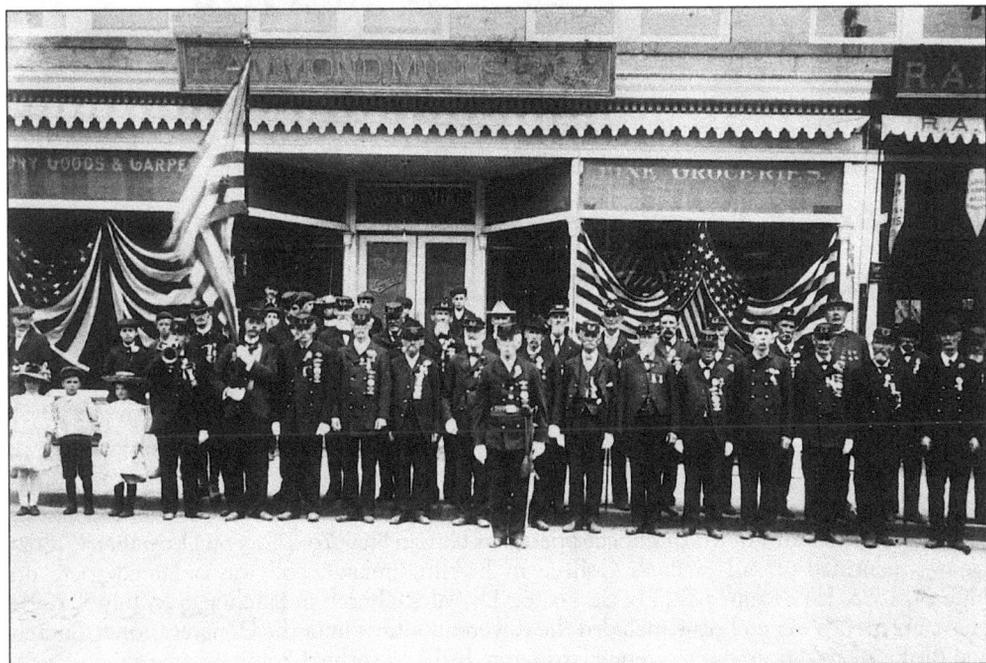

On May 30, 1904, these Civil War veterans assembled in front of the Mills building to take part in the parade.

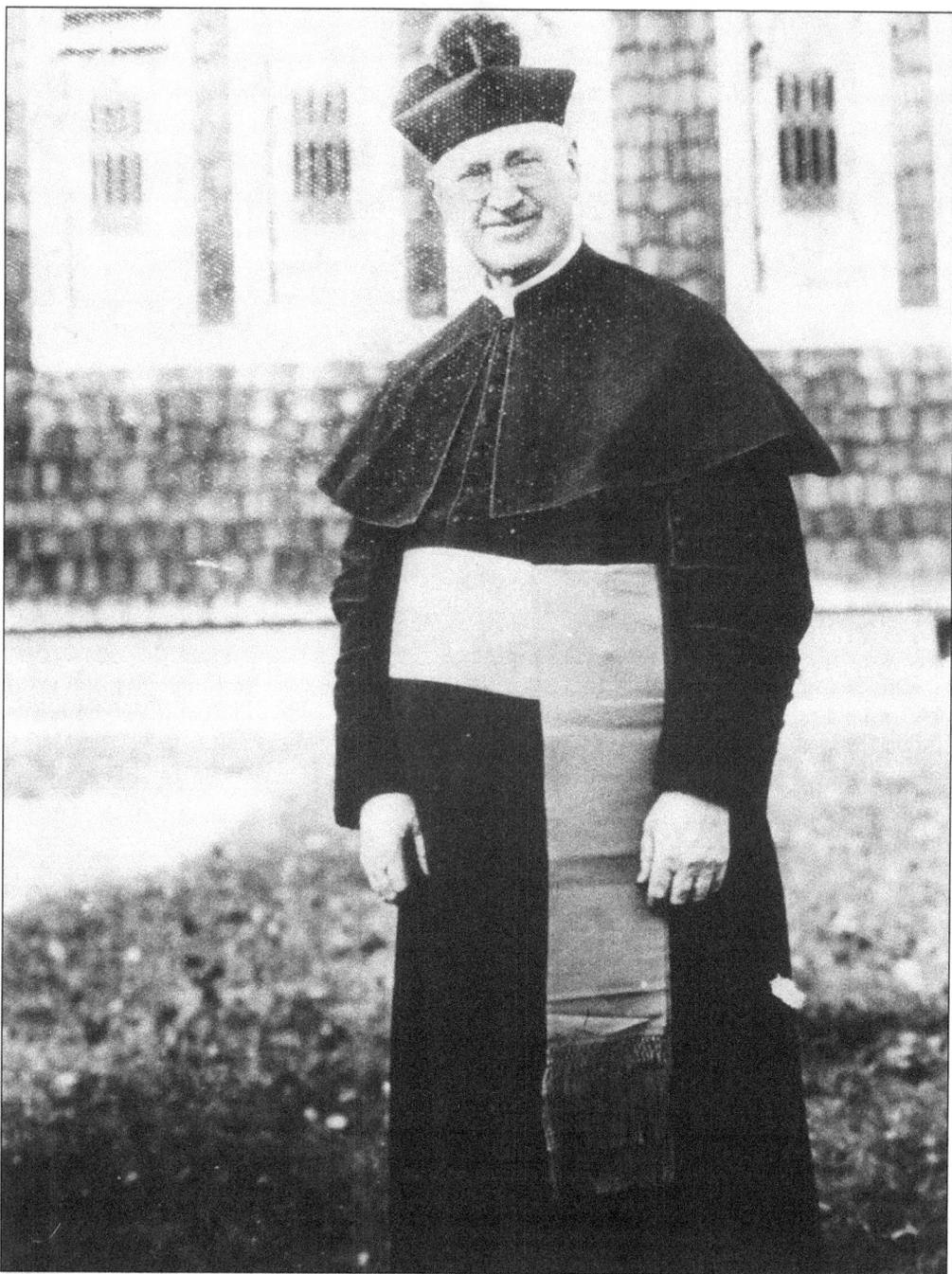

Father Cronin, a well-known Patchogue priest, was born in New York City on December 8, 1862. He was educated at All Hallows College in Dublin, Ireland, and was ordained there on June 24, 1888. He became pastor of St. Francis De Sales Church in Patchogue on July 3, 1897. His many friends in Patchogue included the Reverend Johnston of the Congregational Church and the Episcopal minister, Reverend Harrington. In 1929, Father Cronin became a monsignor. The year 1938 marked the golden anniversary of Father Cronin's ordination. When he died in June of 1946, the village and town hall flags were flown at half-mast in tribute to a great man.

22

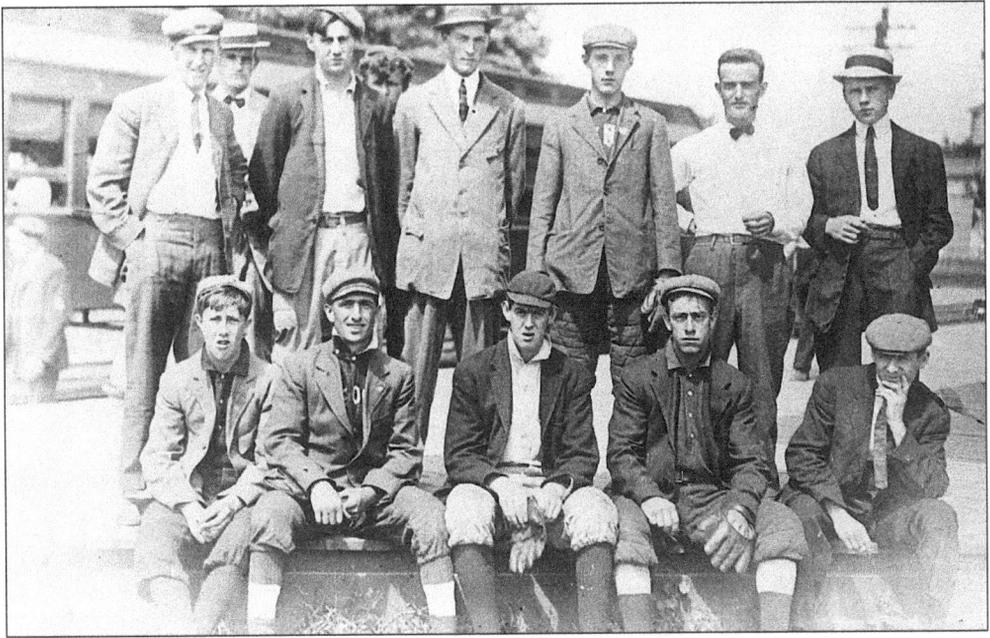

This c. 1910 photograph shows members of a Patchogue baseball team, only a few of which have been identified. Sitting in front, first from the left, is Harvey "Toby" Stokem; fourth from the left is Jack Stokem.

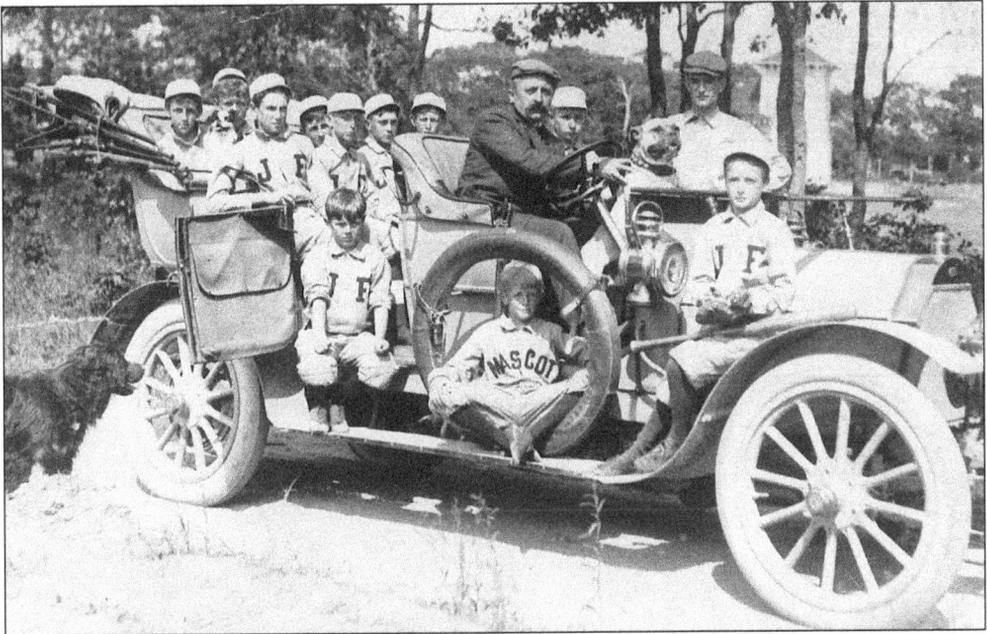

A picture from the beginning of this century shows us the "Jackwill Farm" baseball team, sponsored by Ruth Litt. In the Pierce Arrow listed from left to right are as follows: (front seat) chauffeur Peter Peterson, Humphrey Avery, Mascot "Buff," and Coach Frank Dillman; (outside) Jack Litt, Wellard Litt (in Tire), and Norman King; (middle seat) Ira Still, Roy Smith, Ernest Terry, and Chad Smith; (back seat) Dave Hiscox, Richard Smith, and George Kindtle.

T. F. ARCHER,
AUCTIONEER,

Telephone 660 Post Office Building, Jamaica, N. Y.

POSITIVE AUCTION SALE

OF

Valuable Real Estate

IN THE

VILLAGE OF PATCHOGUE

SUFFOLK COUNTY, N. Y.

Saturday, February 22nd, 1913

On the Premises, Consisting of

8 RESIDENCES AND 150 BUILDING LOTS

Situated on

Carman Street, Rider, Bailey and Bay Avenues

This property is known as the George F. Carman Estate, and is sub-divided into Building Plots and will be sold without reserve to the highest bidder. It is in the heart of the best residential section of Patchogue, near the Bay and five minutes to Depot.

TERMS OF SALE.—Fifty per cent. (50%) on Bond and Mortgage for three years, 20 Monthly Payments; 2½% discount for cash.

The Carmen Estate was the first large estate in Patchogue to be auctioned. The date was Saturday, February 22, 1913.

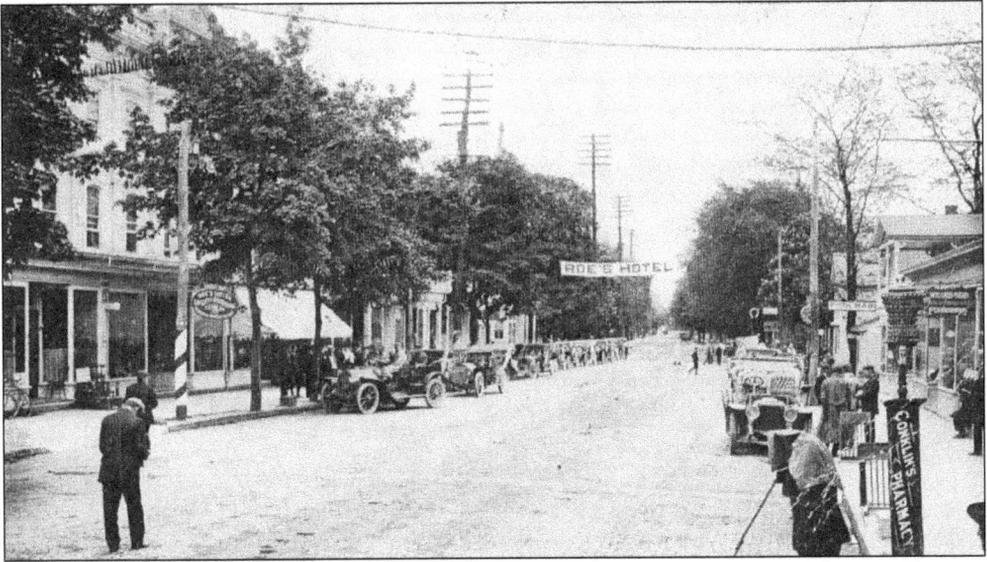

This is a picture taken of East Main Street in 1906. Roe's Hotel on the left was for many years the stopover point for New York bicyclists. Now it has become the favored place for New York automobile owners.

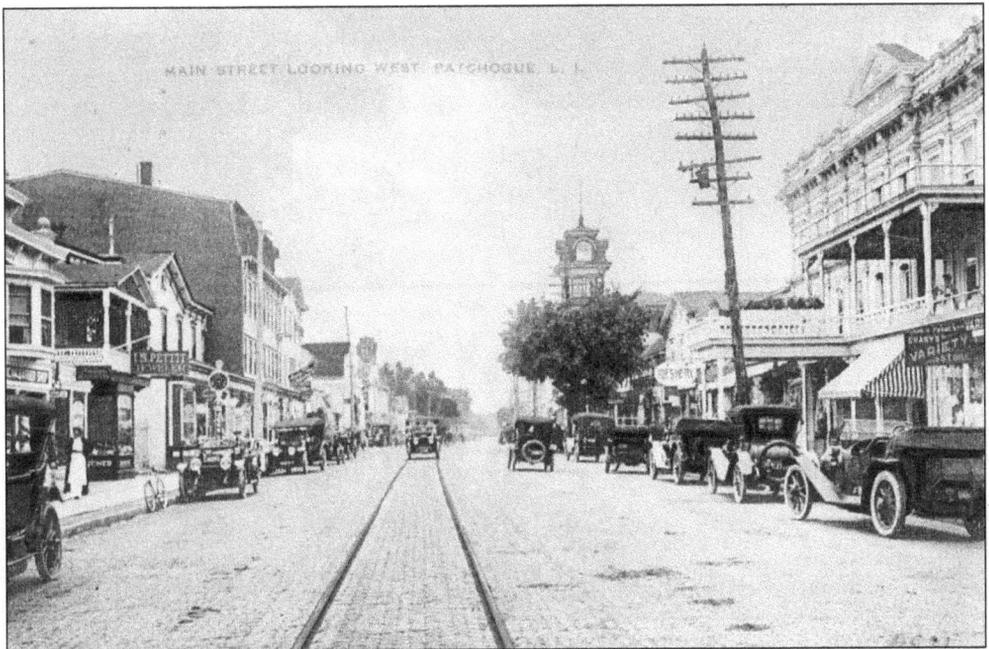

East Main Street, c. 1910, is still paved with brick, but now street car rails have been installed and the automobile has replaced most horse-drawn wagons.

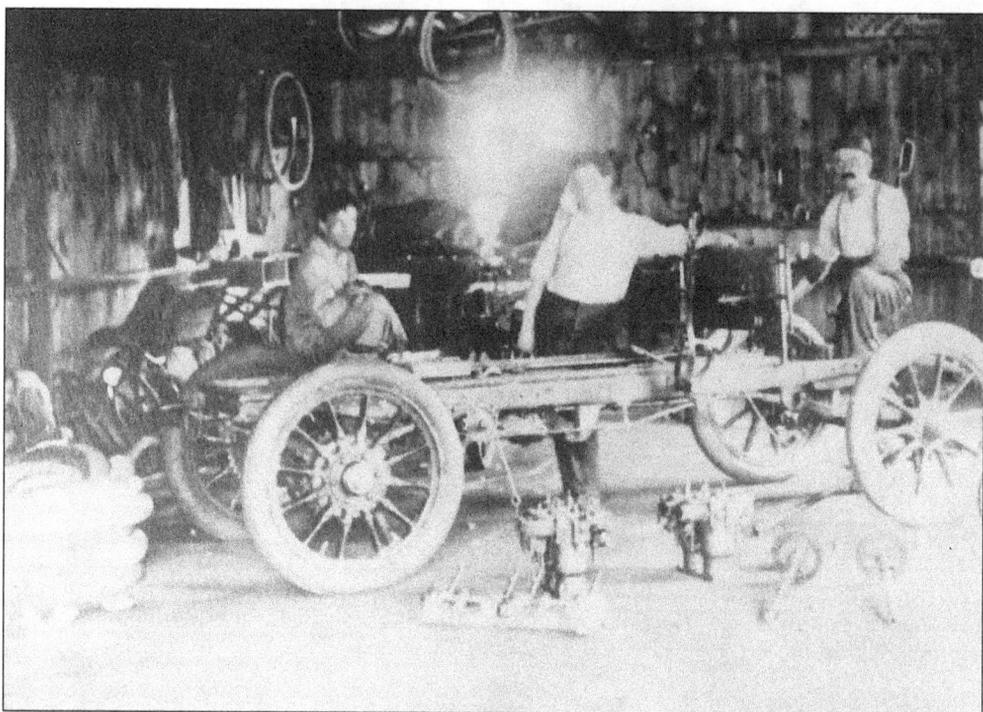

Now that is what one would call a major tune up! Or are these mechanics building a car from a do-it-yourself kit? This scene is at J.O. Hulse's garage on 52 West Main Street *c.* 1905. The man in the center is Clarence Wilford Coleman.

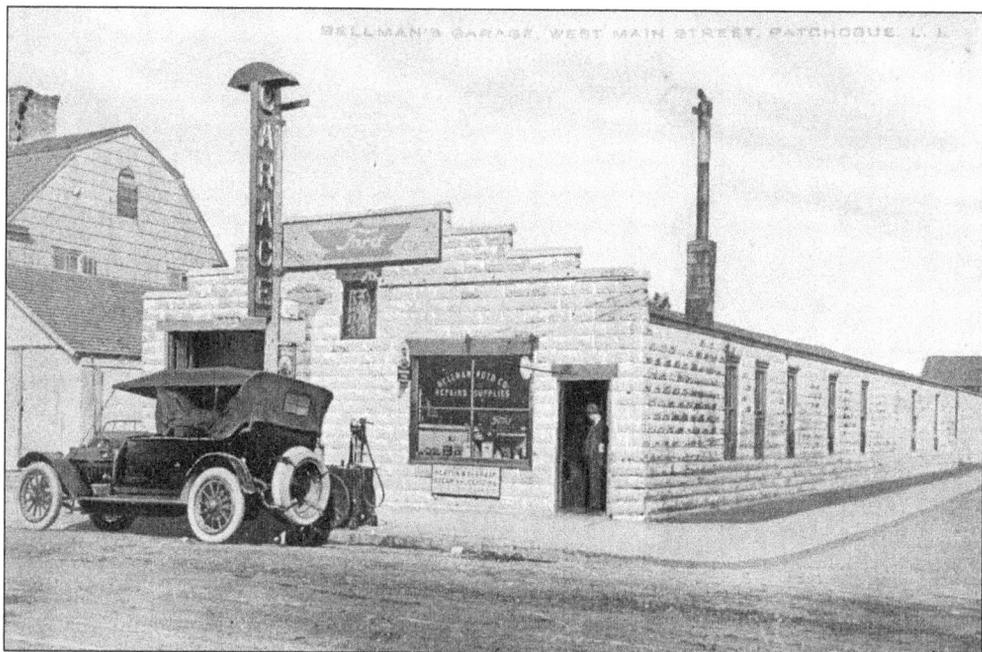

Heyman Tellman's garage was located on the south side of West Main Street, just past the West Lake. By 1926 Patchogue had over 20 automobile repair shops, 14 car dealers, and many parts supply houses.

26

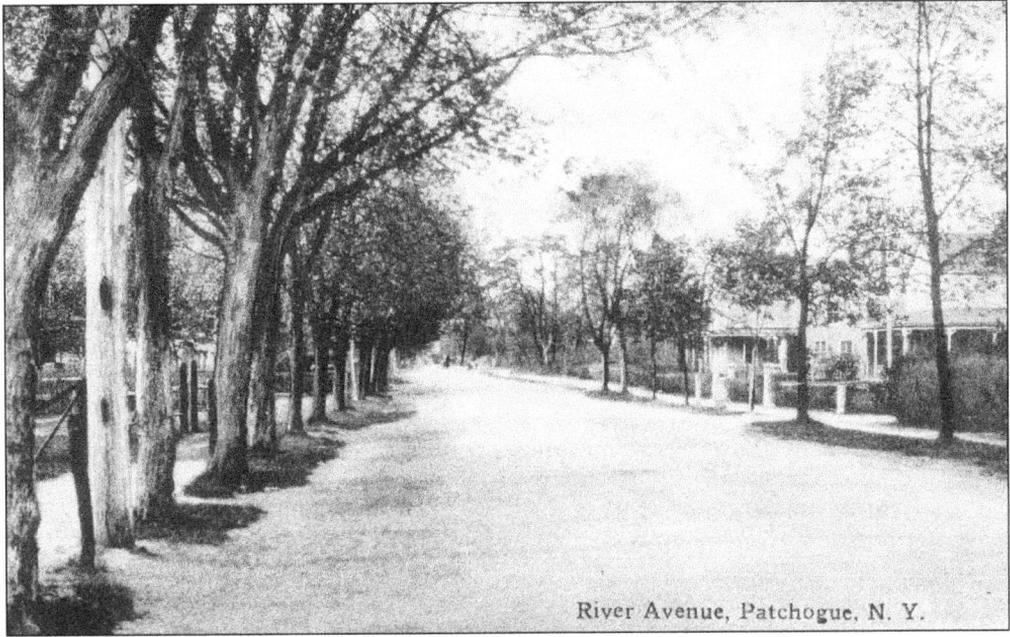

This postcard view of River Avenue, c. 1910, was taken north of the railroad tracks. The buildings on the right are still there today, standing just south of Fordham Street.

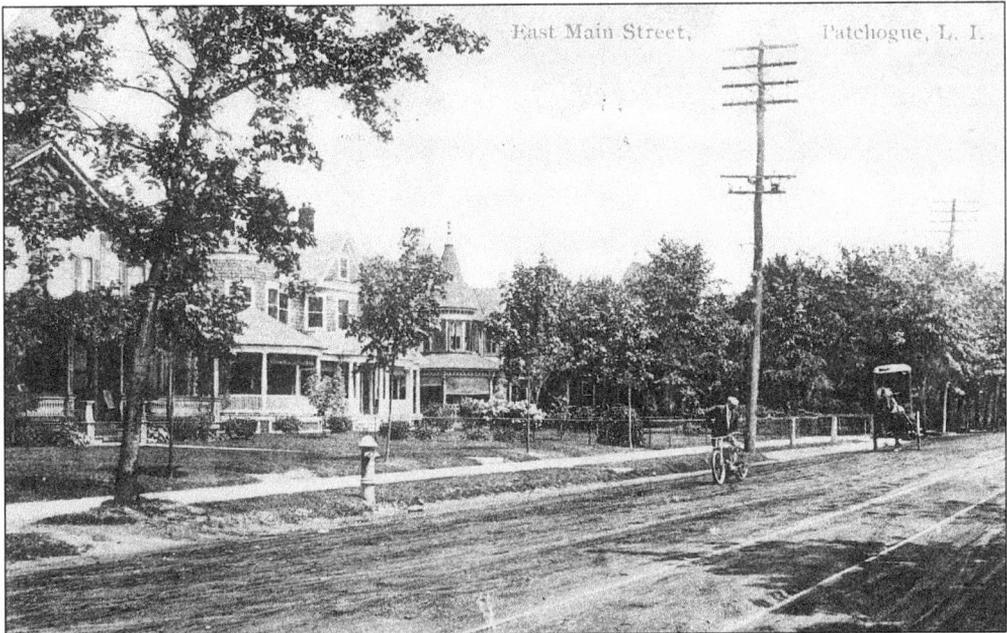

This image of East Main Street was taken in 1908. The three homes on the left just opposite Rider Avenue are the homes of Charles E. Rose (on the left) and the Walter S. Rose home (to the right). The center home was C.T. Lowndes home; in later years it became Nan Gurney's Inn and afterwards the Clayton Nursing Home.

The estate of Kate L. Gilbert, bordering the Patchogue River, was auctioned in July 1916. The 70 acres of the estate provided room for many new homes in Patchogue.

GILBERT HOMESTEAD
Divided Into Lots
TO BE SOLD AT
ABSOLUTE AUCTION
ON

Wednesday	Thursday	Friday
SEPT. 10th	SEPT. 11th	SEPT. 12th
	AT 1.30 P. M.	

The purchasers at the Auction Sale of the Gilbert Homestead, parcel of 10 acres, failing to comply with the terms of sale, Mrs. Gilbert has instructed me to divide the same in building lots and to sell them to the highest bidder.

A part of the Buildings will be Sold separate; also Farming Implements, Household Furniture, Etc.

There is about 3,000 feet of street frontage and about 400 feet of bulkhead water front on Patchogue River. House will be sold on plot about 200 ft. x 200 ft.

TERMS OF SALE 10% down, 15% on delivery of Deed in 60 days, 75% on mortgage at 4% interest for 1, 2 or 3 years, or will be sold on monthly payments.

1000 Souvenirs Given Away

Don't Fail to Attend as this will be your last opportunity to buy this most beautiful property.

A second auction was held on the Gilbert Estate in September 1916, auctioning off the remaining 10 acres, including the main house.

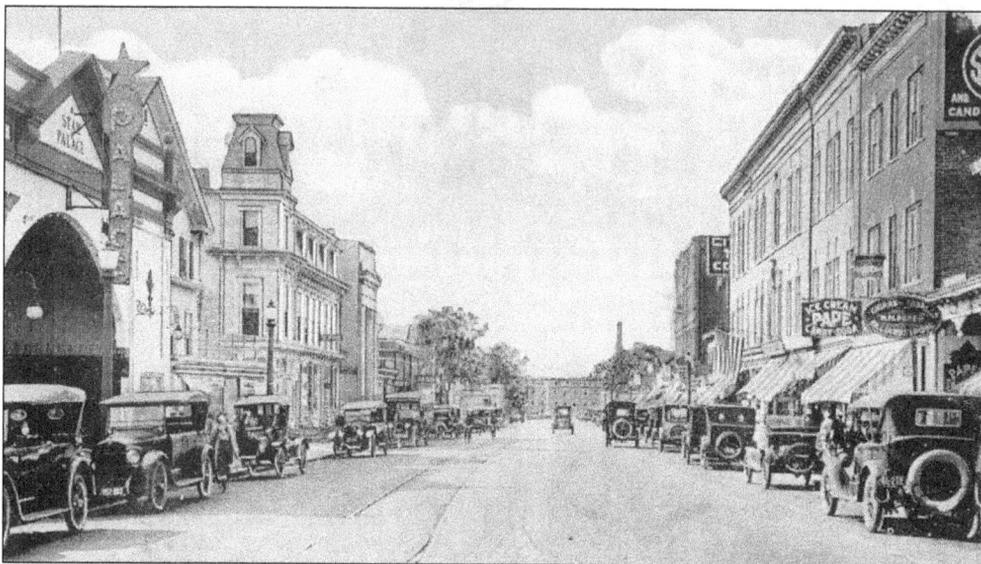

West Main Street is pictured here the way it looked c. 1918. The Star Palace is on the left; followed by the Central Hotel; the Roe Block, which now houses the Colony Shop; and the Patchogue bank building. The first building on the right is part of Bartletts Saloon, then follows the red Pape building, the Syndicate building, and the large red Masonic Temple.

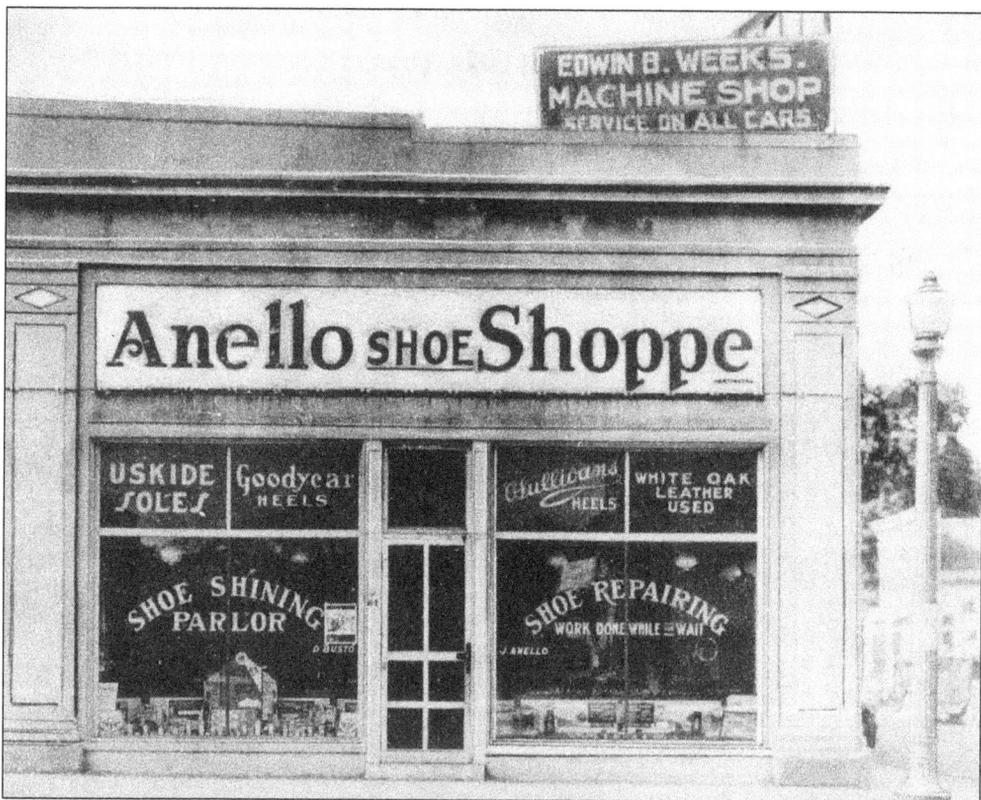

In the 1920s Anello's Shoe Shoppe, 84 West Main Street, stood on the corner of Railroad Avenue.

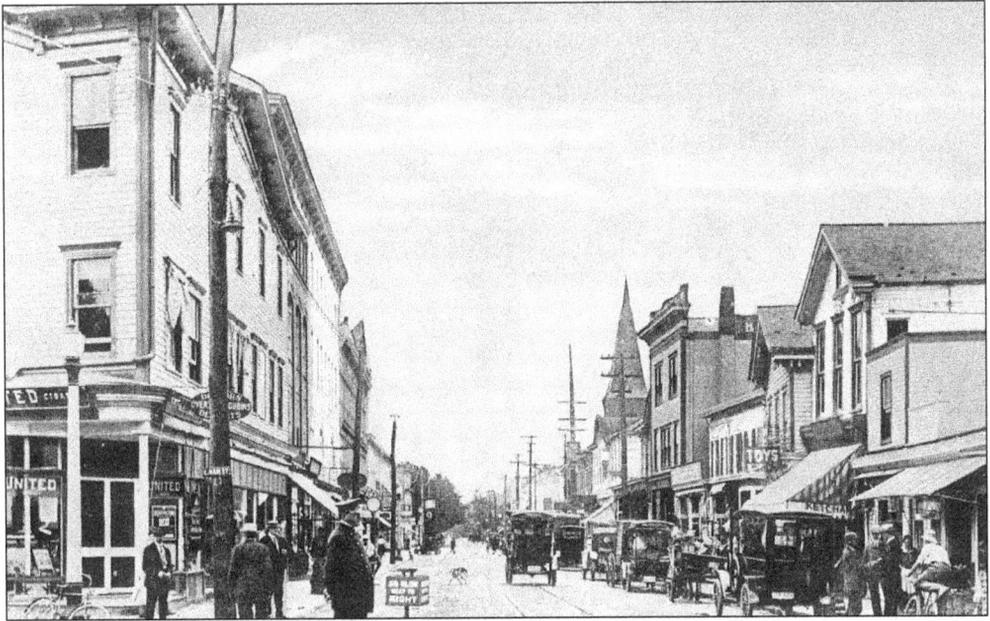

South Ocean Avenue is pictured here the way it looked c. 1915. The sign in front of the policeman was the first form of traffic control on the 4 Corners; later on this was upgraded to various other signs, lights, and booths.

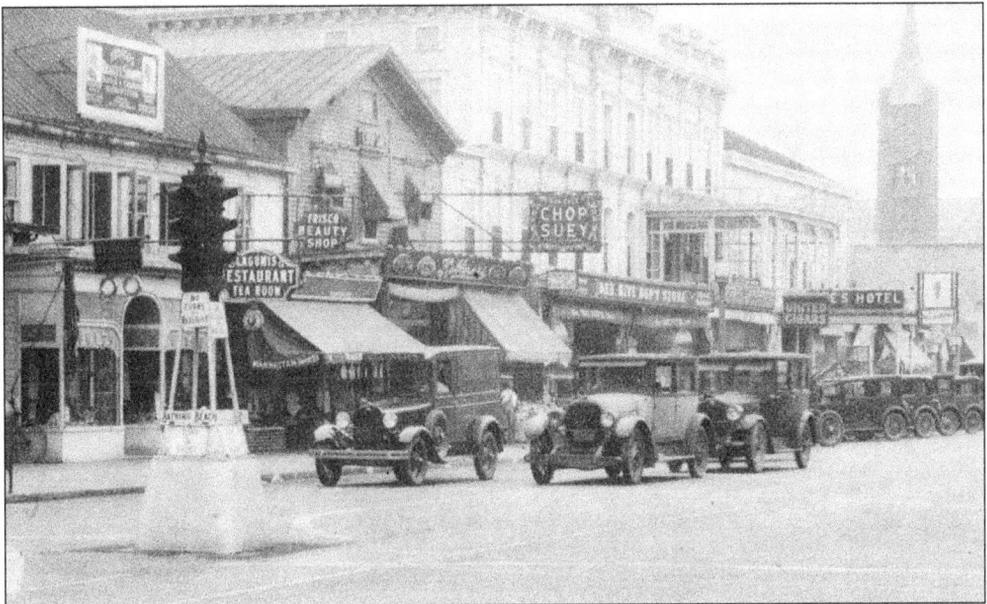

The 4 Corners in the 1920s now sported a traffic light mounted on a concrete pillar and steel frame. The Bee Hive department store is located on the ground floor of Roe's Hotel.

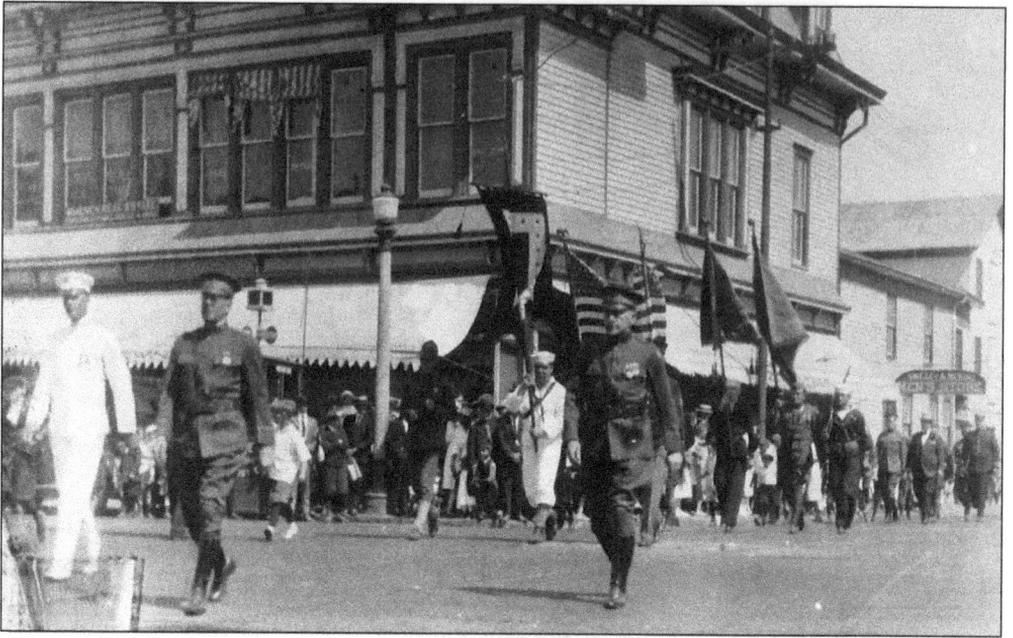

The Decoration Day Parade is pictured here in 1919 on North Ocean Avenue and Main Street. The officer in the center foreground is Ludwig Brall and the sailor carrying the flag is Jimmy Brooks.

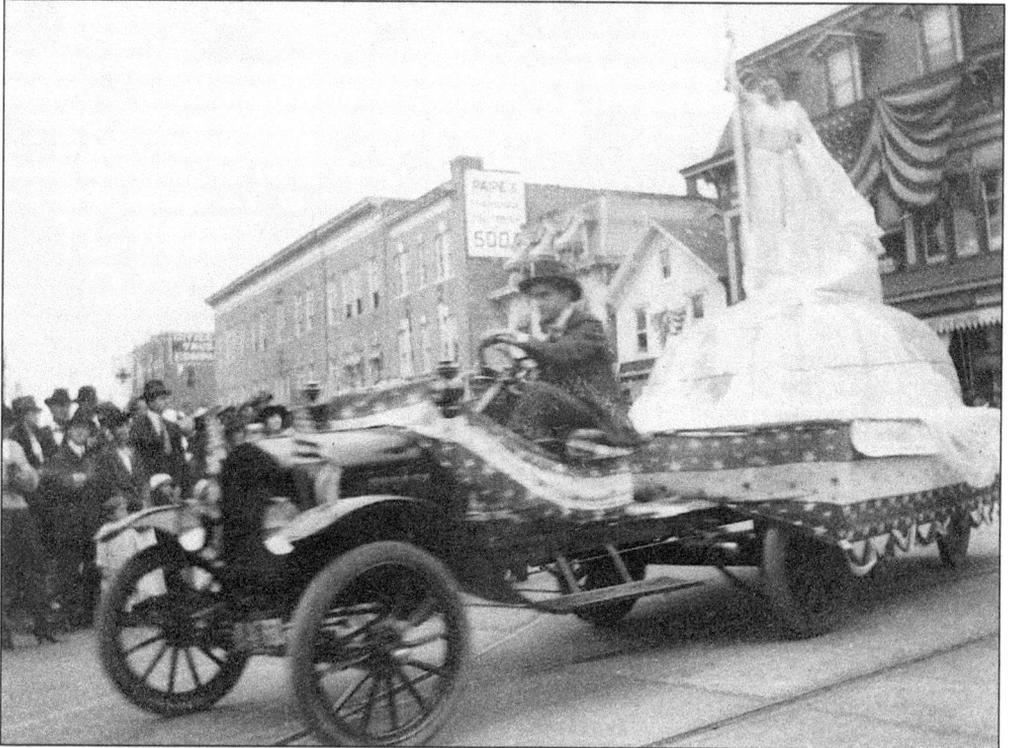

A Liberty Bond drive was photographed here in 1918 on Main Street. Many Liberty Bond drives were held to help finance the war efforts in World War I.

32

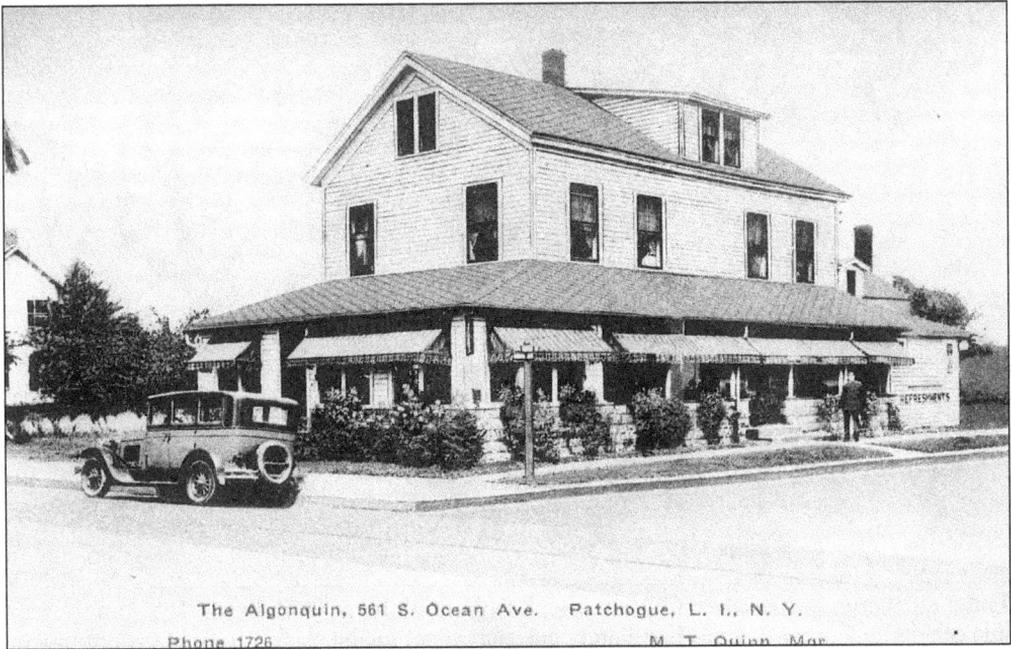

The Algonquin Restaurant on the northeast corner of South Ocean Avenue and Smith Street was photographed in 1926. Today this building is an apartment house.

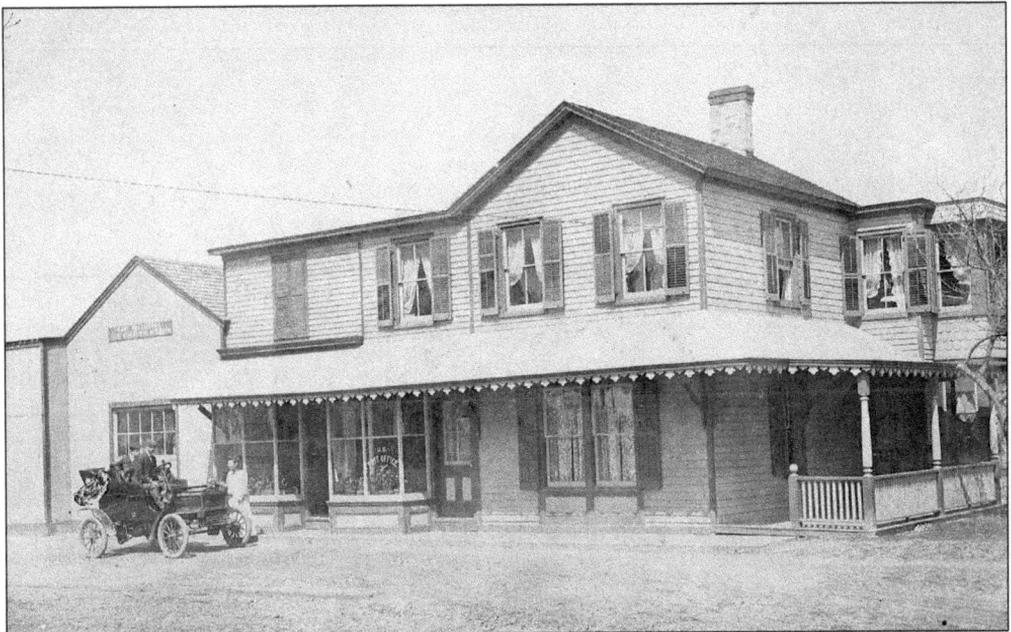

This building on South Country Road in East Patchogue was an ice cream factory. It also served as a post office in 1907.

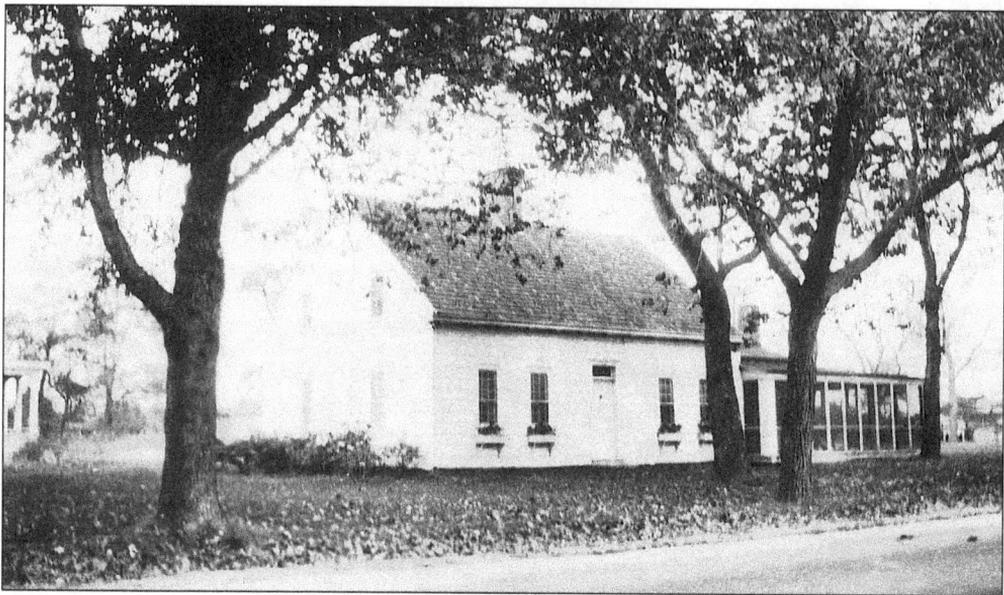

This 1920 picture was taken of Captain Joseph Robinson's home, built before 1850, on the east side of South Country Road in East Patchogue (just past Pine Neck Avenue). Many prominent and well-known people lived on South Country Road.

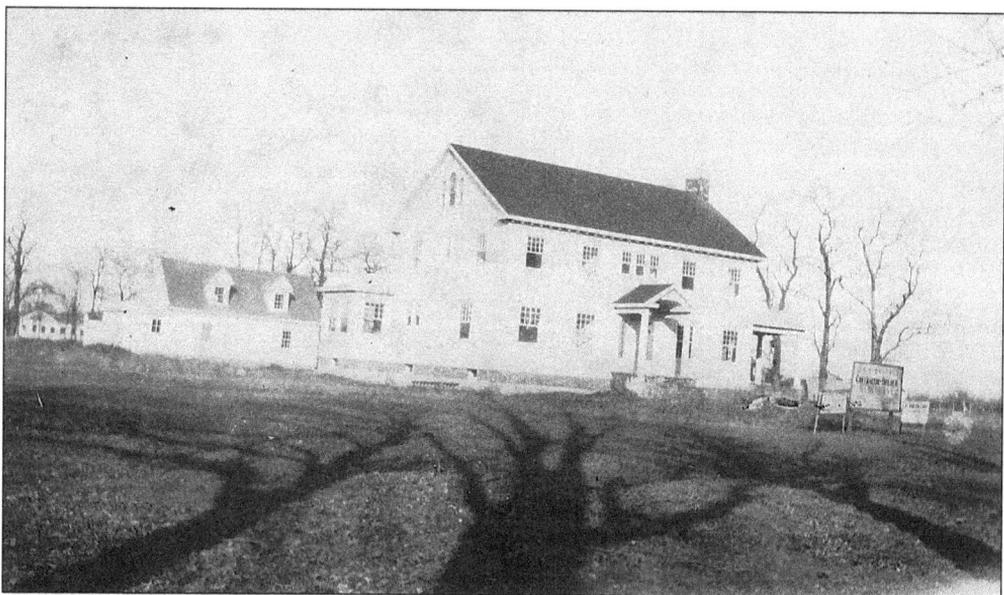

By 1927 the above house was moved to the back of the property to make room for a larger home. Two dormers were also added.

BOYLE PARK

Located in One of Long Island's Most Picturesque and Beautiful Towns

IN THE INCORPORATED VILLAGE OF

PATCHOGUE

SUFFOLK COUNTY LONG ISLAND, N. Y.

OCEAN AVENUE
RYDER AVENUE
WIGGINS AVE.
MARVIN STREET
BOYLE LANE

BAY AVENUE
DANES STREET
ROBINSON ST.
BAILEY AVENUE

BAY AVENUE ACROSS STREET FROM BOYLE PARK

UNUSUAL OPPORTUNITY

182 CHOICE LOTS

AT

PUBLIC AUCTION

ON

Saturday, September, 5th, 1925

2 P. M.

ON

PREMISES

RAIN OR

SHINE

UNDER

TENT

SHORE FRONT — OCEAN AVENUE

Additional Maps and Information from

T. F. ARCHER & SONS, Auctioneers

15 Twombly Place Phone Jamaica 0660 Jamaica, N. Y. C.

The Boyle Estate, one of the few large estates in Patchogue, was auctioned on September 5, 1925.

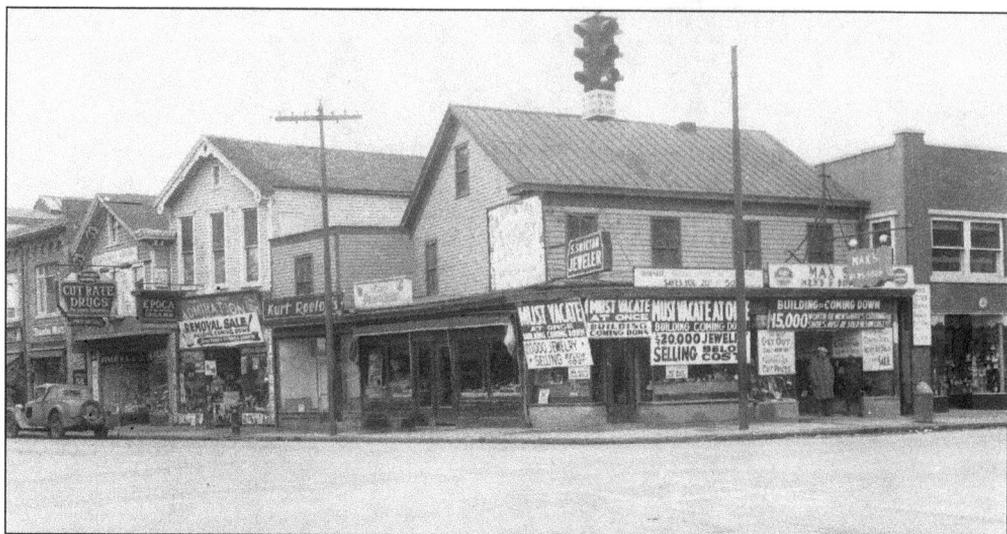

In 1936 the stores on the southwest corner of Main Street and South Ocean Avenue had to vacate so the buildings could be demolished to make room for the new Furman building. Simon Smietan's Jewelry Store occupied the corner building (which was formerly John Ginocchio's Fruit and Confectionery Store). Kurt Roeloffs's Store of Optometry is next to it on South Ocean Avenue.

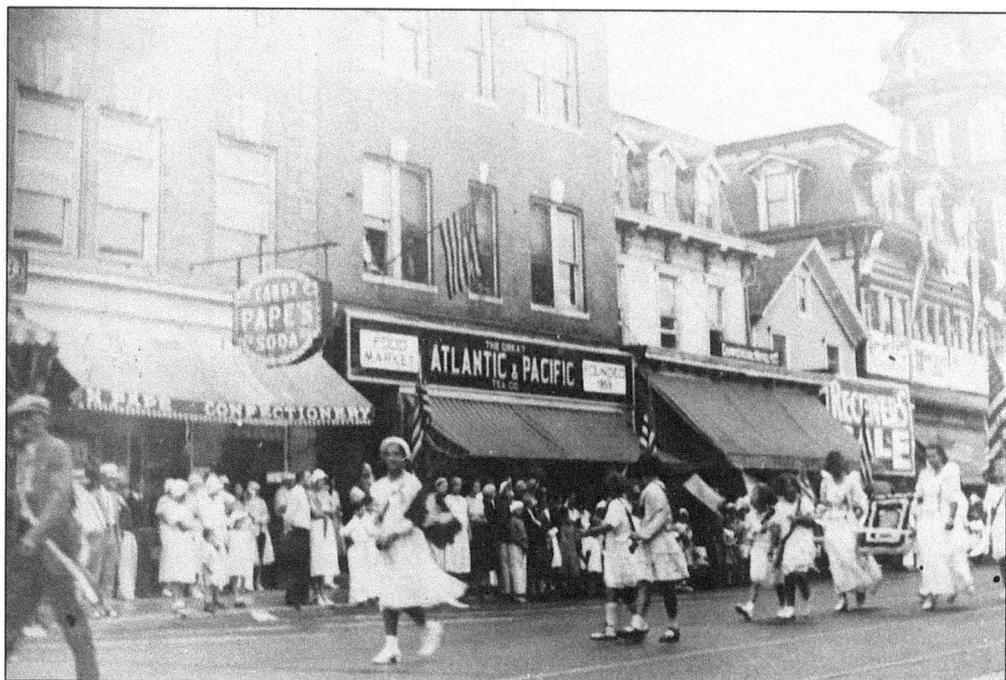

A parade took place on West Main Street c. 1930. There was an A&P store in the Pape building at this time. In 1926 there were A&P stores listed at five locations in Patchogue: 120 East Main Street, John Barrie manager (near today's Patchogue Stationary); 288 East Main Street (near Bay Avenue); 85 South Ocean Avenue, William C. Newcomb manager (near Terry Street); 23 South Ocean Avenue, Jacob Le Blue manager (near the 4 Corners); and 15 Carmen Street, which is still a delicatessen today.

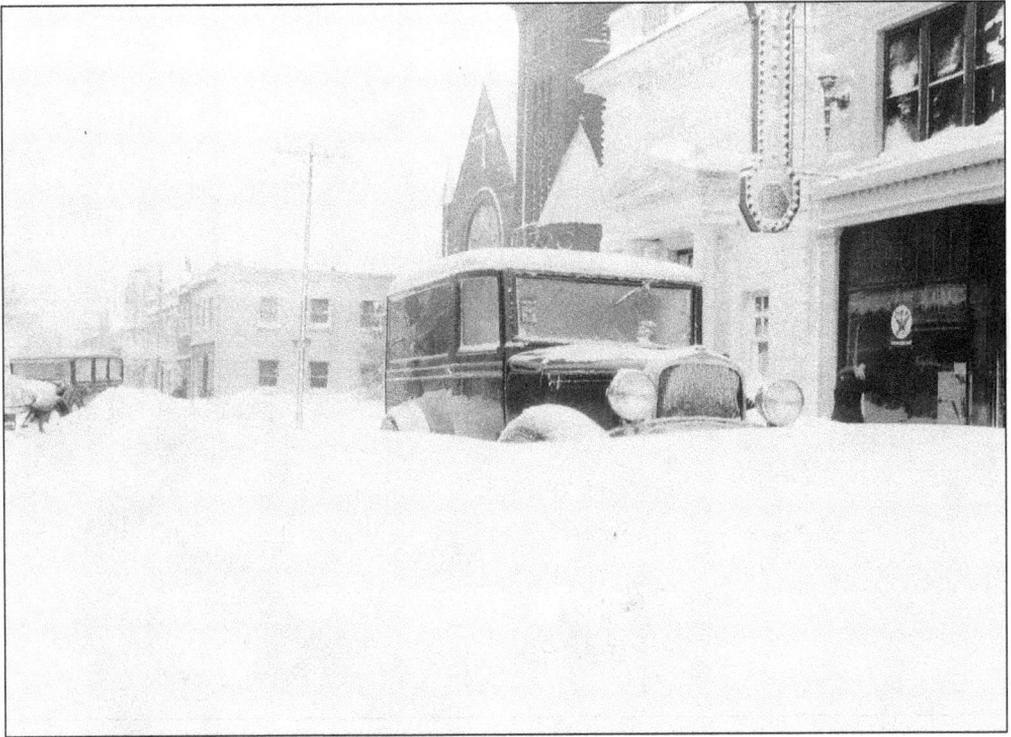

South Ocean Avenue is pictured here after a 1934 snowstorm. The buildings, from right to left, are the Patchogue Electric Company, the Union Savings Bank, the Methodist church, the New York Telephone Company, and the Rialto Theater.

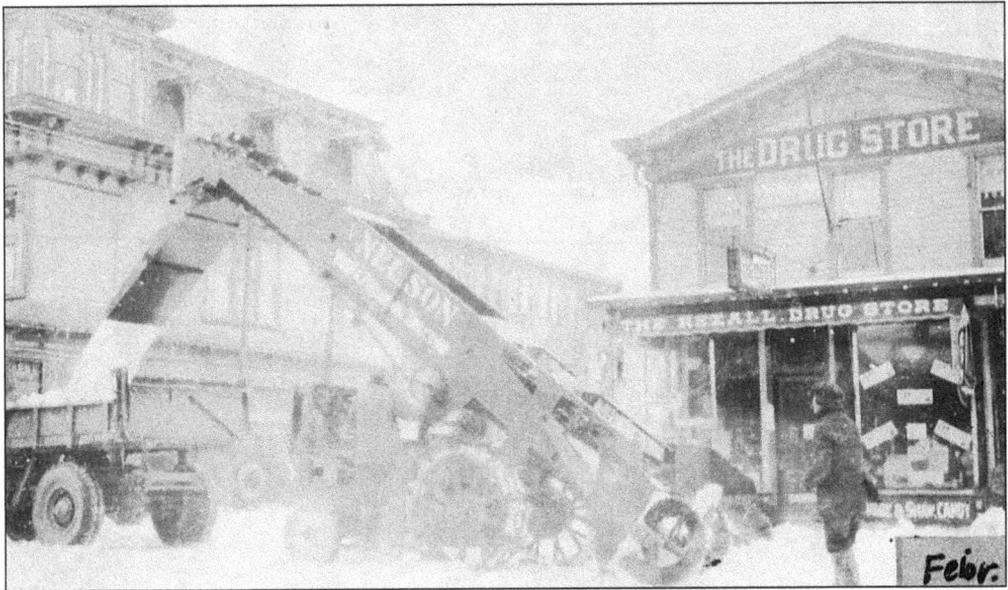

In February 1927, new motorized equipment allowed for much faster snow removal, as seen in this image of a clean up after a heavy snowfall on Main Street. Nelson McBride's drugstore is on the right.

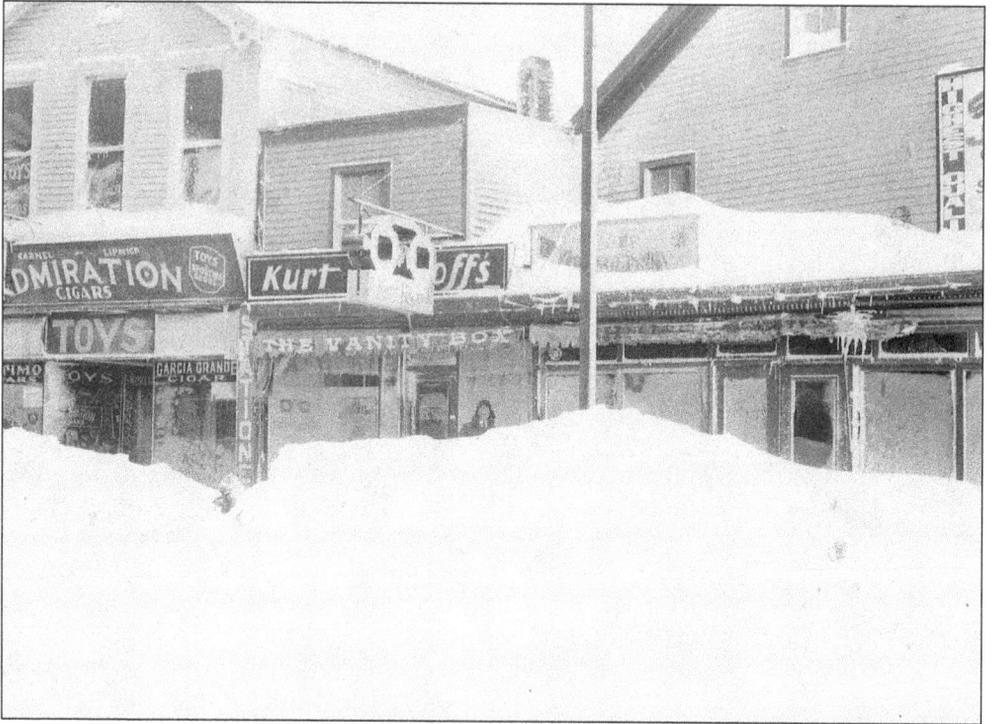

This is another picture taken after the 1934 snowstorm on South Ocean Avenue. On the left is Carnel and Lipnick's Stationary store and to the right of it is Kurt Roeloffs, optician.

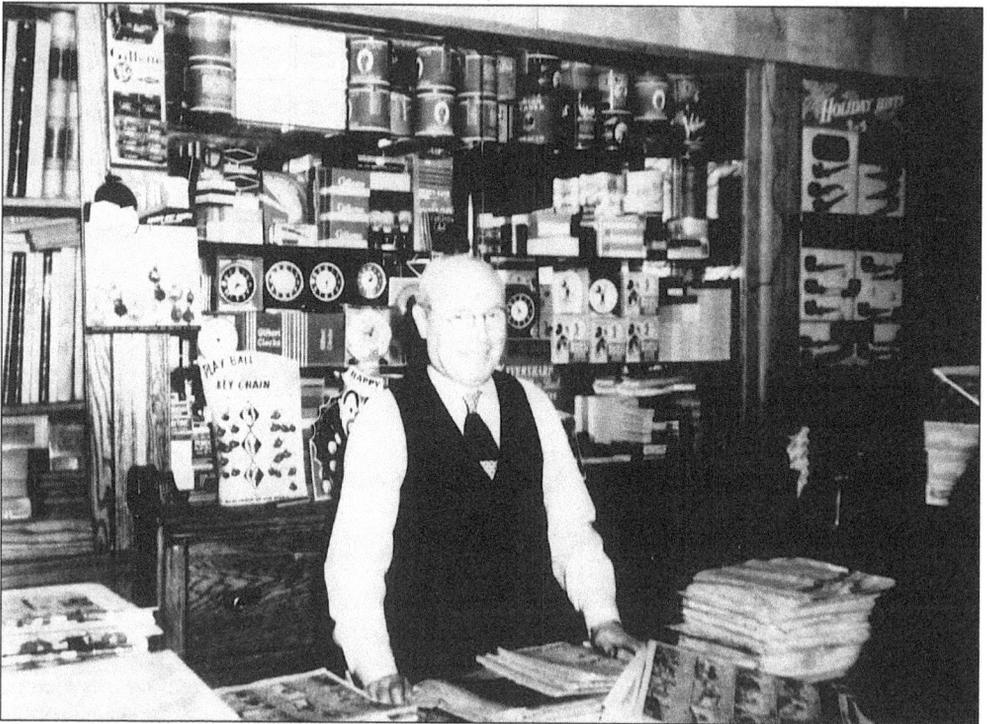

This is Sam Carnel in his stationary and cigar store on South Ocean Avenue *c.* 1940.

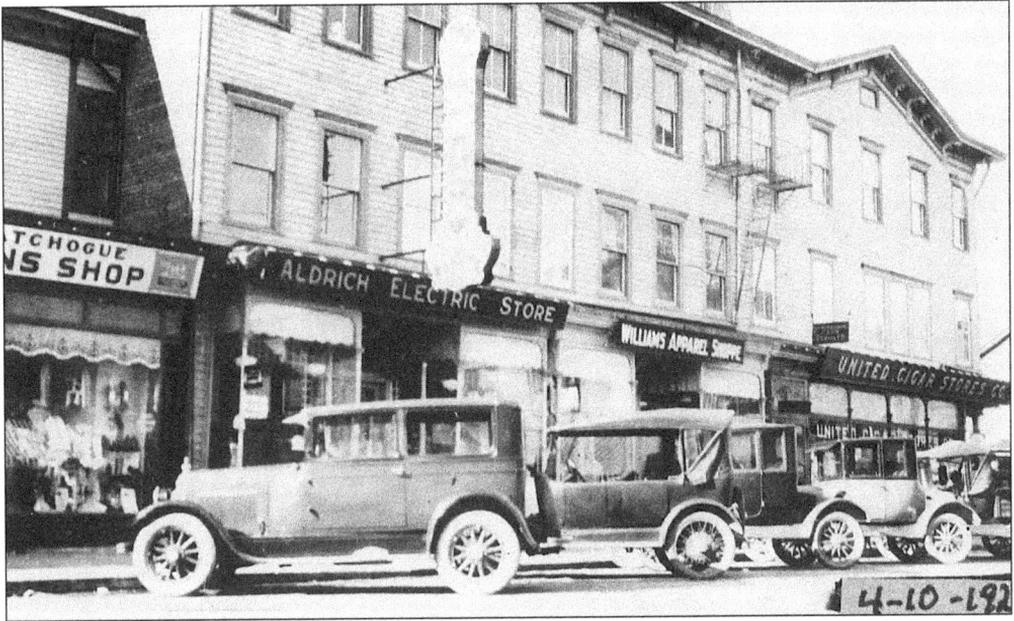

The Mills building on the southeast corner of Main Street and Ocean Avenue is shown here in October 1926. Ludwig Brall's United Cigar store, William's Apparel Shop, and Aldrick's Electric store were on the ground floor as well as many other small businesses on the second floor. The New York Telephone Company had their switchboards located here until the new building next to the Methodist church was completed.

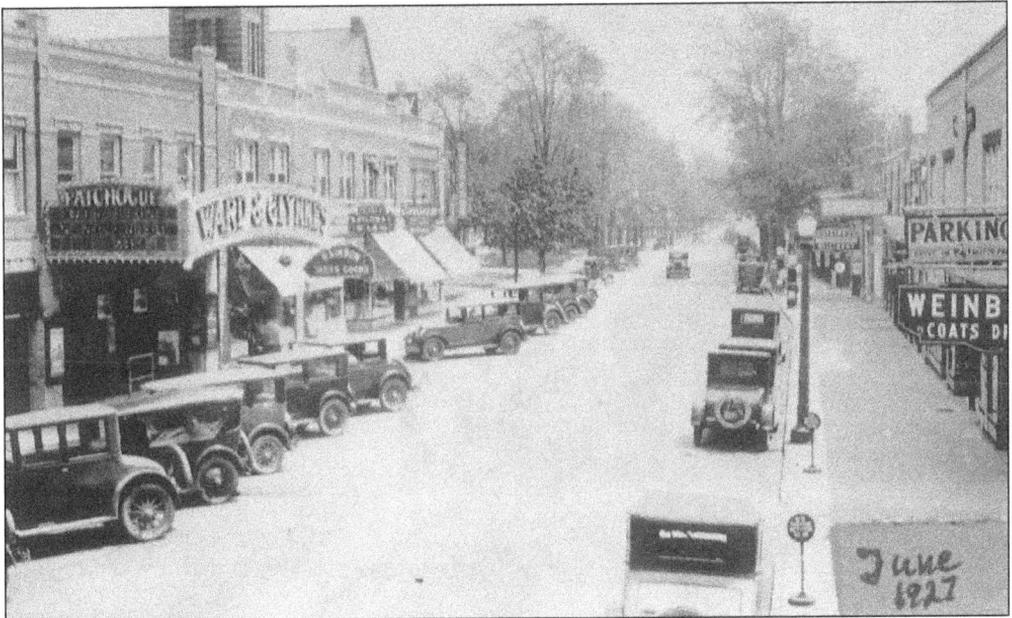

East Main Street, shown here in June 1927, has not changed much today. Ward and Glynne's Theater is on the left.

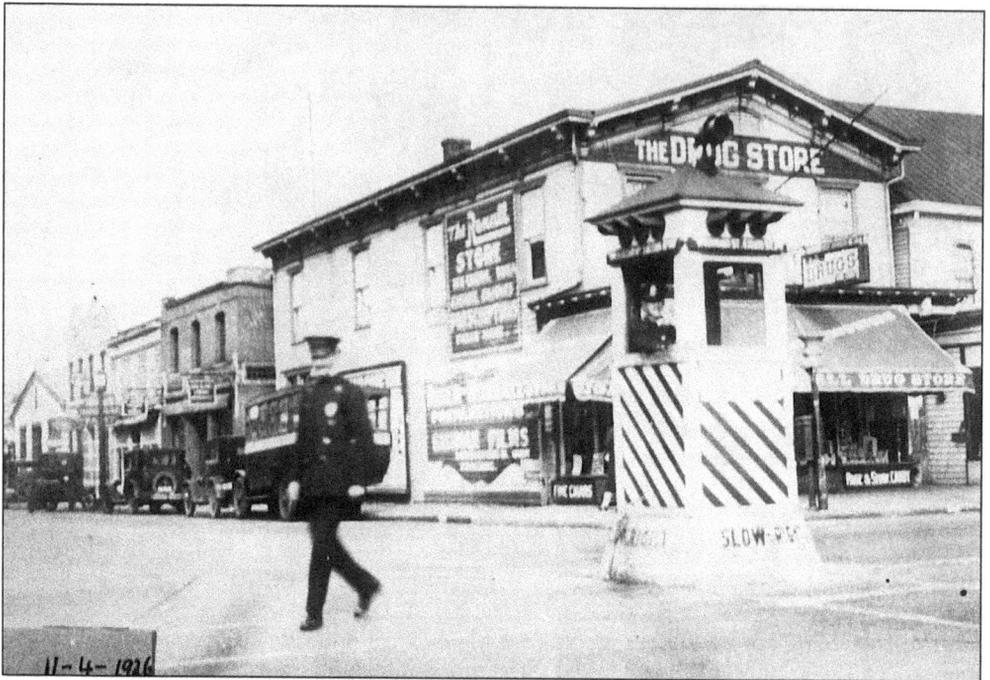

The manned traffic control booth on the 4 Corners was photographed in 1926.

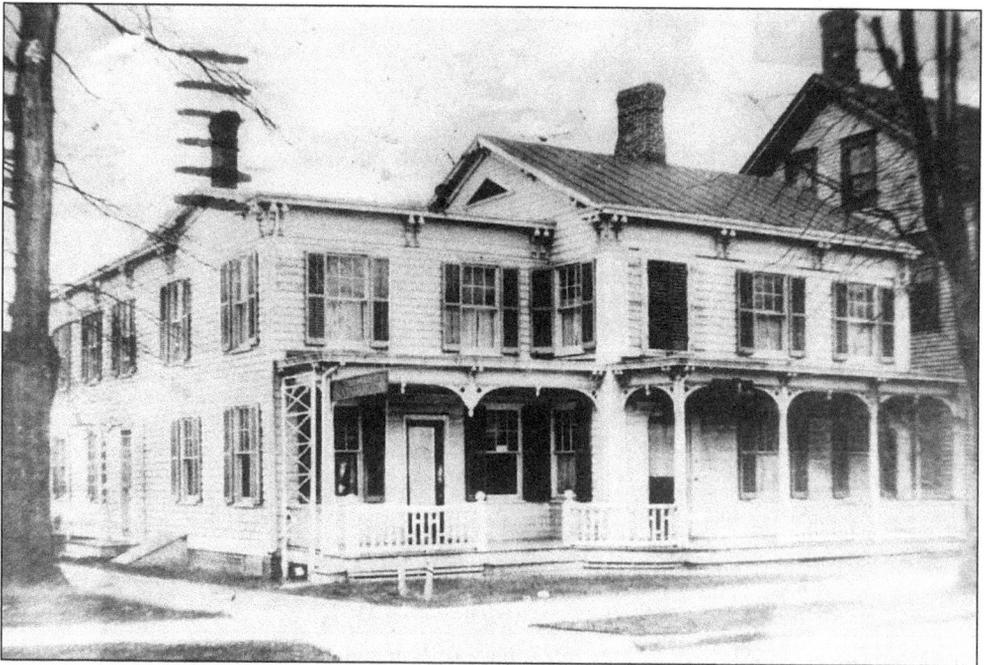

Browns Boarding House stood just east of Nicols Hotel on East Main Street.

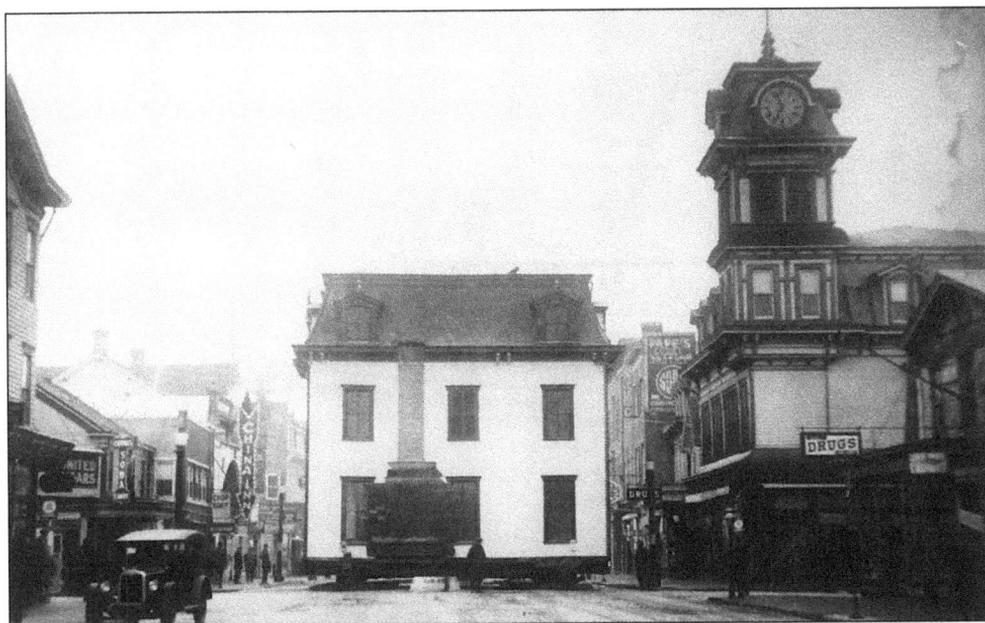

The old Elks Club building on the northeast corner of Maple Avenue and Main Street had to be moved to make room for the new building. Here the building is moving past Swezey's on its way to its new location on West Avenue, which today is the parking lot of the Sixth District Court building. The date is February 7, 1925.

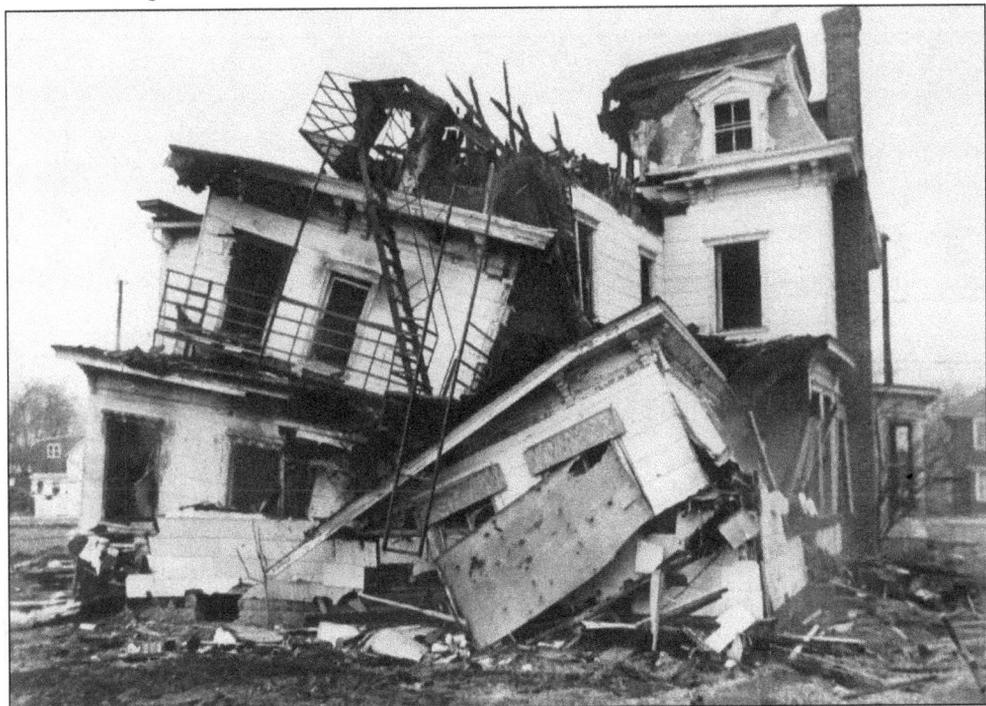

On West Avenue the former Elks Club building became an apartment house which deteriorated over the years. The home burned on June 13, 1974, became a total loss, and was demolished. As a result eight families were left homeless.

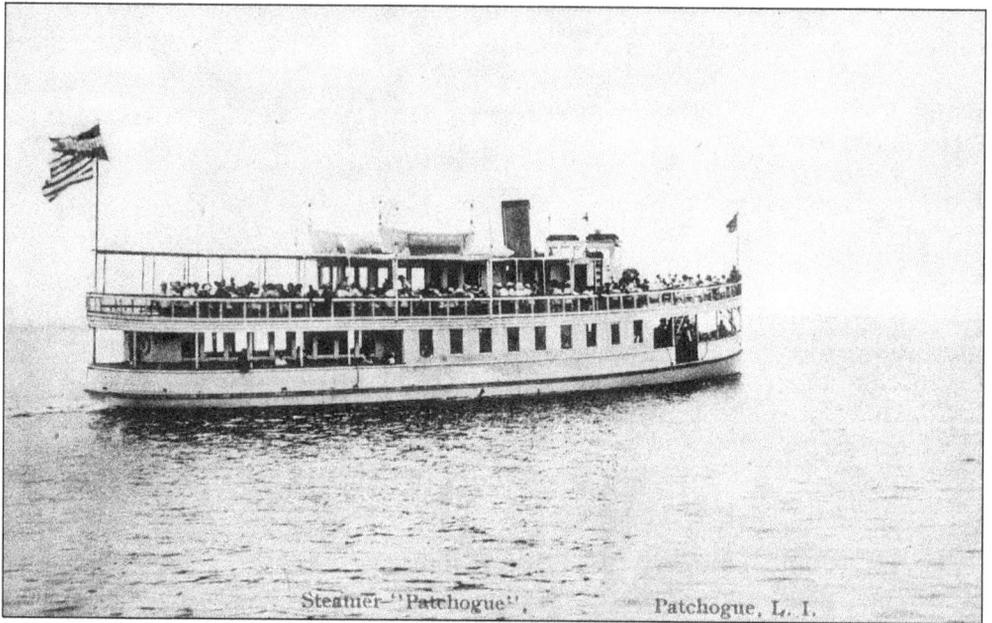

The ferry *Patchogue* pictured here on her way to Fire Island. The *Patchogue* was built in 1912 on City Island for $20,000. She was 106 feet long and could carry 300 passengers. She was in operation for only two years, 1912 and 1913. Business was not as good as was expected and she was sold in the spring of 1914 for $15,000.

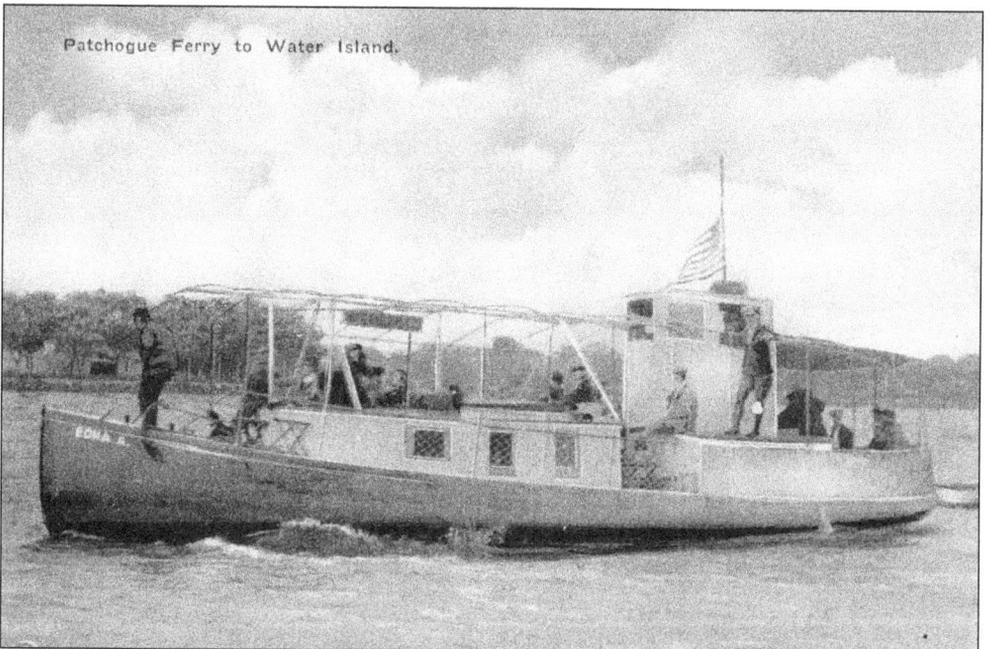

Captain Ed Swezey's *Edna A.* provided ferry service to Water Island's White House Hotel, a large hotel on Fire Island. She apparently had been converted to a powerboat some time after 1900, since Captain Ed took out sailing parties from the Clifton Hotel in the 1890s with the *Edna A.*

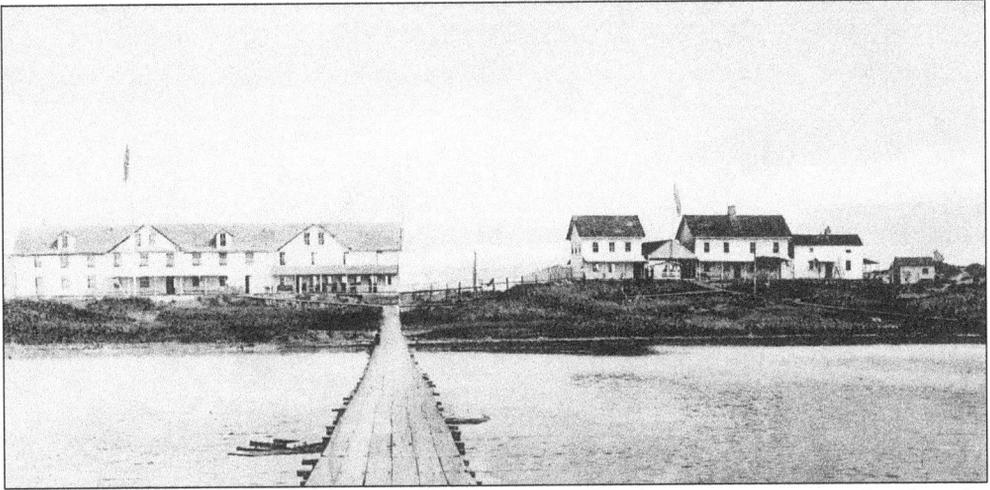

This view shows Water Island on Fire Island from the bay side. It was a very popular place for vacationers. The large building on the left is the White House Hotel.

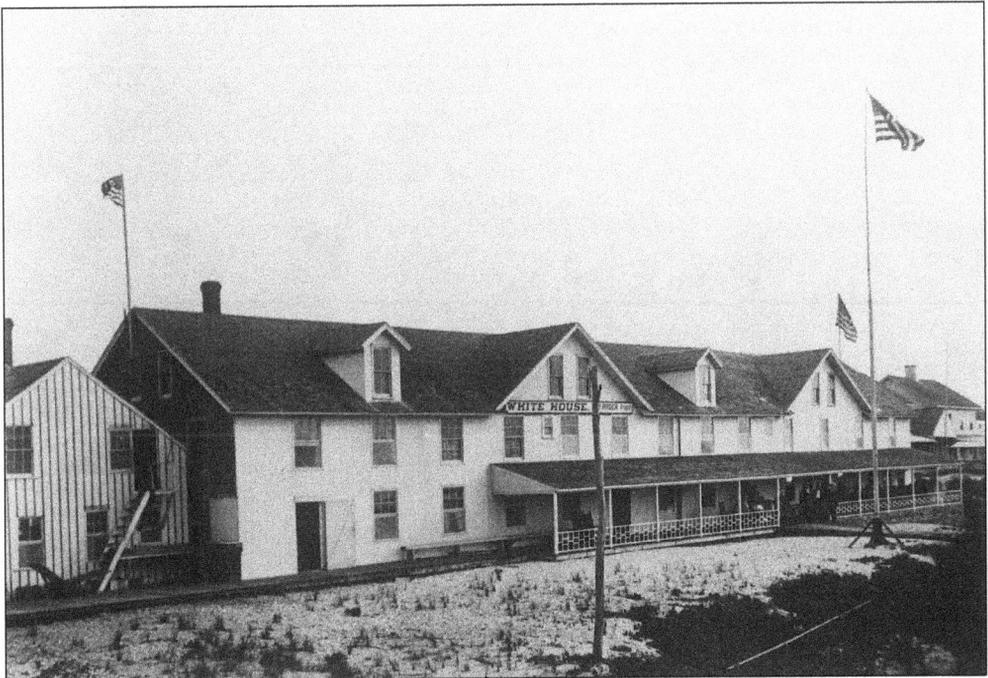

The proprietor of the White House Hotel on Fire Island, pictured here in 1905, was Mr. Edward O. Ryder. He lived on Ocean Avenue in Patchogue.

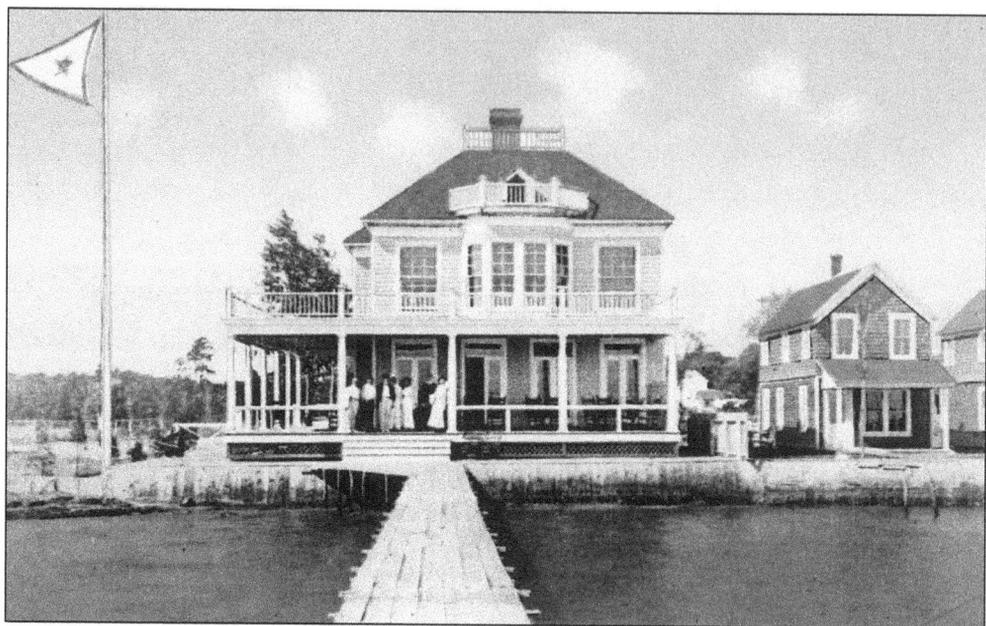

The South Bay Yacht Club on the foot of Cedar Avenue on the Great South Bay was moved by barge to Sayville in later years.

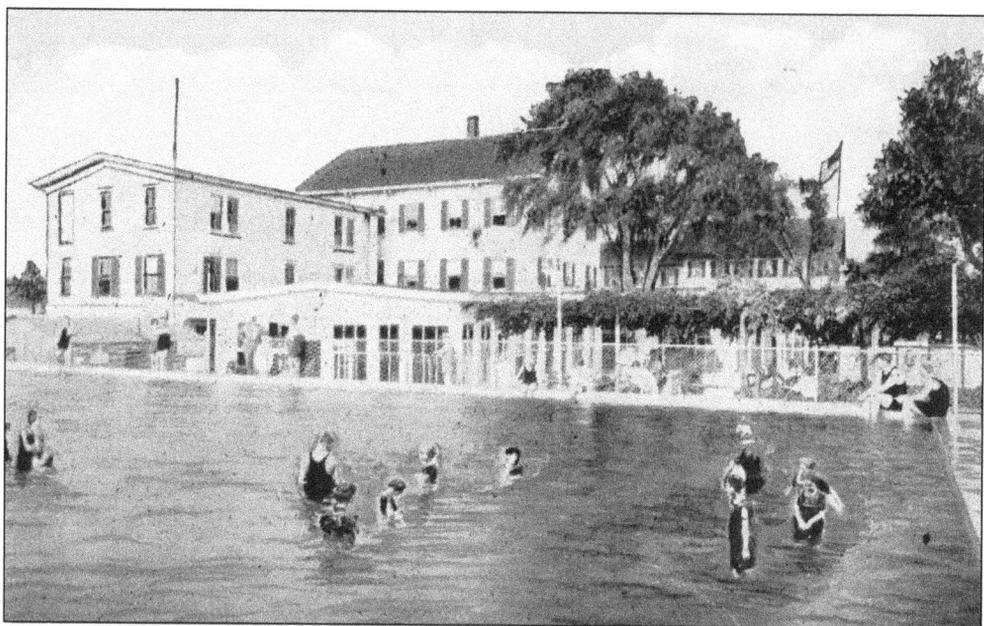

The new Mascot Hotel, located at the foot of South Ocean Avenue, built a saltwater swimming pool for its guests—a first in Patchogue.

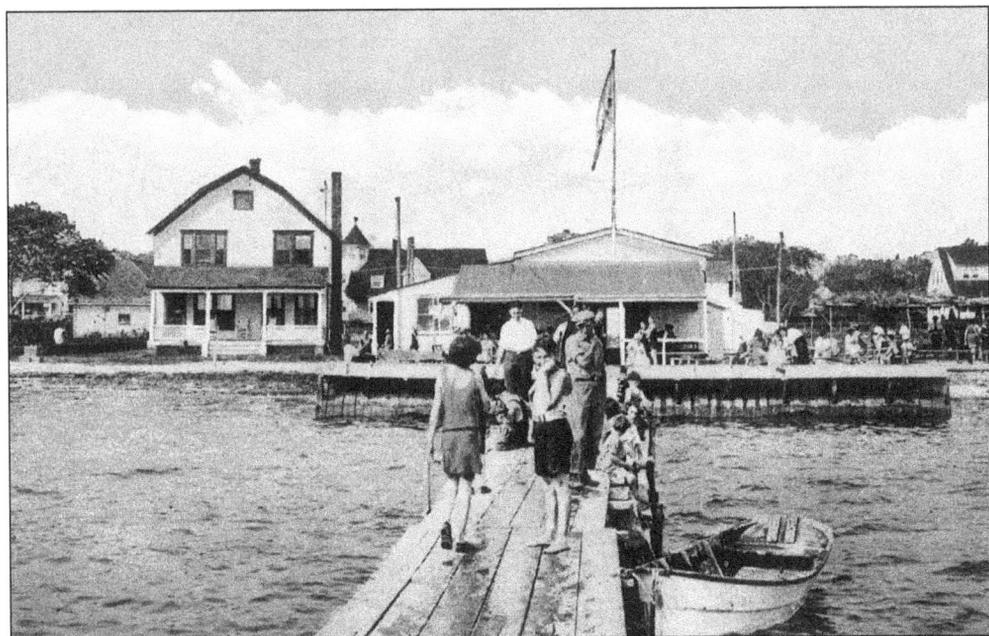

The Patchogue public bathing beach on the Great South Bay for a short while, *c.* 1905, was the site of the Montauk Hotel, which was totally destroyed by fire after only a few years of operation. Ruth Smith purchased this property and donated it to the village of Patchogue to be used as a public beach. This picture was taken *c.* 1925.

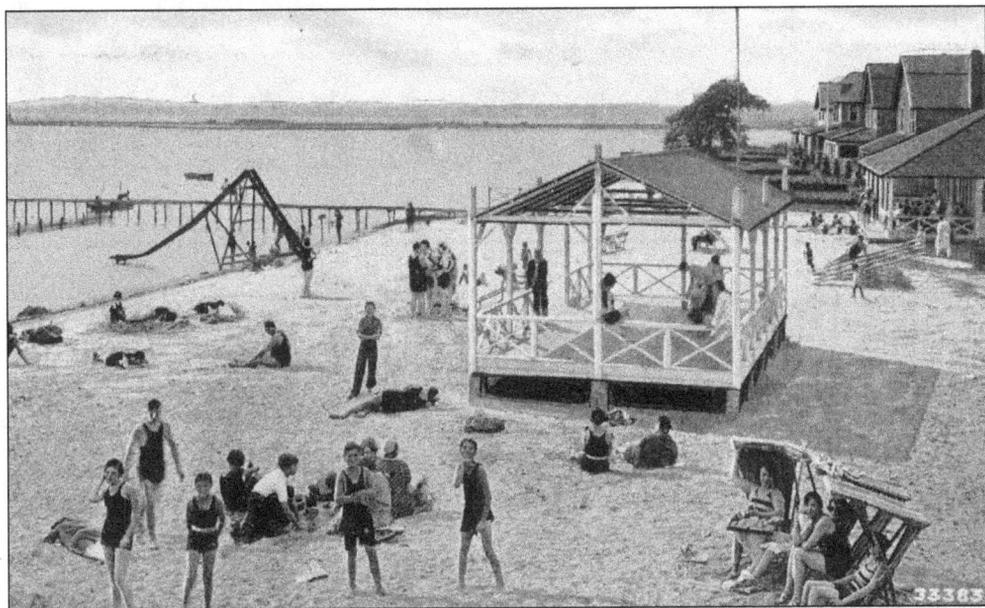

This is the same beach, known as Smithport Beach, in the 1930s . Later on this became the site of the Patchogue pool.

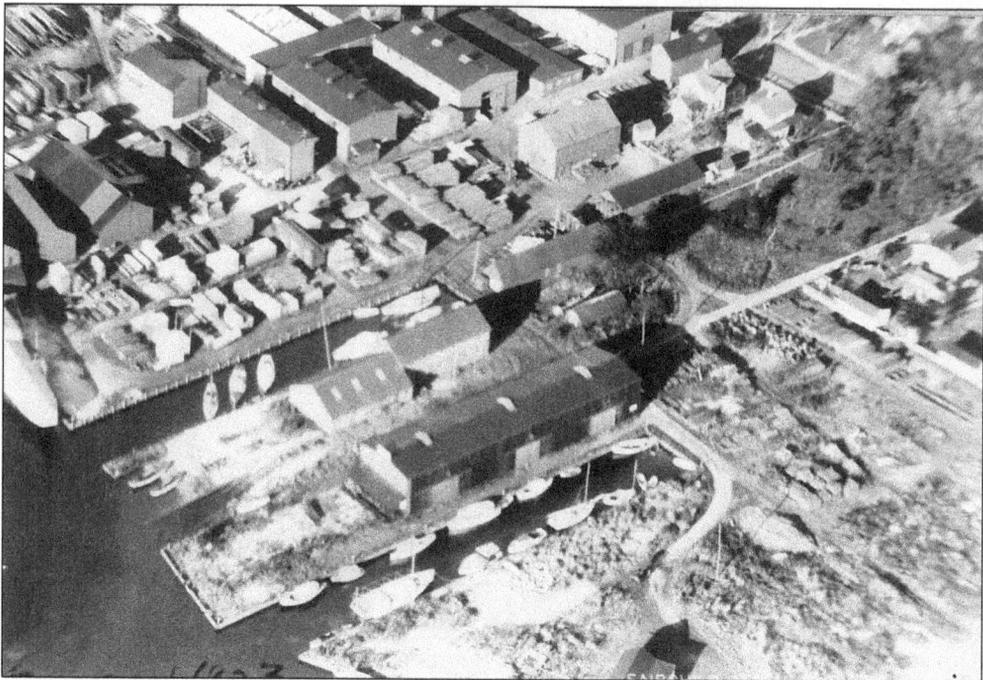
A 1923 aerial photograph allows the viewer a good look at Gil Smith's Boatyard, which is just behind the large building in the center of the picture.

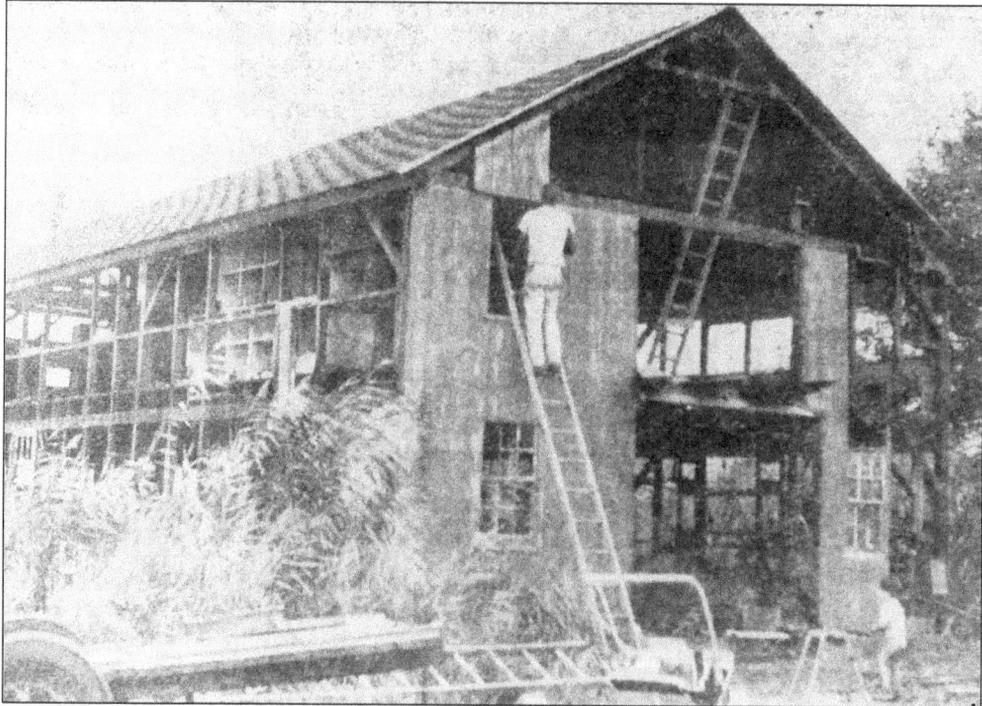
The razing of Gil Smith's boat shed took place in 1968. This picture shows Mr. Lockhart from Bay Shore dismantling the sheathing from the shed with the permission of the new owner of the property.

Two

Patchogue's Efficient Services

Patchogue could be proud of the excellent services that were provided to the community. A large modern fire department and an excellent police force made this a very safe community. Water, light, and gas services were provided by local plants with good service records and the school system was unsurpassed.

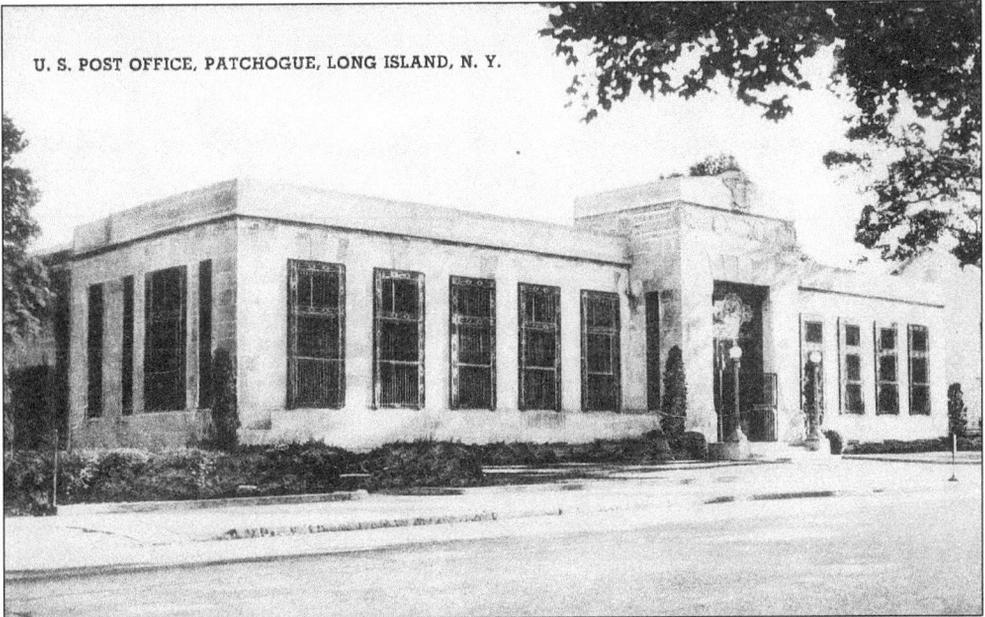

U. S. POST OFFICE, PATCHOGUE, LONG ISLAND, N. Y.

The finished post office in 1934 was the first federal building to be erected in Suffolk County.

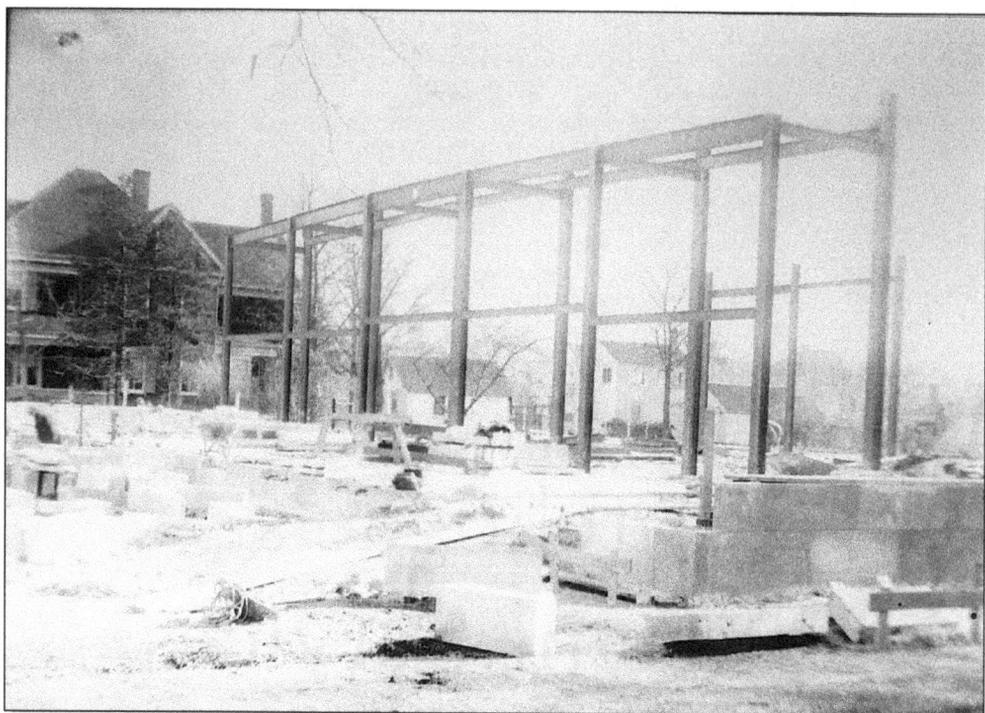

In 1932 the construction of a new post office was started. This picture was taken on December 14, 1932. R.W. Erikson was the general contractor assigned to the project and Nathan Abramson was the construction engineer. The building was designed by the well-known Patchogue architect John V. Von Pelt.

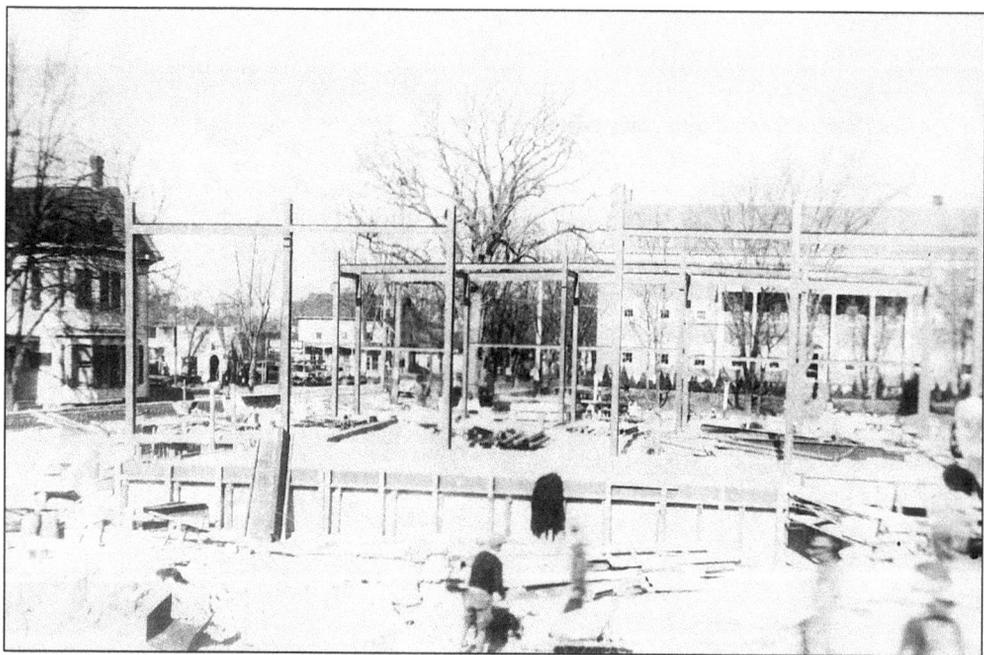

The image above was taken of the construction project looking north, with the Patchogue Hotel in the background.

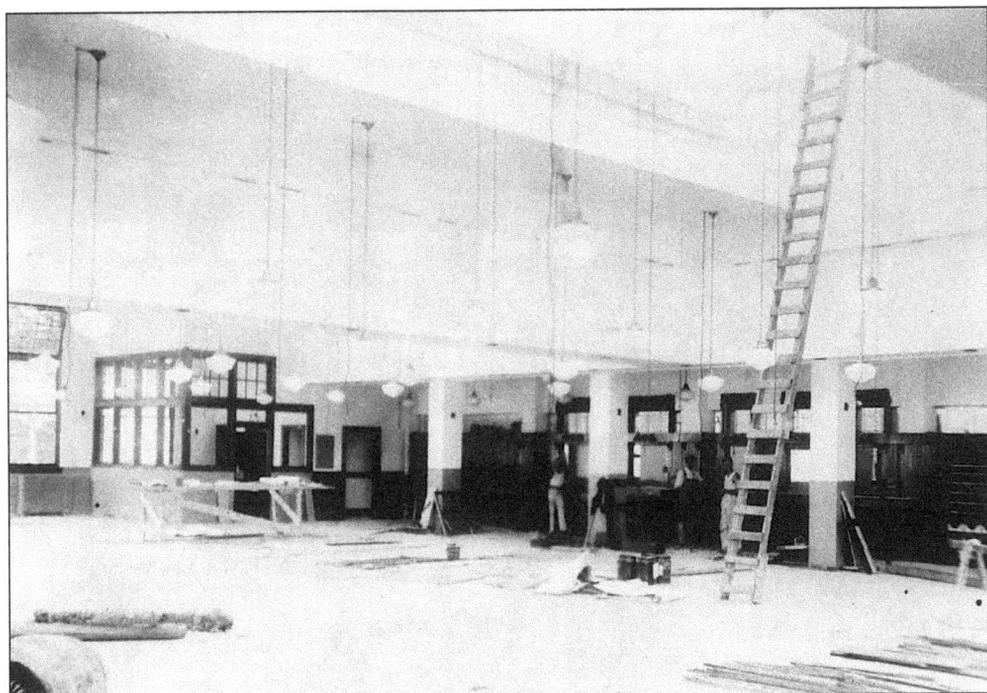

This photograph, taken on August 1, 1933, shows the final touches to the interior of the post office.

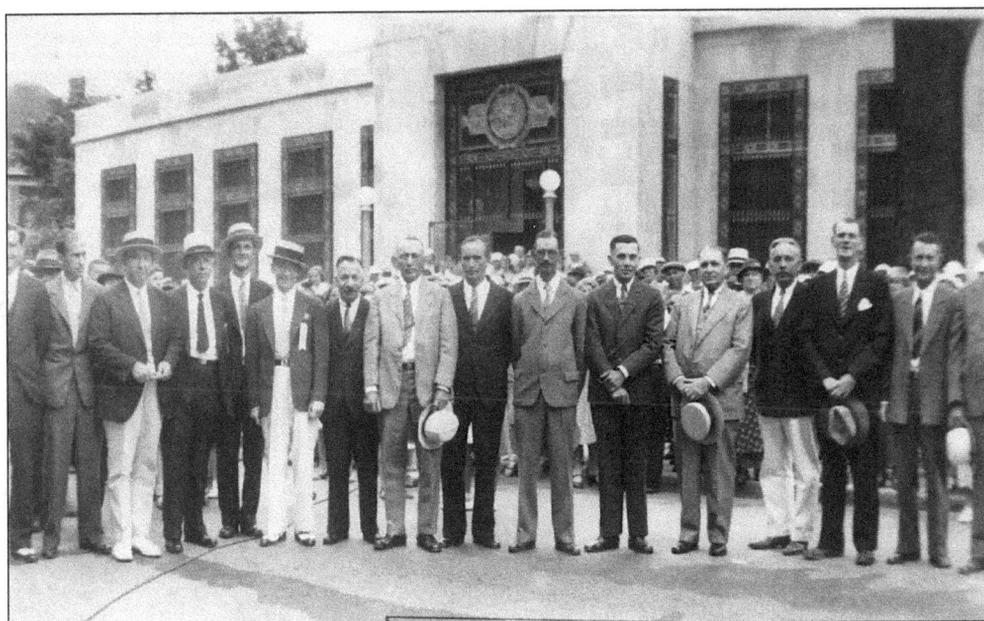

The dedication ceremony of the Patchogue Post Office is pictured here on August 31, 1933. The original photograph was an ultra-wide group shot, but the format of this book only allows the center portion of the photograph to be shown.

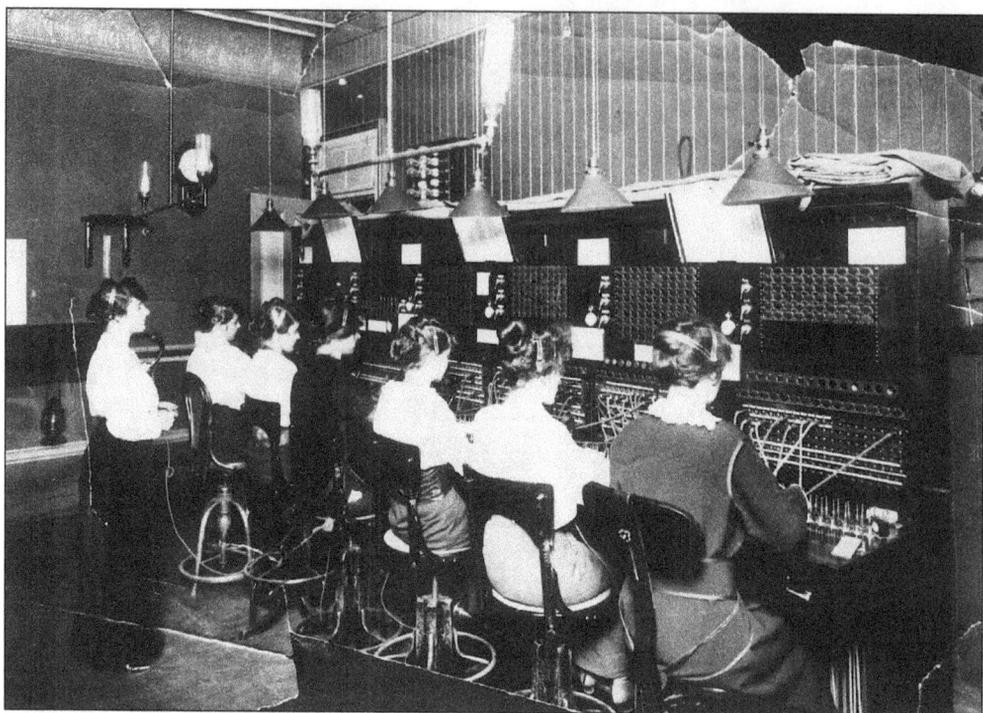

The first Patchogue telephone exchange was located in the Mills building. This is a 1916 picture of the switchboard with the six operators. The supervisor, or chief operator as this position was titled in 1916, was Mary C. Rogers Warden (standing on the left).

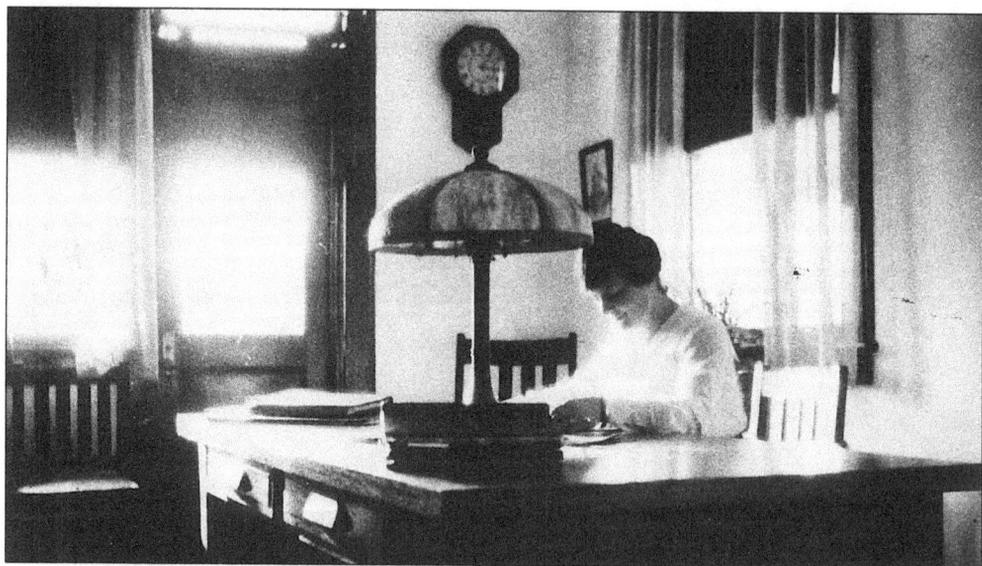

Mary C. Warden, chief telephone operator, is shown here in her office. In 1917, when Patchogue's population numbered 7,500, there were 762 telephones in use, including 316 business customers.

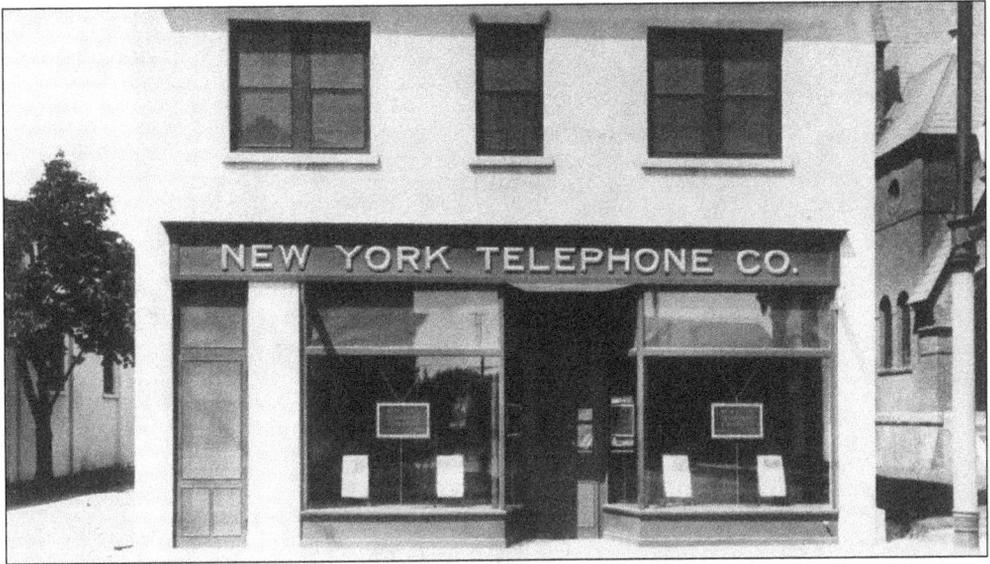

The New York Telephone Company moved their operation *c.* 1918 from the Mills building to a new building on South Ocean Avenue, just south of the Methodist church. Today this building is the Four Sisters Community Center.

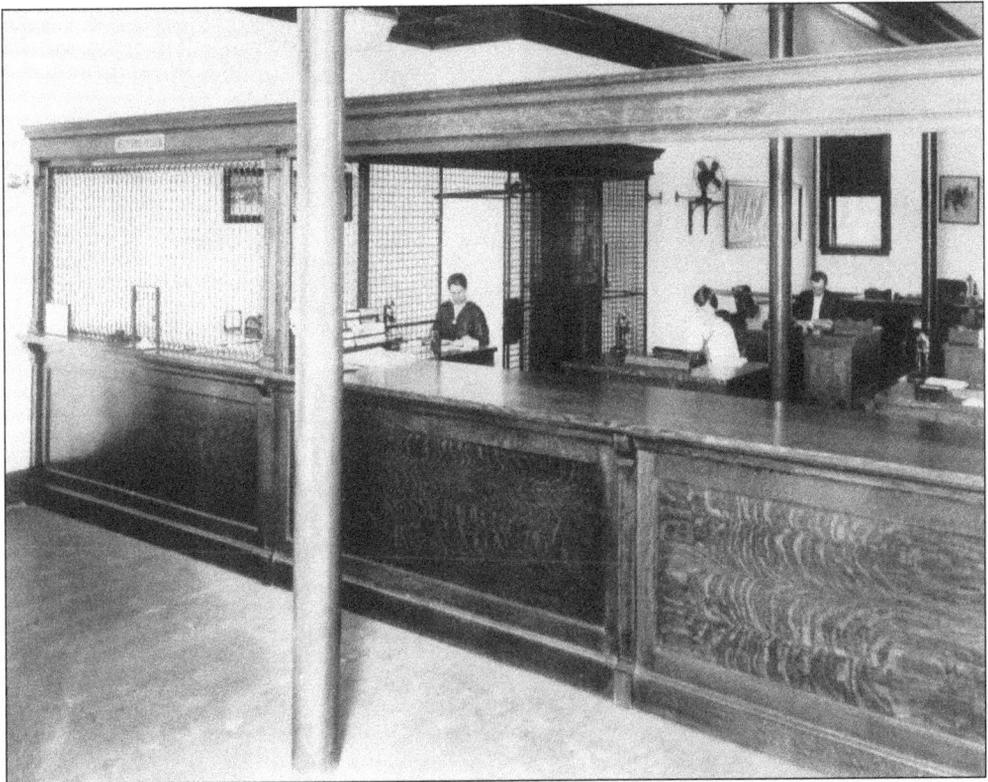

This is the office of the New York Telephone Company on South Ocean Avenue. It is a far cry from the first small switchboard installed in 1893 in John M. Conklin's drugstore on East Main Street to serve six subscribers. His daughter, Lila, became Patchogue's first operator.

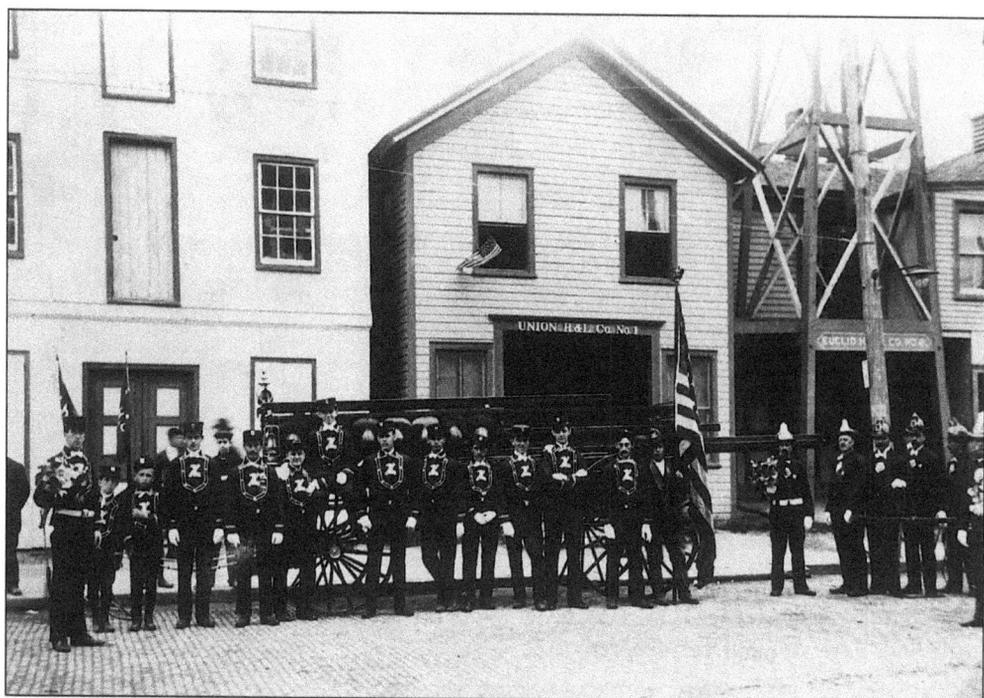

The date is May 30, 1904, and the Union Hook and Ladder Company #1 is ready for the parade. This picture was taken on North Ocean Avenue opposite Oak Street in front of their headquarters.

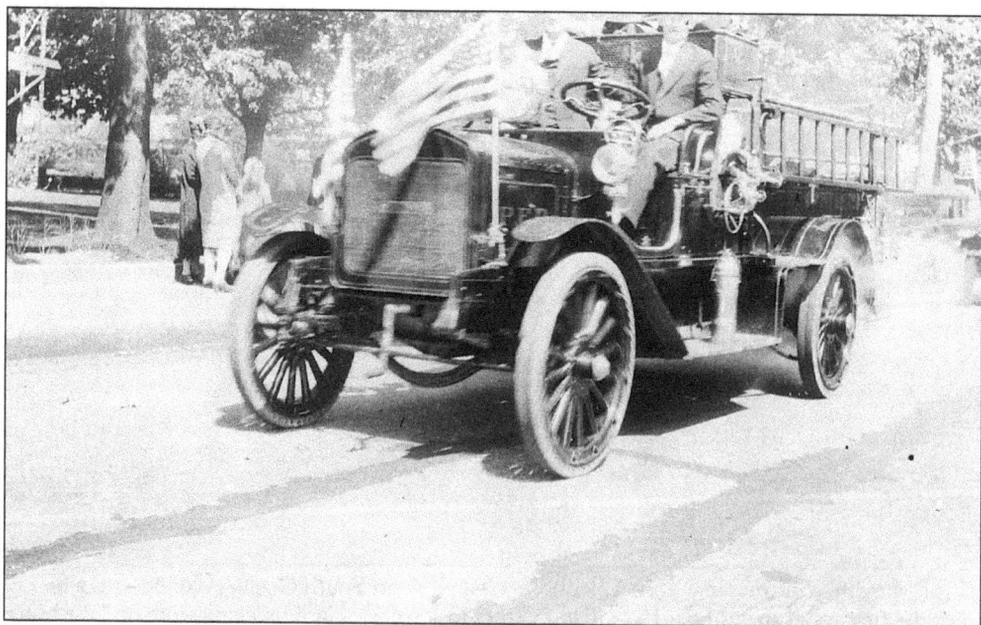

Saxton Wise is driving the Euclid Pumper during a parade in the 1920s.

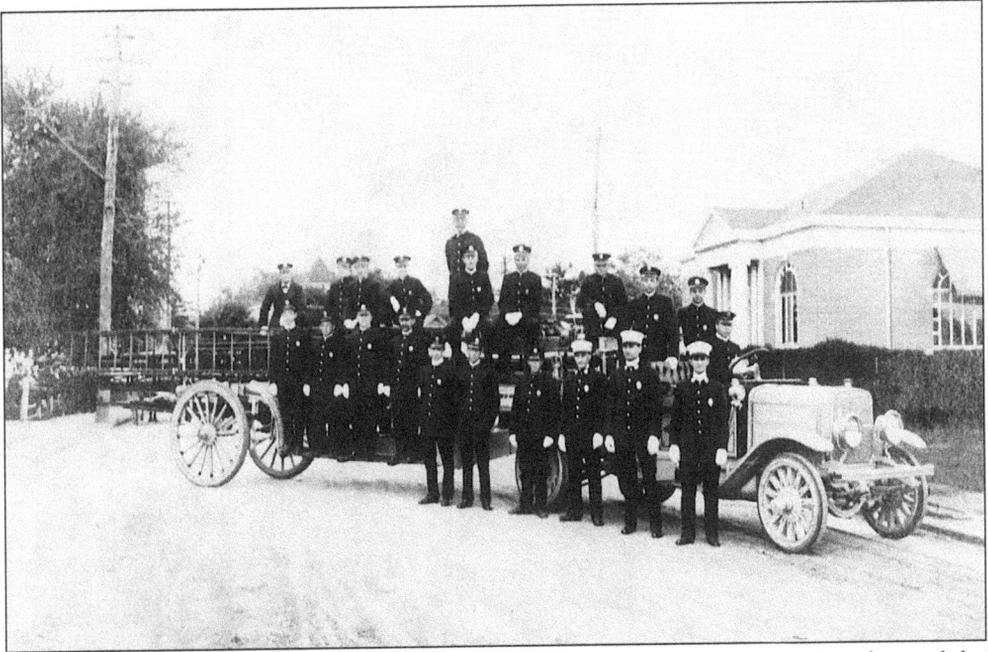

The Union Hook and Ladder Company members pose for a picture in 1915 in front of the firehouse on Lake Street. The fellow in the right front is Bill Sinn, and the truck is a 1914 Kissel Car Tractor.

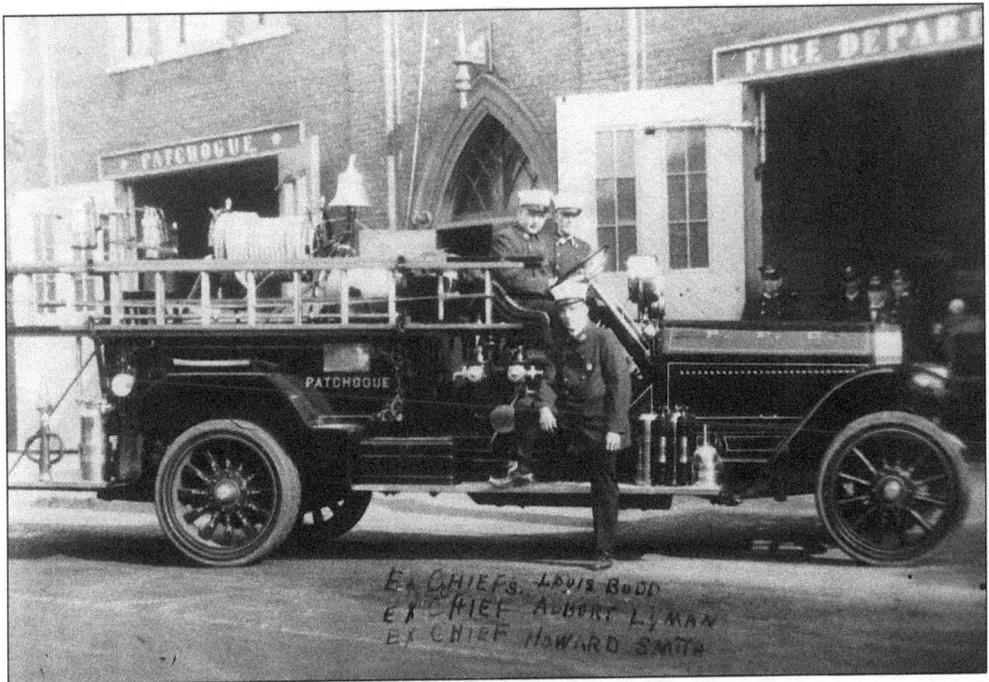

Louis Budd, Robert Lymann, and Howard Smith, three former fire chiefs, pose on a 1919 American LaFrance Pumper in front of the Lake Street firehouse.

When the West Patchogue Fire Department was first formed, they stored their equipment in the rectangular building on the left on West Main Street opposite River Avenue. To the right of it is the old Union church.

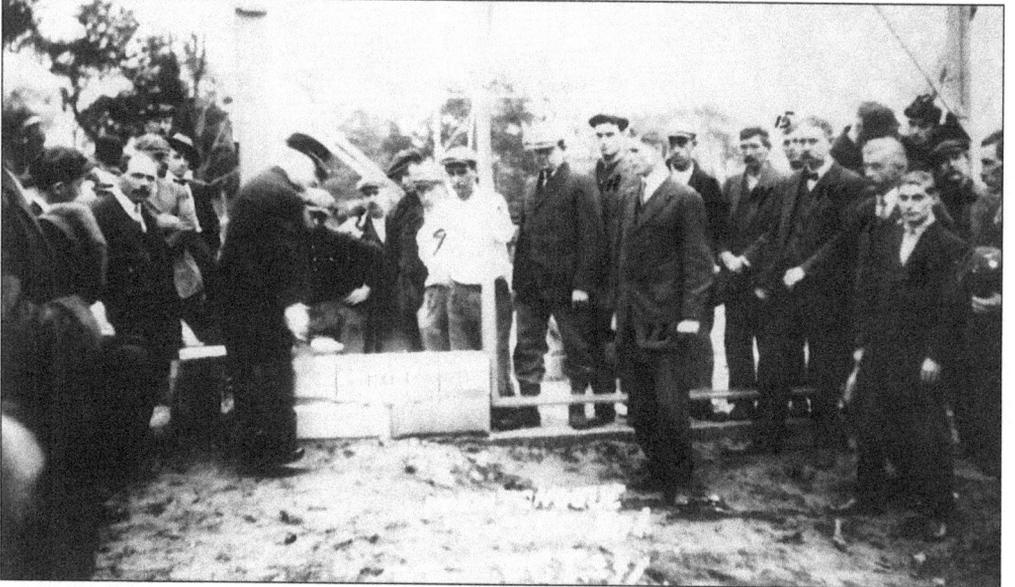

On October 24, 1914, the cornerstone was laid for the new building for the West Patchogue Fire Department on the east side of River Avenue, a few feet south of the school. The gentlemen standing to the left of the cornerstone is Rev. Probst, chaplain. Listed from left to right from the fellow in white are as follows: (#9) Seaman Jones, Paul Haase, William Stokem, William Underwood, Jack Stokem, George Jones, and Michael Weiner.

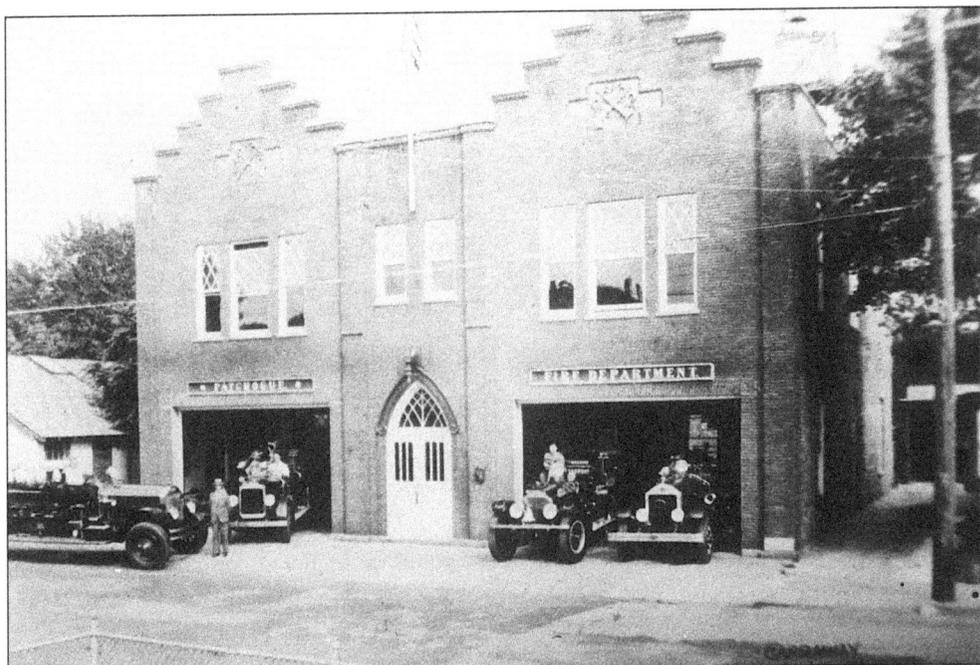

The firehouse on Lake Street served the department from 1905 to 1970.

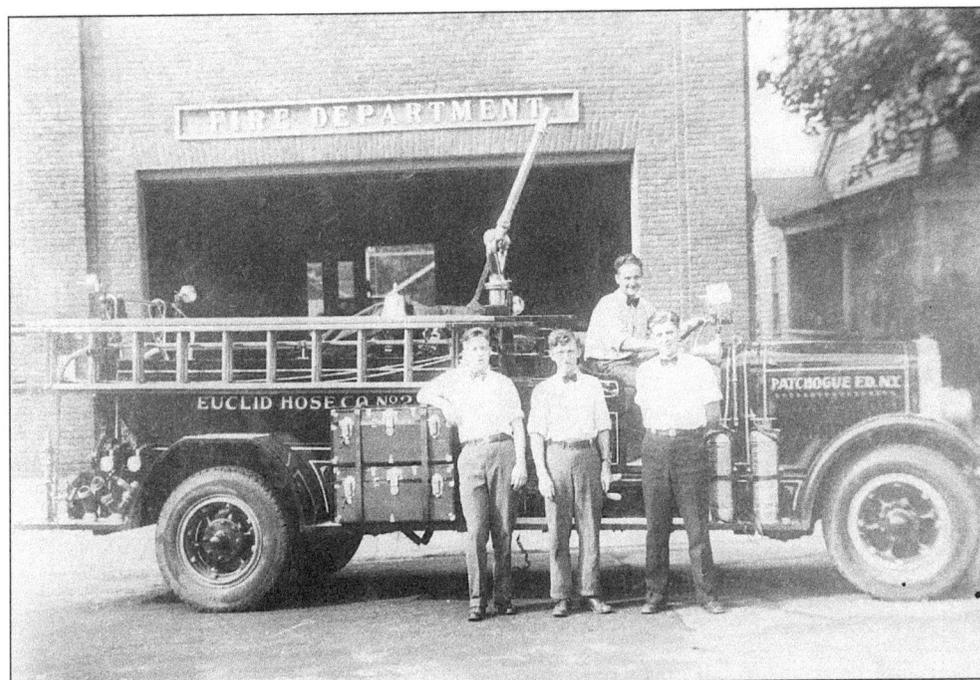

The 1929 buffalo hose wagon of the Euclid Hose Company in front of fire department headquarters on Lake Street. The Euclid Hose Co. members in this picture from left to right are Captain Edward G. Phannemiller, Chief Saxton A. Wise, Lieutenant Joseph Cottell, and unknown.

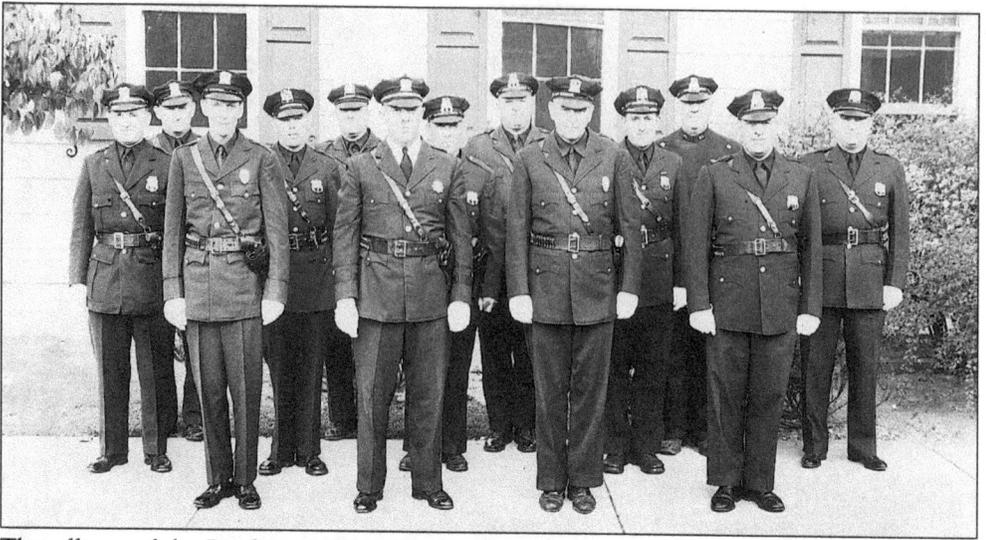

The officers of the Patchogue Police Department posed for a photograph c. 1936. They are, from left to right, Walter Manning, William Wiedemer, Samuel Perry, George Meyer, Vernon Tully, Reynold Wicks, Adolph Morge, Bryant Norton, Roland Baker, Otto Brauner, Herman Mester, Theodore Sedate, and William Cordes.

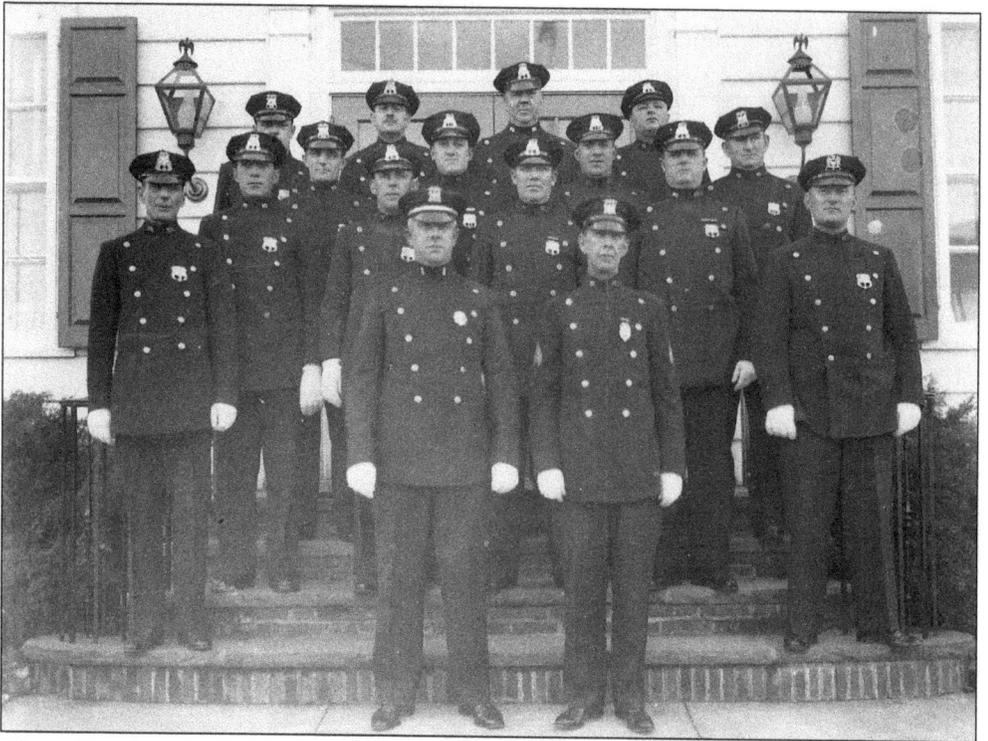

The police department and officers are shown here c. 1939. Listed from left to right are as follows: (front row) Reynold Wicks and Weldon Logan; (middle row) Sam Perry, Winfield Corsten, Dan Gillette, Al Morge, Otto Brauner, Norris Gillman, Theodore Sedate, Vernon Tully, William Wiedemer, and William Cordes; (back row) Austin Clowes, Roland Baker, Herman Mester, and Bryant Norton.

56

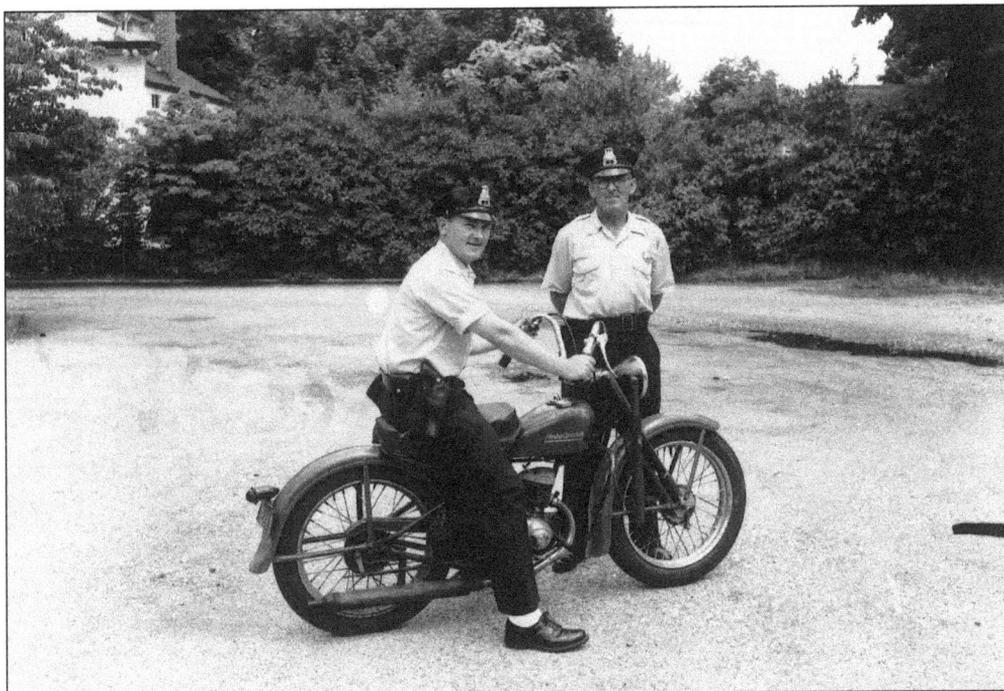

Police officers Walter Manning (on motorcycle) and Adolph Morge pose behind the headquarters on Baker Street.

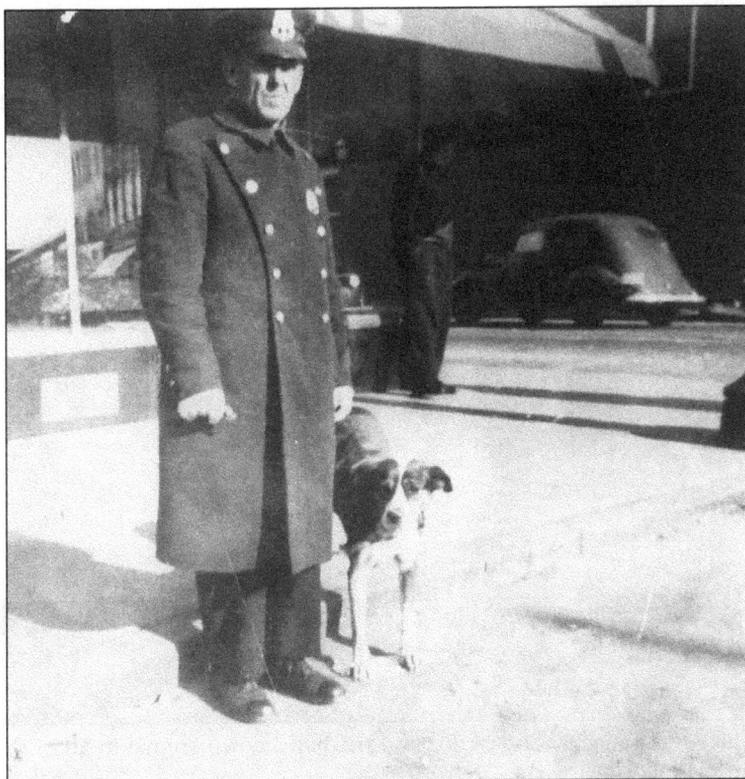

Al Morge and "Duke," the police mascot, are pictured here in front of Swezey's. A plaque dedicated to the memory of Duke is embedded in the sidewalk in front of Swezey's, his favorite spot.

"DUKE"—POLICE DOG

*W*HEN is a police dog not a police dog? For the answer, you have only to consult the members of the Police Department of Patchogue, Long Island, New York, where Duke is a member of the force. Veteran cops will tell you that Duke joined the force eleven years ago when Patrolman Morris Gilman fished the pup out of an unfinished cesspool. Since that time, Duke has proved his worth repeatedly as a "police" dog although his various ancestors stamp him as a 100 per cent mongrel.

Duke began his police work with his rescuer, Patrolman Gilman. He was the constant companion of Gilman on the officer's rounds. Late one night, as man and dog were checking up on store fronts to be certain they were locked, Duke's warning growl apprised Patrolman Gilman of an intruder at work. A whispered command silenced the keen-eared dog and Patrolman Gilman crept forward to make a capture.

This was only the first of many similar exploits involving Duke. The mongrel really captured Patchogue's heart when a front page news story revealed that Duke had saved a kitten from drowning. The kind and gentle dog which could be so savage toward burglars had leaped into the water to rescue a helpless kitten which some person had cruelly attempted to drown.

In his spare time, Duke keeps all other dogs moving from the village's principal intersection. This traffic post brings him some tough encounters with bigger dogs who don't recognize his official authority. As a result, Duke has his share of scars. After one fight with a Dalmatian, Duke had to be patched up by a veterinarian, but the Dalmatian never returned to the corner.

Before the village installed parking meters two years ago, Duke covered every foot patrol with Patrolman Gilman. With the advent of the meters, however, Duke's routine changed. Patrolman Gilman got the "scooter patrol" checking the meters. Duke found it easy to run alongside the scooter, and maintained his traffic post outside patrol hours.

Eight years ago, when Patchogue had a round-up of stray dogs, the Patrolmen's Benevolent Association decided to take out a license for Duke, as a precaution. But the village's legal minds vetoed the idea on the question of responsibility. So James Inman, then a member of the force, took out a license and became the owner of record, although everyone knew that Duke was still a member of the force. Patrolman Gilman now has the license.

Duke feels morally obligated to spread a little cheer around the Patchogue Volunteer Fire Department, too. Ever since the fire department lost its mascot, the "police" dog has been dropping in on the boys to keep them company. Of course, he appreciates the small favors which are bestowed on him there in the form of choice bones and tid-bits.

Wherever he may be in the village, Duke is up and at 'em when the fire alarm sounds. He's up and racing for the corner of Main Street and Ocean Avenue—his traffic post by the way—to wait for the first fire truck which stops there to pick up the volunteers. He has appointed himself guardian of the truck's equipment while the firemen fight any blaze.

The patrolmen and volunteer firemen of Patchogue to this day dispute the pedigree describing Duke which is on file with the dog's license in the Village Clerk's Office. They insist that the word "mongrel" should be changed to "Thoroughbred Police and Fire Dog," even if Duke is the only one of his kind.

Duke was a special kind of dog and the best-known animal in all of Patchogue. This magazine article tells his story.

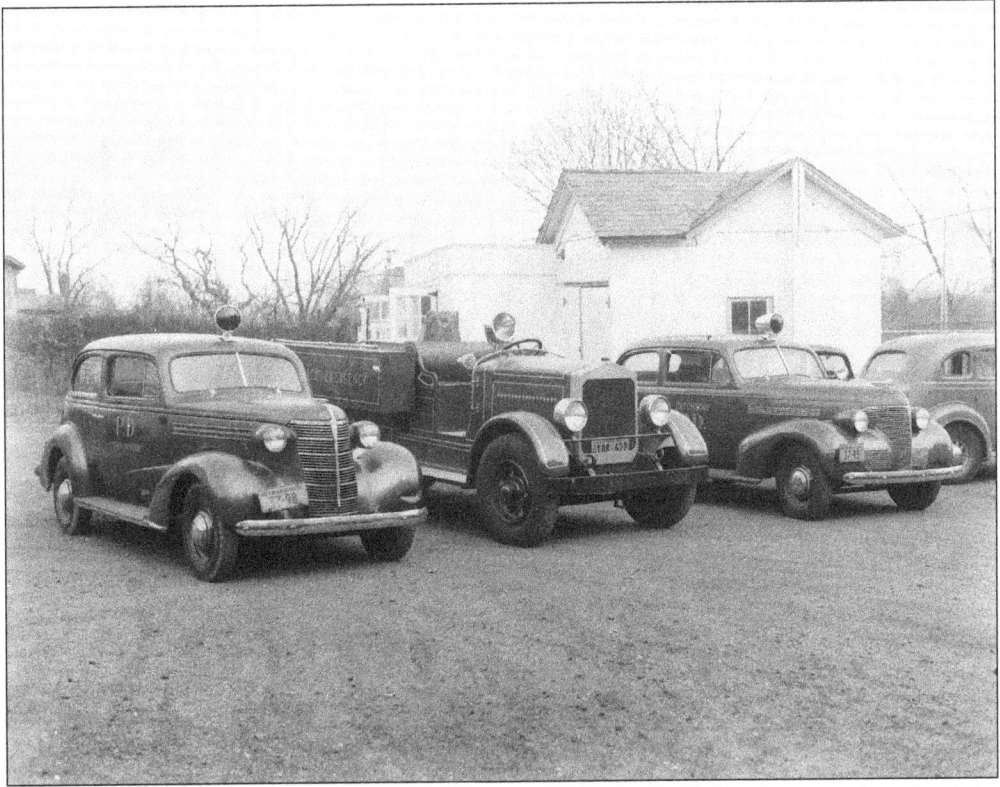

This is a photograph of a 1940 line-up of police vehicles in the Baker Street parking lot. The former firetruck was used to transport a boat for emergency water rescues.

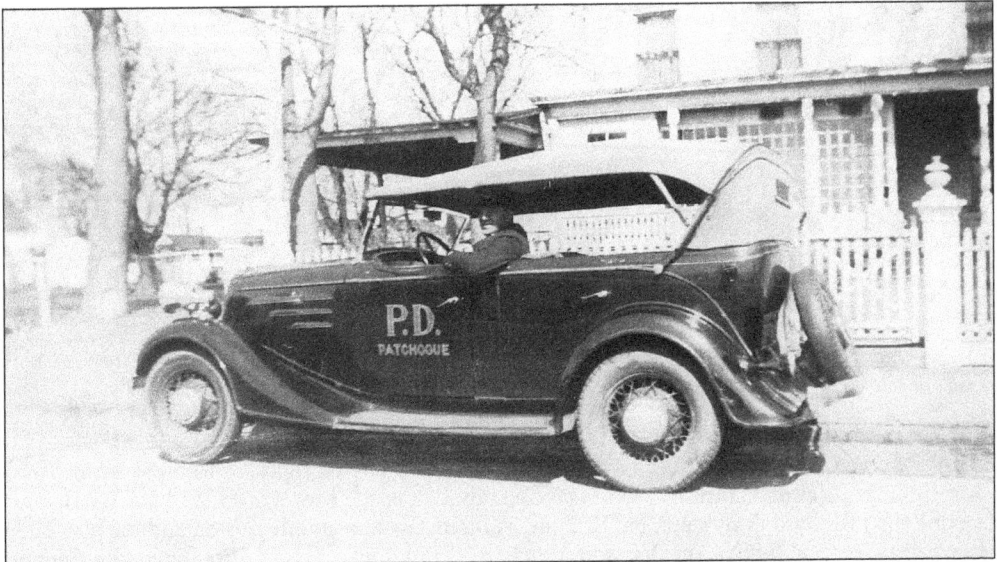

Patrolman Theodore Sedate is pictured here with a 1936 patrol car.

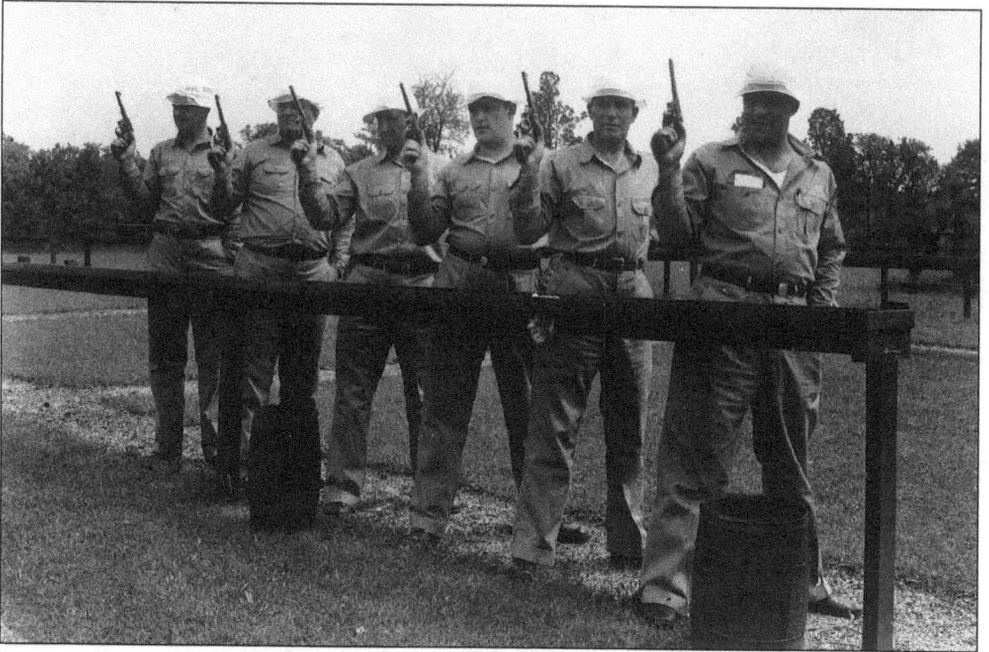

These police officers on the Taber Street pistol range are, from left to right, Roland Baker, Bryant Norton, William Wiedemer, Austin Clowes, Norris Gillman, and Theodore Sedate

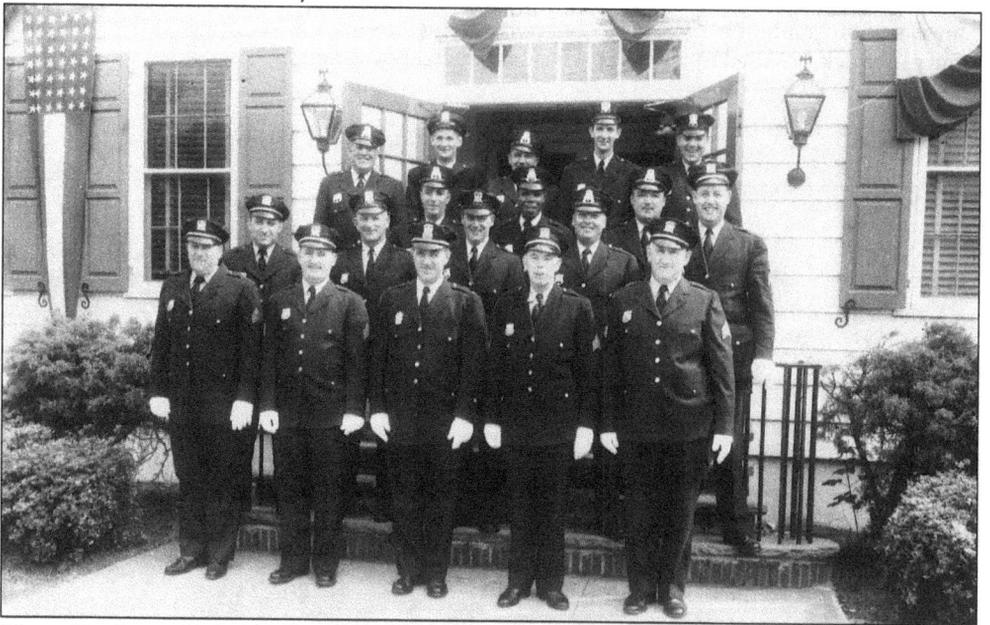

These Patchogue Police Officers of the 1950s are, from left to right, as follows: (front row) Otto Brauner, Walter Manning, Dominic Chiuchiolo, George Meyer, and William Wiedemer; (second row) Richard Benincase, Pat Rooney, William Costen, Stanley Vilot, and Joe Hawkins; (third row) Arthur Benincase, Vernon Harris, and unknown; (back row) Theodore Sedate, John Burns, John Drew, unknown, and Warren Chamberlain.

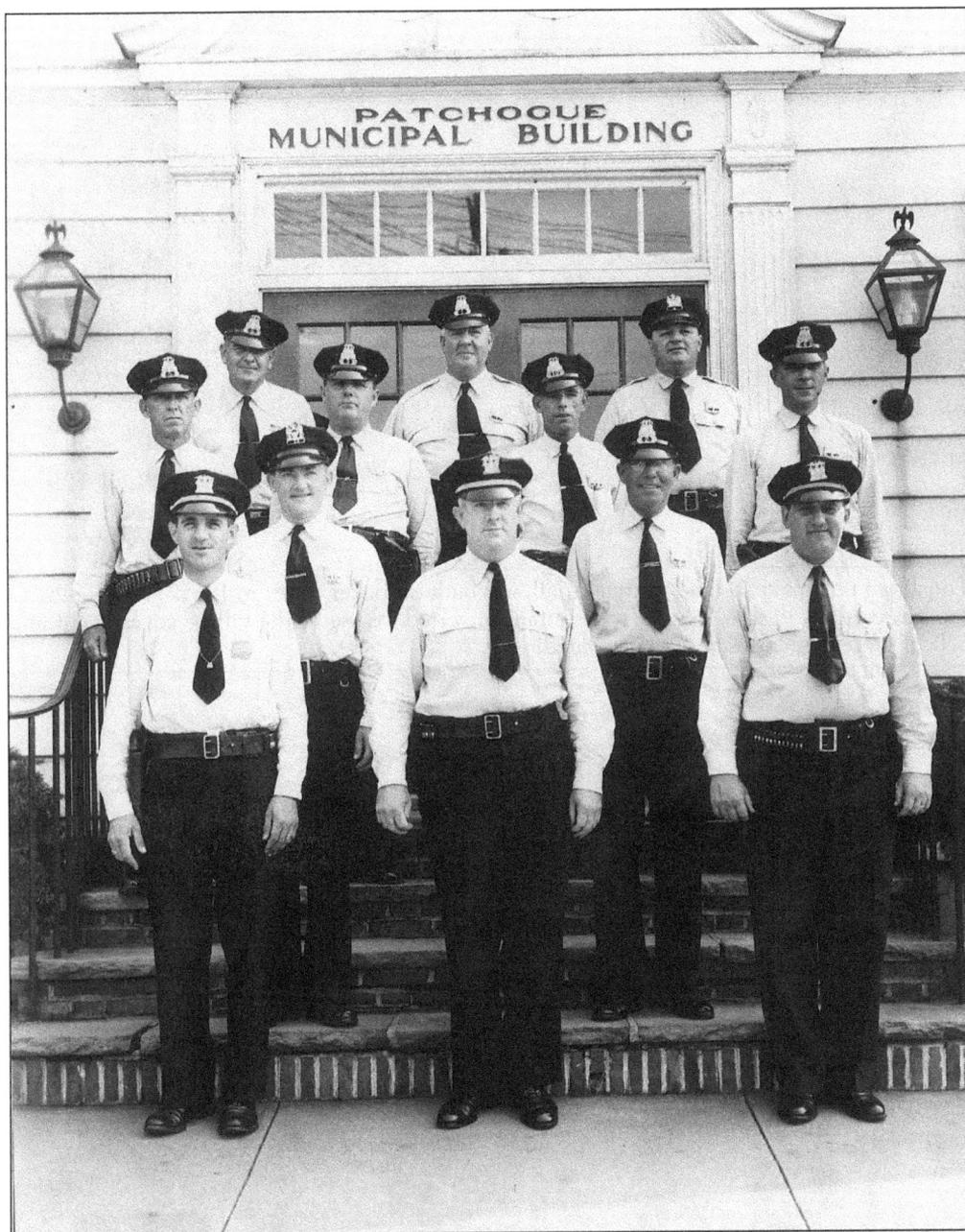

The Patchogue Police Officers in 1948 listed from left to right are as follows: (front row) Dominic Chiuchiolo, Reynold Wicks, and Otto Brauner; (second row) Walter Manning and Norris Gilman; (third row) Al Morge, Vernon Tully, George Meyer, and Winfield Corston; (back row) Roland Baker, Herman Mester, and Bryant Norton.

The new municipal building, or village hall, was built on Baker Street in 1935. The building to the left, partially visible, was a private home converted for use by the village government and police before they moved to the new building.

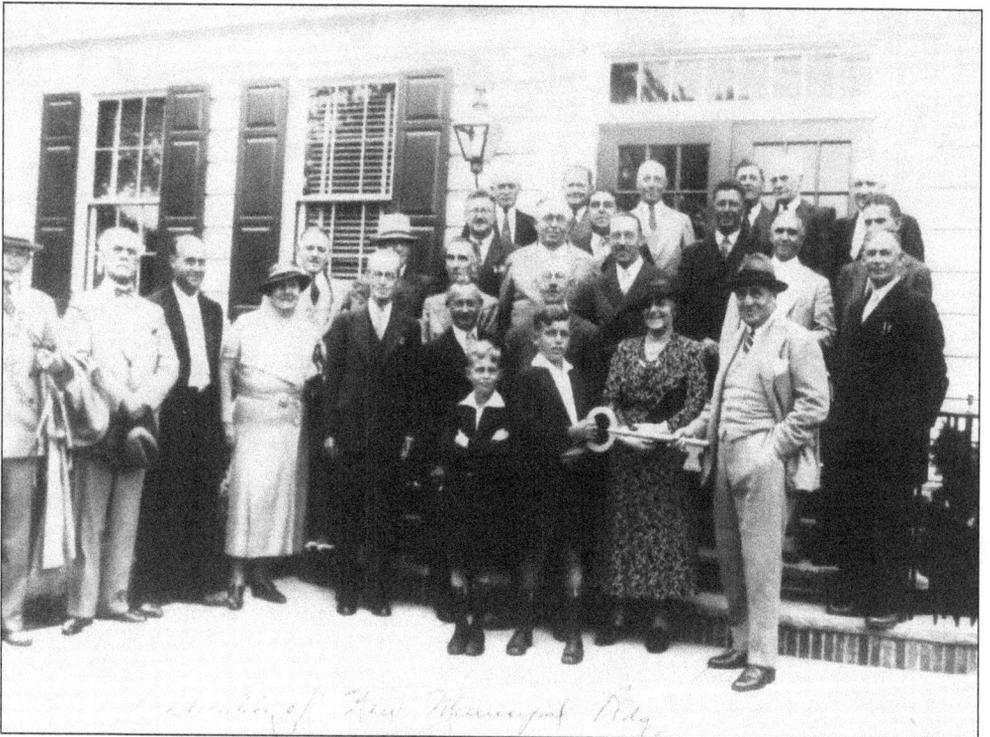

The dedication of the new Patchogue Municipal Building was photographed here on September 3, 1935. Among those in this group are Herb Austin, Dr. Foster, Phil Hattemer, Ed Jeneck, Charlie McNeal (with white hat), Charles Butler, Mr. Huttenlocker, and Ford Hughes (second from the right).

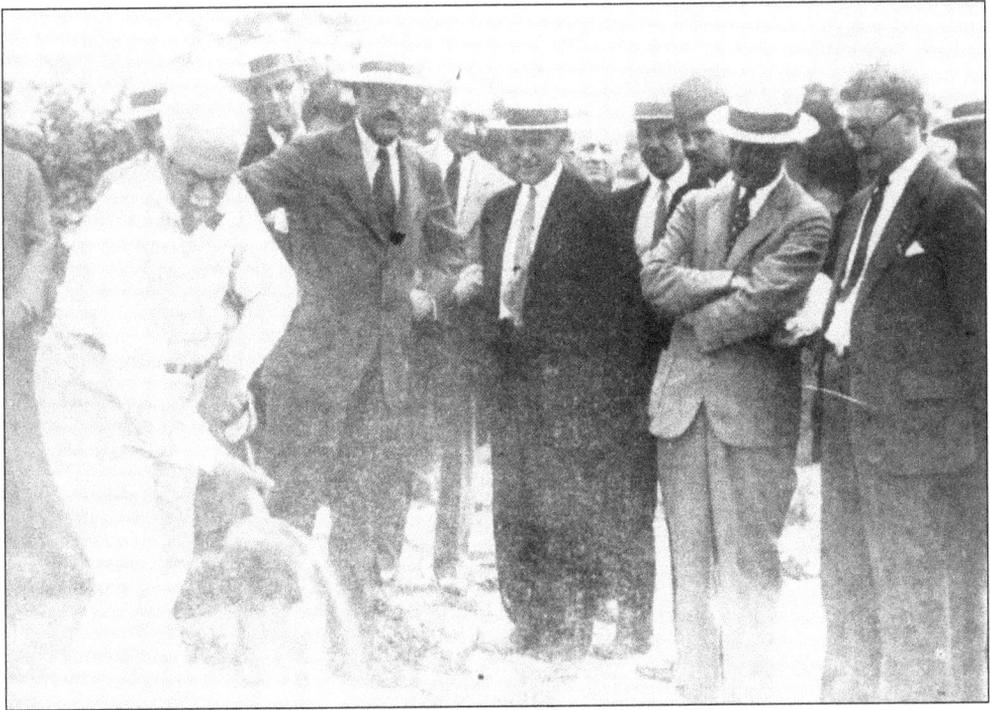

Dr. Agate Foster, the mayor of Patchogue, is breaking ground for the new incinerator on Waverly Avenue. The incinerator was erected at a cost of $53,300 and began operation early in 1931. Charles Butler is the man on the right.

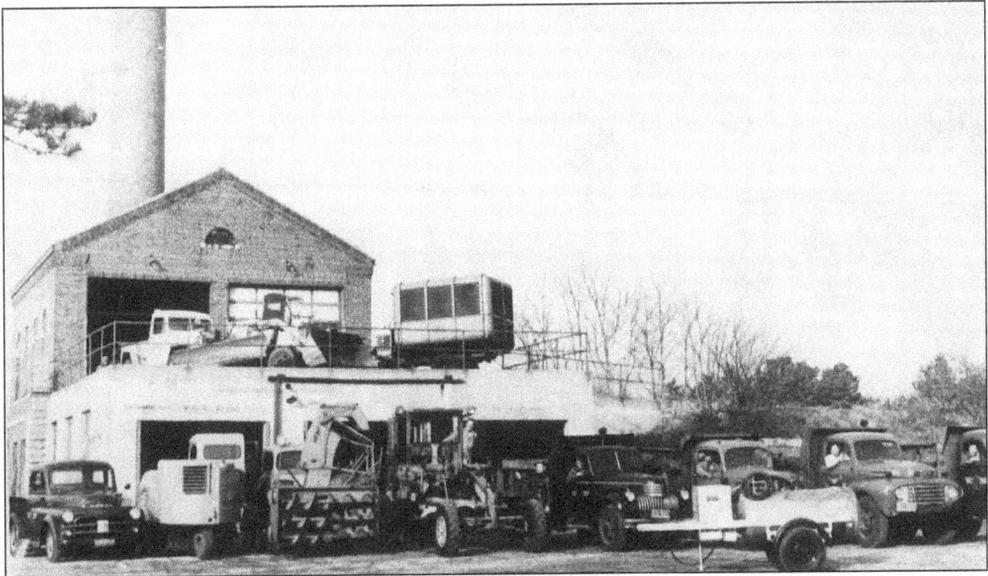

Village highway department equipment in front of the incinerator building on the grounds of the municipal garage site on Waverly Avenue was photographed here c. 1957.

The first Patchogue jail was located behind the old firehouse on Lake Street. No great comforts here—just a plain old lock-up.

As the population grew, so did the need for jail cells. This picture from the 1930s shows a much enlarged jail.

The *Patchogue Advance* newspaper was first issued in 1871. In the beginning it was called the *Advance*, then the *Patchogue Advance*; today it is called the *Long Island Advance*.

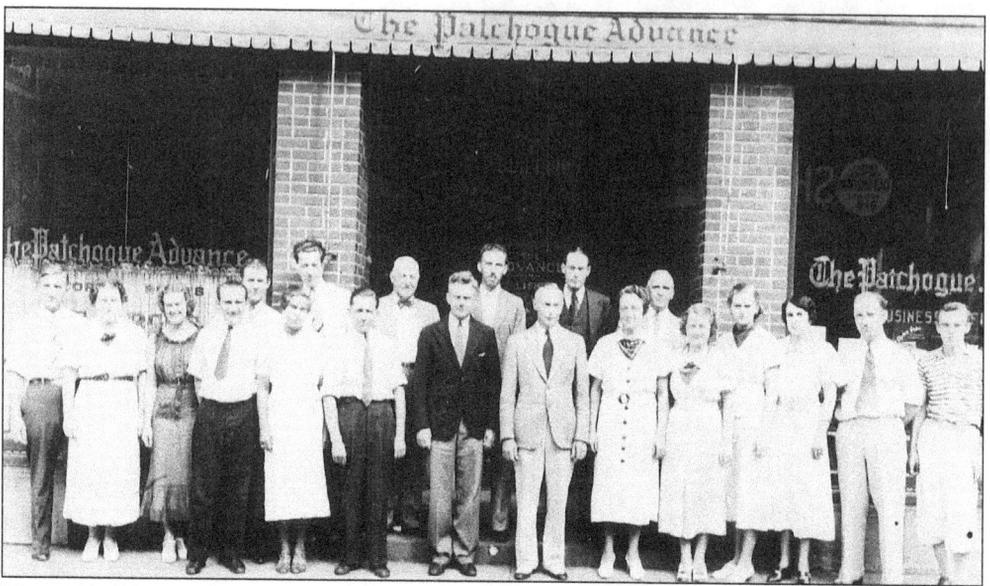

The staff of the *Patchogue Advance* posed for a photograph in 1936. They are, from left to right, Edward Bryan, Margaret Campion, Virginia Rowe, Jerry Cejka, George Cesman, Charlotte Jones, Raymond Buys, Myron Buys, John T. Tuthill Sr., Frank P. Johnson, Ronald "Pat" Dey, John T. Tuthill Jr., Lloyd C. Harris, Glady Hammer DeVito, George W. Andrews, Mary Campion, Marguerite Henken, Lillie Valentine, Marcel Wagner, and Wallace King.

THE ARGUS

Vol. LIII — No. 27 Patchogue, N. Y., Tuesday, April 19, 1938 12 Pages Five Cents a Copy

Accidents Mar Easter Week-end
★ STORY ON PAGE 3

Village Budget Hearing Friday Night
★ STORY ON PAGE 2

Train Wrecks Auto. Family Escapes
★ STORY ON PAGE 10

Blue Point Firemen Elect Him as Chief

The *Argus* was another Patchogue newspaper. It was first published in 1884 by L.B. Greene. The *Argus* operation was bought by the *Patchogue Advance* on October 8, 1930, and was published alongside the *Advance* for several years.

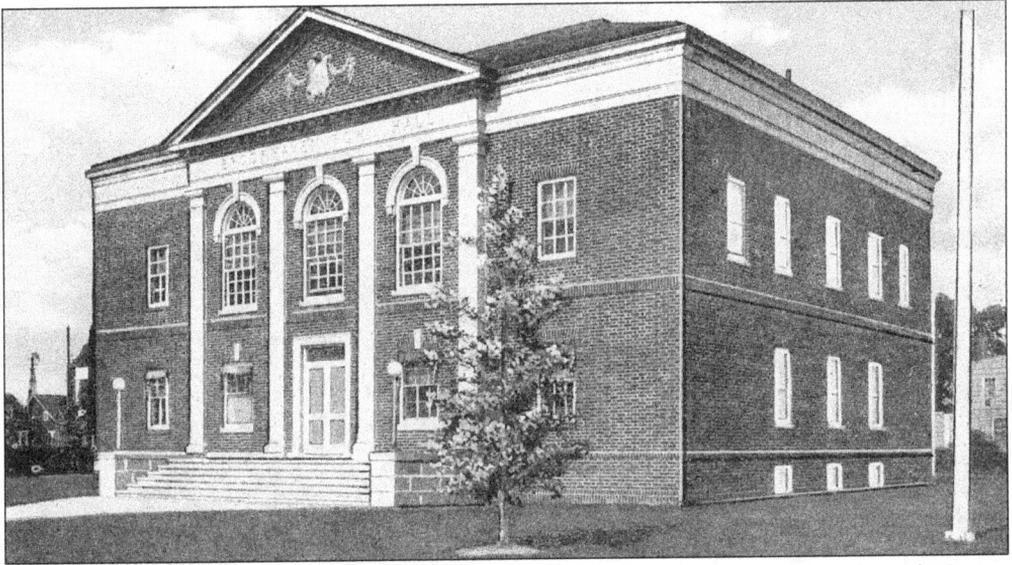

The new Brookhaven Town Hall was built in 1926 on the northeast corner of South Ocean Avenue and Baker Street at a cost of $47,000. The dedication took place on June 5, 1926. The old Brookhaven Town Hall stood on the north side of East Main Street, just a few feet west of the Congregational church. It was a small wooden building.

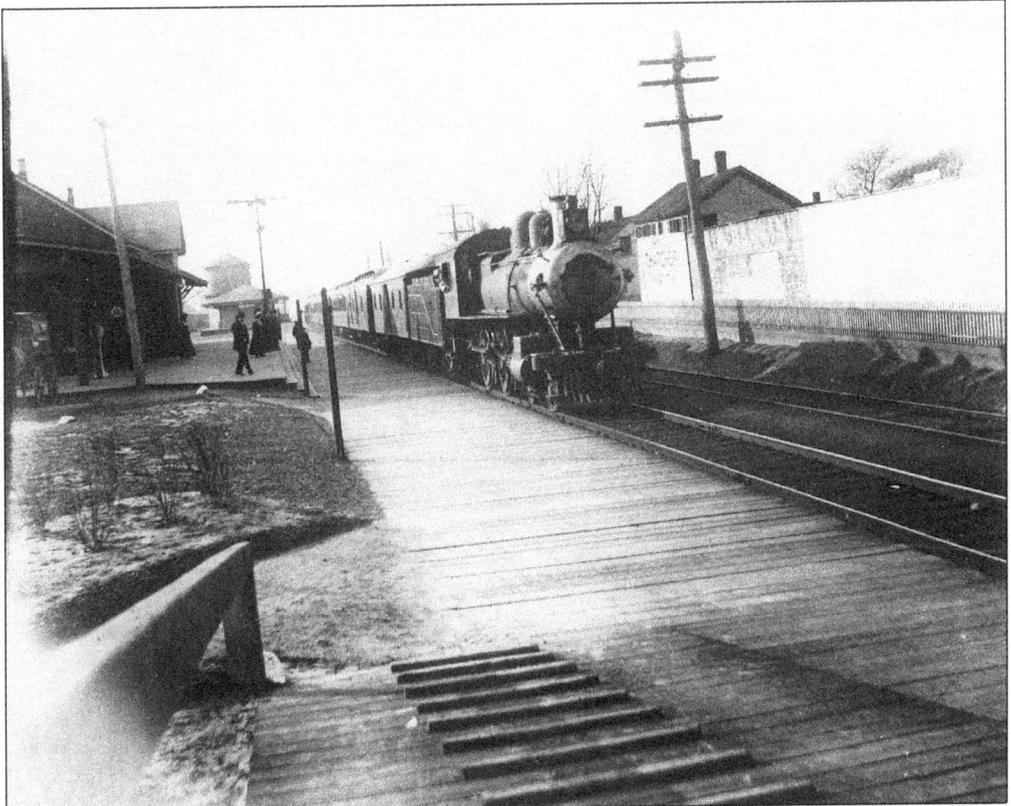

The Patchogue Railroad Station is pictured here *c.* 1905.

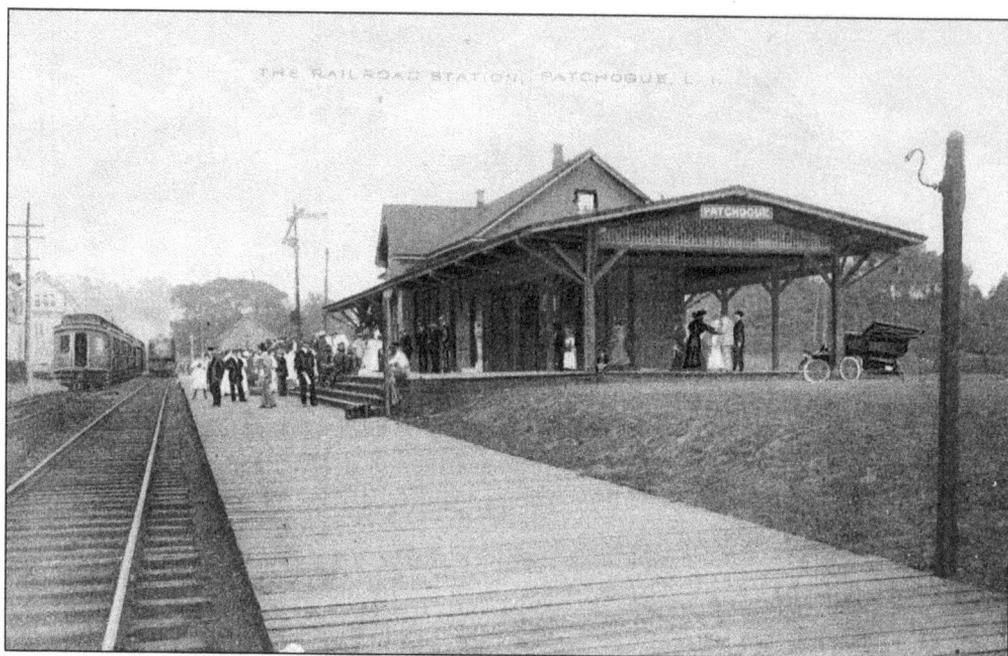

The station is pictured here looking from the west. Train connections from Patchogue were very good. In the 1920s on the average 15 trains per day each way stopped in Patchogue, with increased service in the summer. There also was a night "Theater Train" from New York.

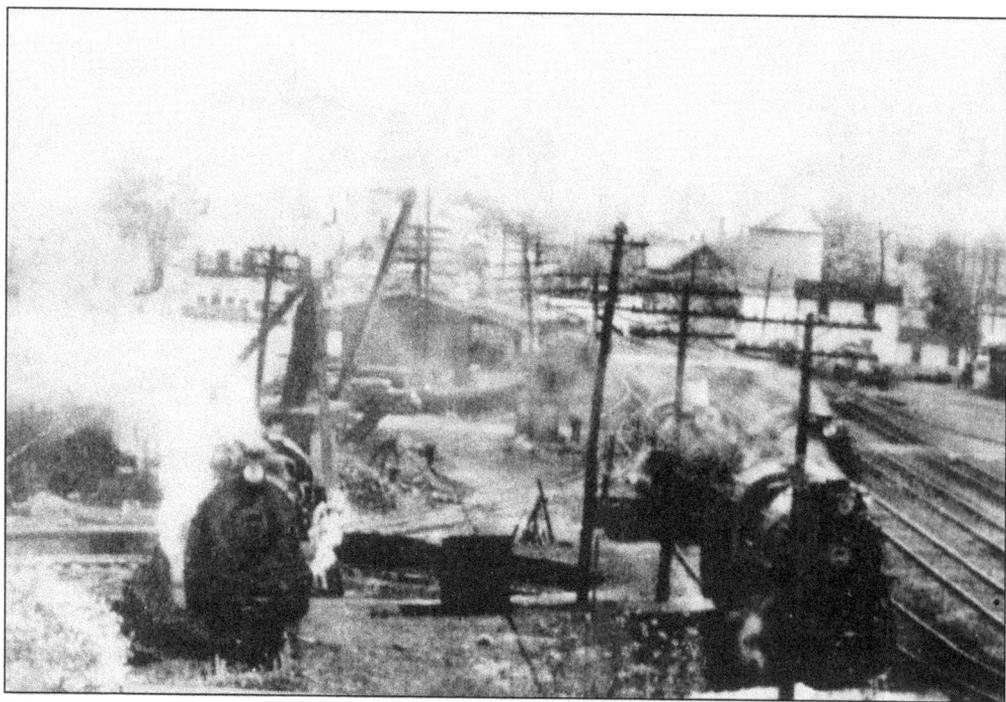

This view of the Patchogue Rail Road Yard was taken during the last days of steam.

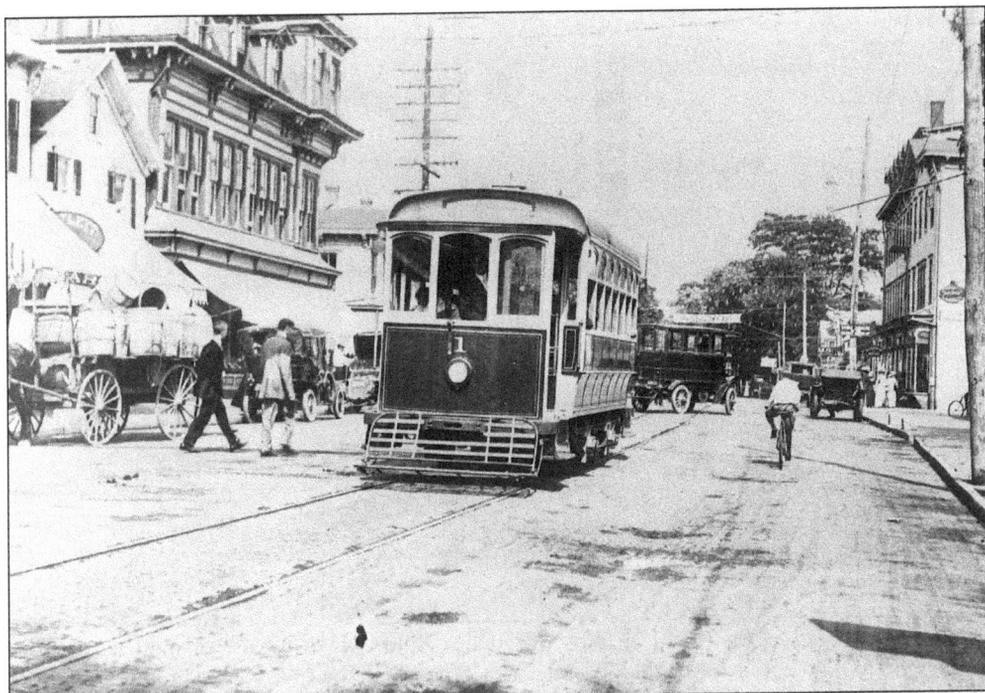

From 1911 to 1919 the battery-powered trolleys provided good service but gradually faced more and more competition from bus lines. This eventually forced a closure of the trolley line. Here is car #1 on Main Street.

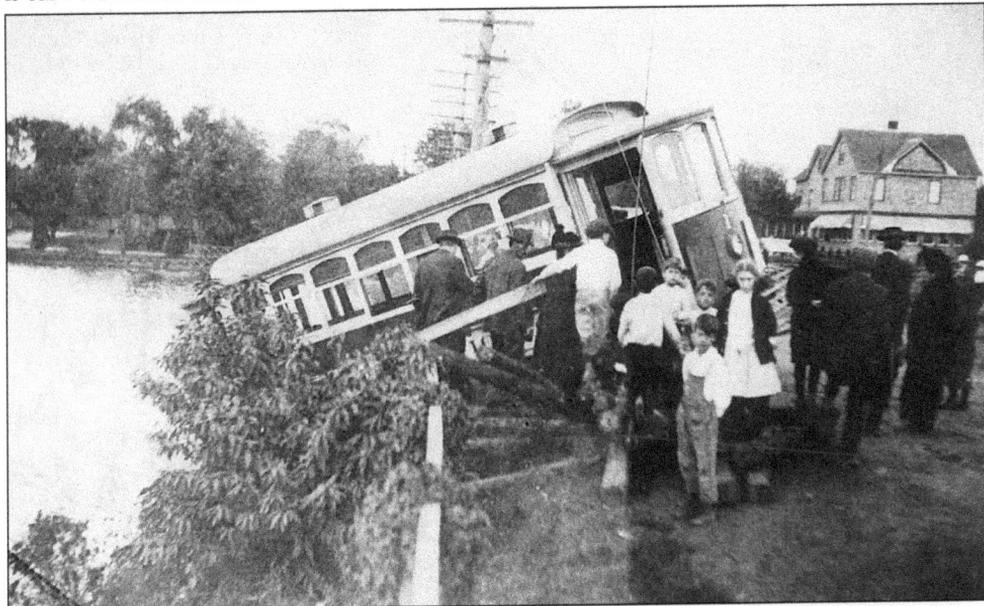

The trolley cars were of light construction with a short wheelbase. Young boys found out very quickly that by jumping onto the back of the trolley with a few buddies they could make the trolley act like a rocking horse by doing kneebends in unison. Was it a rock on the rails or a few boys full of mischief that made this trolley try to take a swim in the West Lake? No one was injured, but a few passengers got very wet.

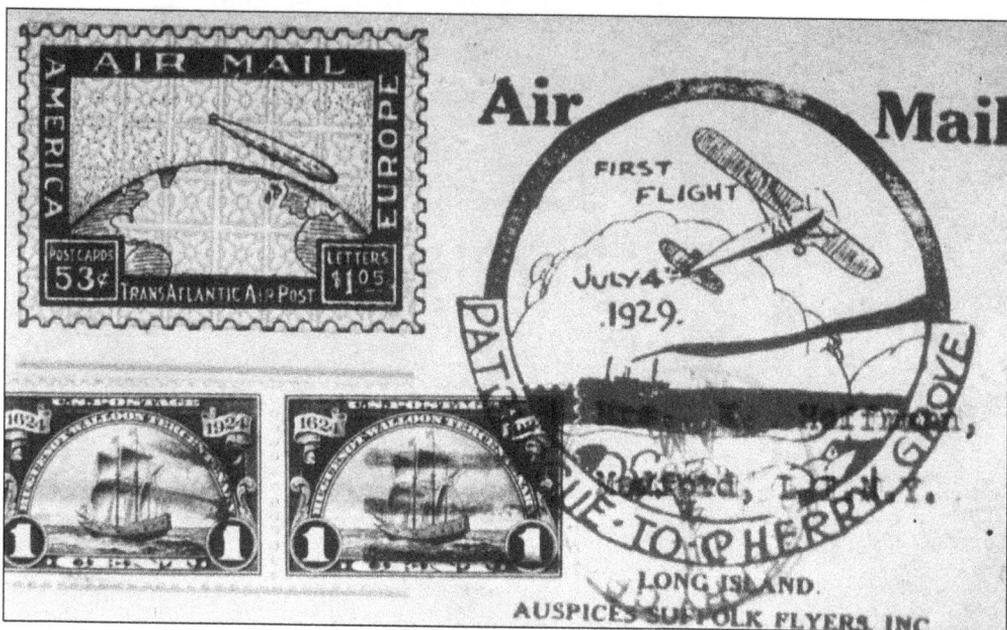

A challenge between two local citizens over who could deliver a sack of mail faster from Patchogue to Cherry Grove developed into a race between the speedboat *Jen* and a plane of the Suffolk Flyers Club. Tremont Adams was the owner of the *Jen* and Herb Austin was the president of the Suffolk Flyers Club. This is one of the 1,750 pieces of mail delivered by plane on July 4, 1929.

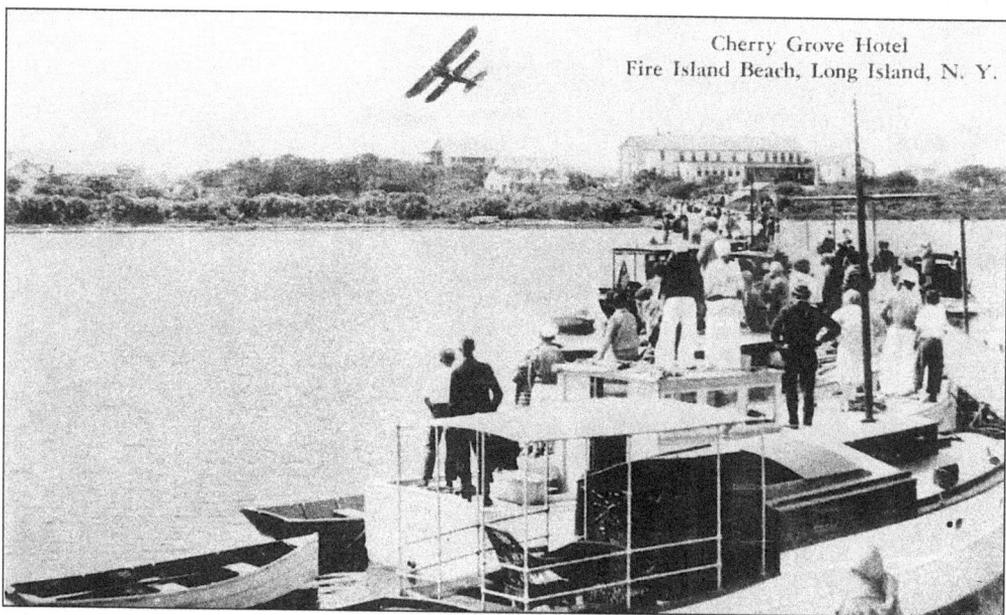

Thousands of people were watching the race between the *Jen* and the plane from the shoreline. The *Jen* was the fastest boat on the bay for many years, capable of speeds of up to 55 mph. Leaving from the dock on the foot of South Ocean Avenue she was beaten only by a matter of seconds by the plane that left from Bayport. Here the pilot, Bill Hunt, is dropping the mailbag on the Cherry Grove dock. The time is 10:36 on July 4, 1929.

In the early month of 1929 a group of Patchogue men organized the Patchogue Wing of the Suffolk Flyers Club. The members were busy locating a flying field for the club. The first field between North Ocean and Jayne Avenues was found unsuitable for beginners. They moved next to a field in Bayport just south of today's field and then to Roe Avenue near the bay in East Patchogue. This picture was taken at the Roe Avenue location in the 1930s.

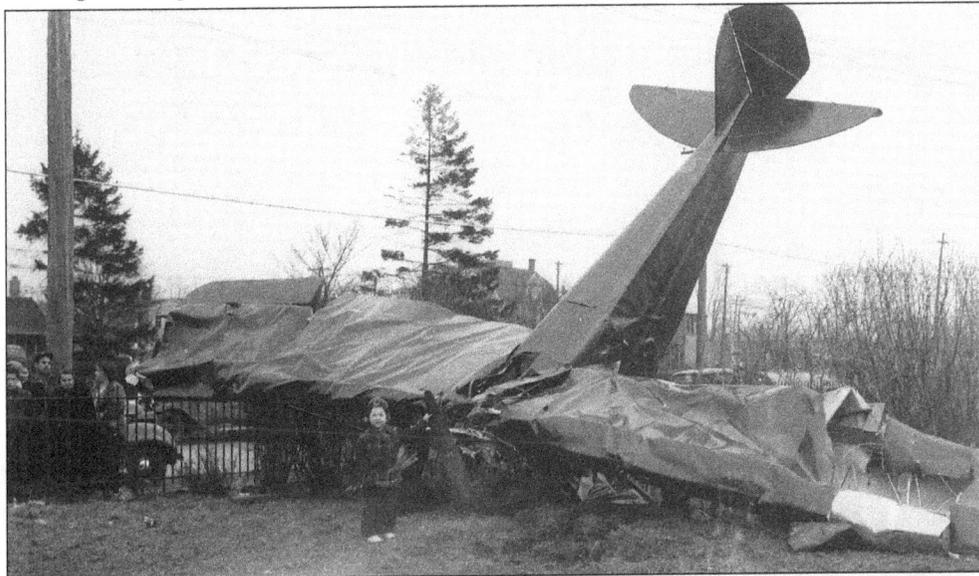

A plane crash in Patchogue happened on March 3, 1937, at 6 p.m. The plane, piloted by Mr. Spalding, developed engine problems while flying over the Patchogue Railroad Station in an easterly direction. The pilot made a hairpin turn over Brookhaven Town Hall and tried to land on a small field, which is now the schoolyard of Holy Angels School opposite the station. The plane stalled and crashed a few feet off Division Avenue. Mr. Spalding and his passenger, Mr. Butler, were killed instantly. The photograph was taken by Adolph Morge.

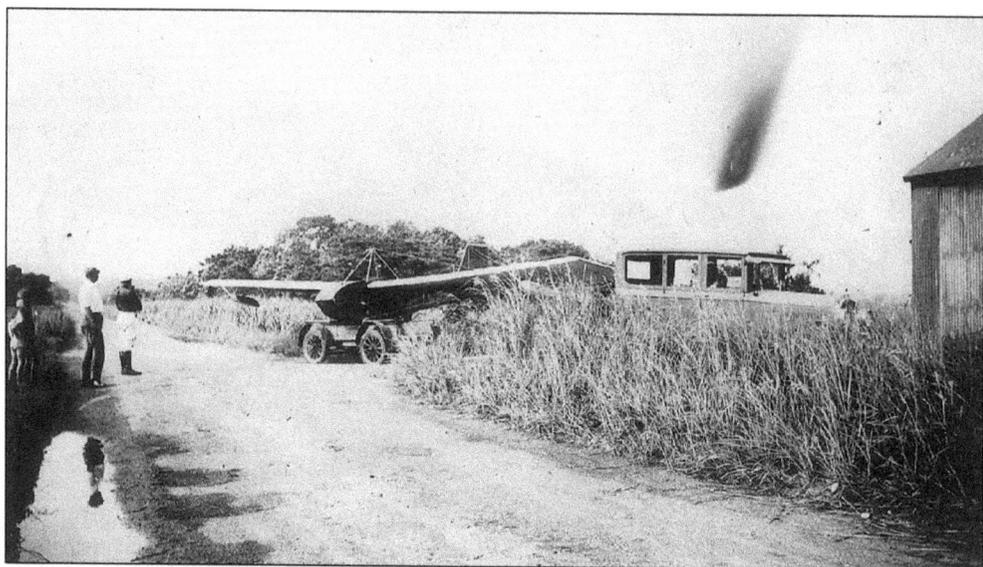

A small plane arrives by trailer at the Patchogue Airport on Roe Avenue in 1933.

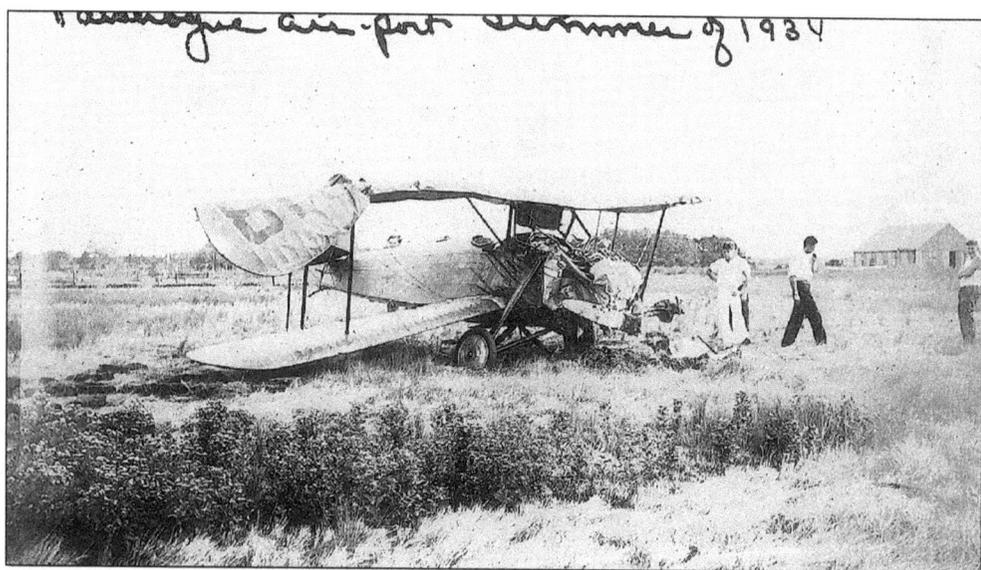

In the summer of 1934 this Waco biplane, piloted by Henry Sieger of Patchogue, developed engine problems on takeoff and crashed from a height of 150 feet between Pine Neck Avenue and Swan Creek. Herman Maez, a passenger, had to spend a week in the hospital, but Henry Sieger and the other passenger, Gilbert Trimmer, walked away with only minor injuries. The plane dove at a 45-degree angle into a muddy field, which helped to prevent serious injury.

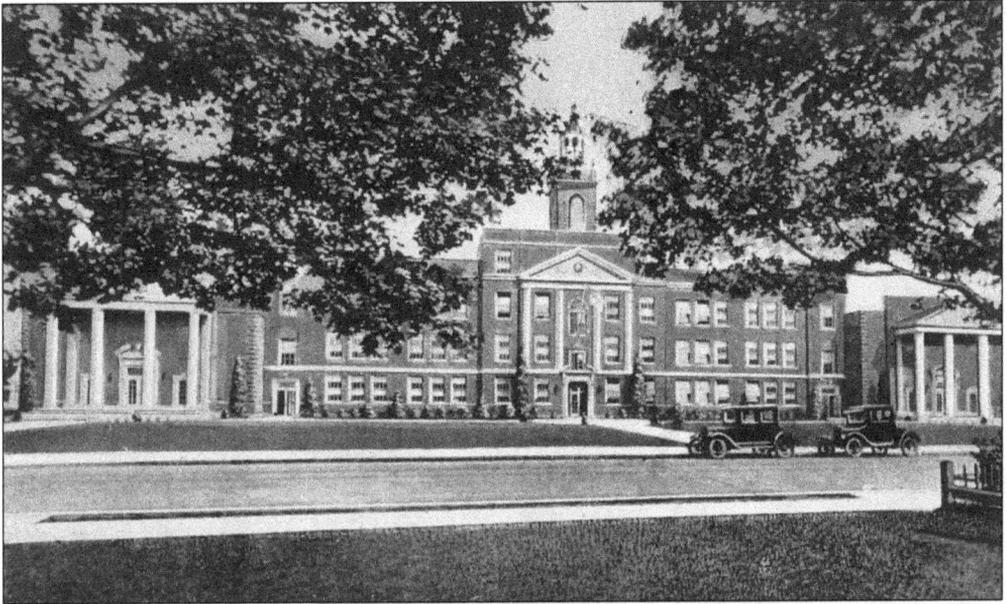

In 1916 the school district purchased a building site on South Ocean Avenue and later erected a large brick structure that was to become the new high school at a cost of $500,000. In October 1924 the dedication ceremony took place. Mrs. Ruth Lith donated a large adjacent parcel of land which became the sports field.

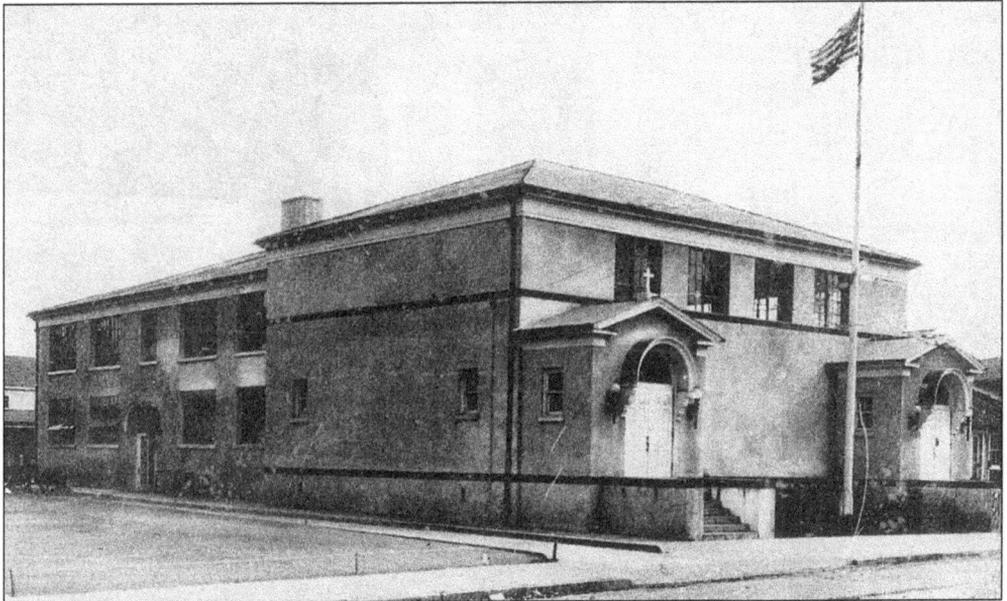

The former St. Francis Parochial School borders the high school on the south side. Today it is the administration building of the Patchogue-Medford School District.

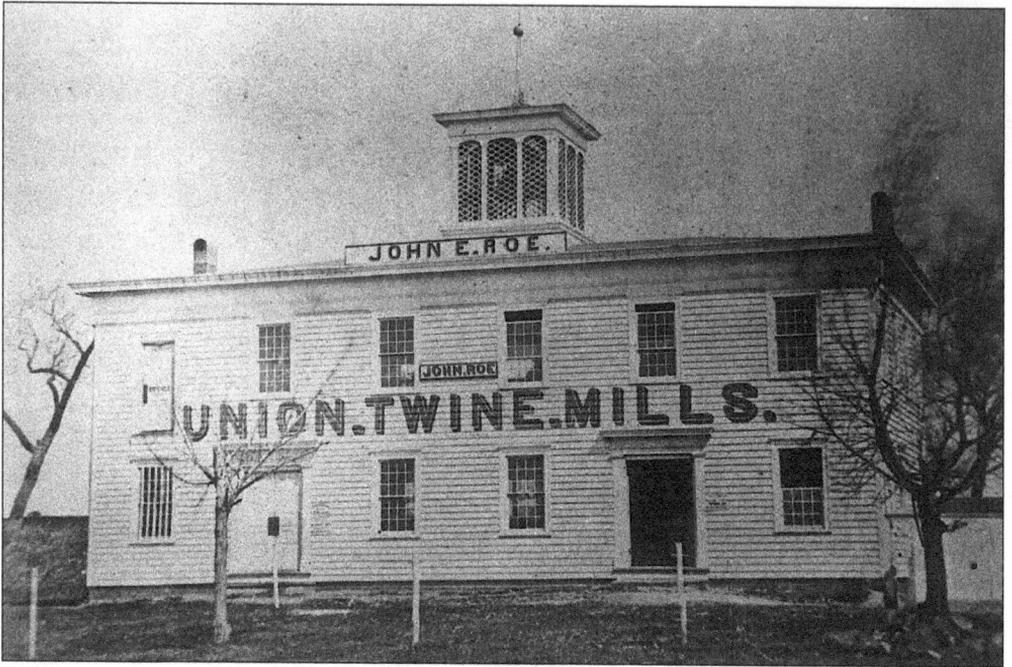

John E. Roe's Union Twinemill was constructed in 1851 and was actually the first building of the future Lacemill. John E. Roe died interstate 1872 and John S. Havens handled the mill affairs. He leased the mill to Carlsow, Henderson, and Co. from Scotland in 1880. They manufactured crinoline and bleached imported lace. After the mill was sold in 1890 to the Patchogue Lace Manufacturing Co., the first looms were imported and installed.

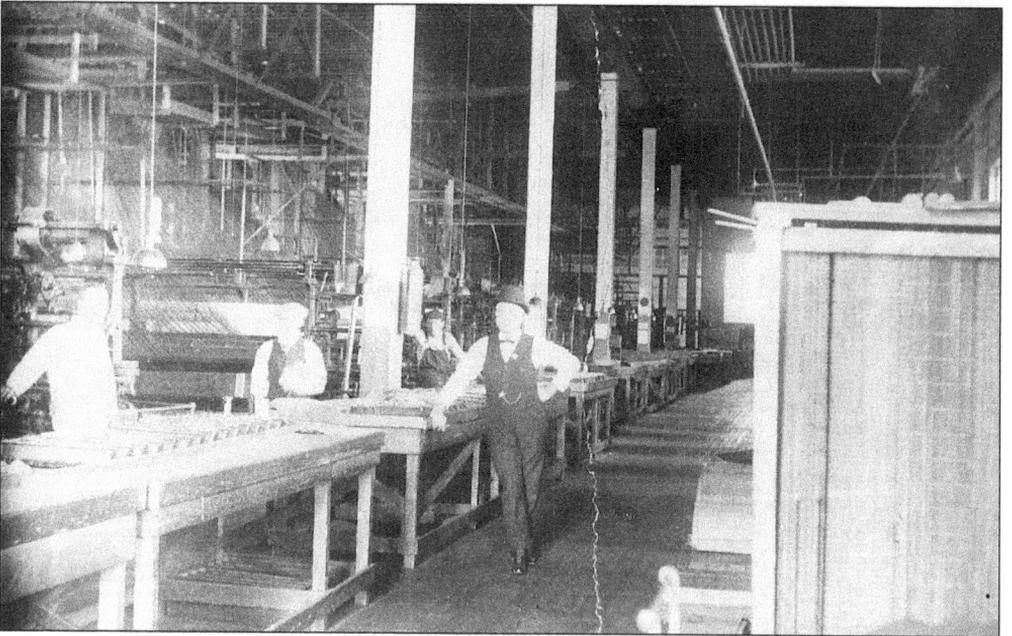

The large weaving shed in the mill is pictured here.

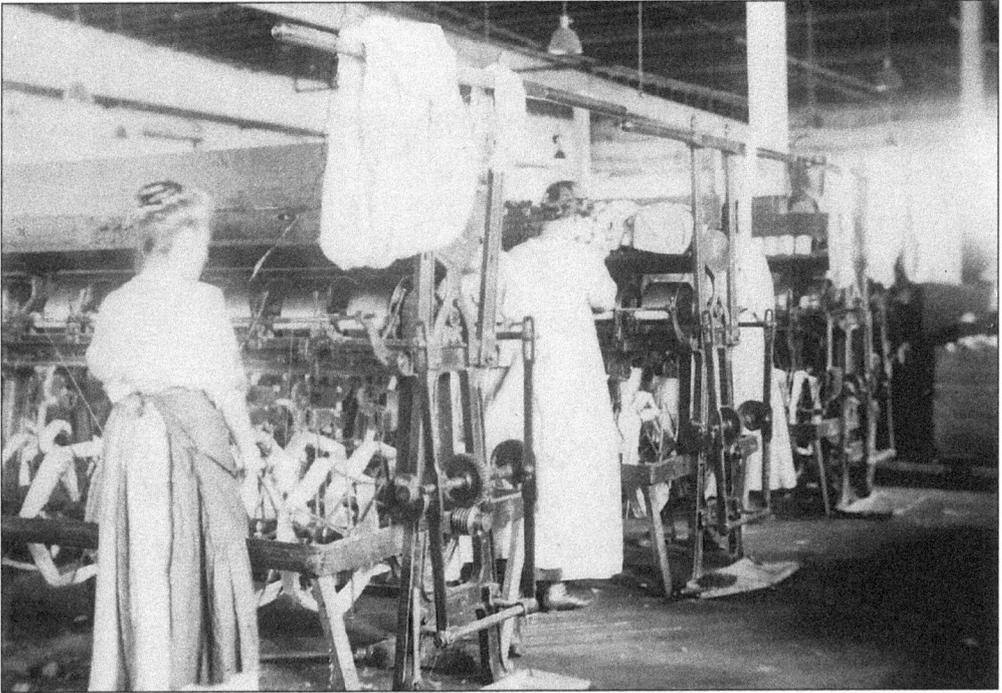

These women are winding yarn which would be fed to the weaving looms at a later time.

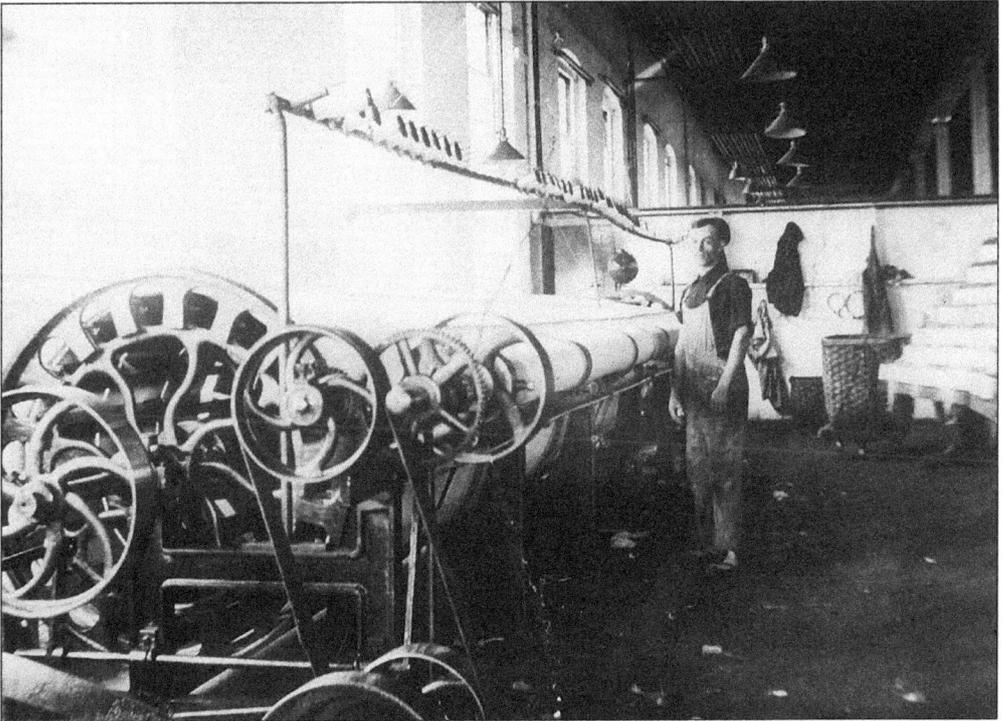

This is one of the large machines in the mill used for the warping of yarn.

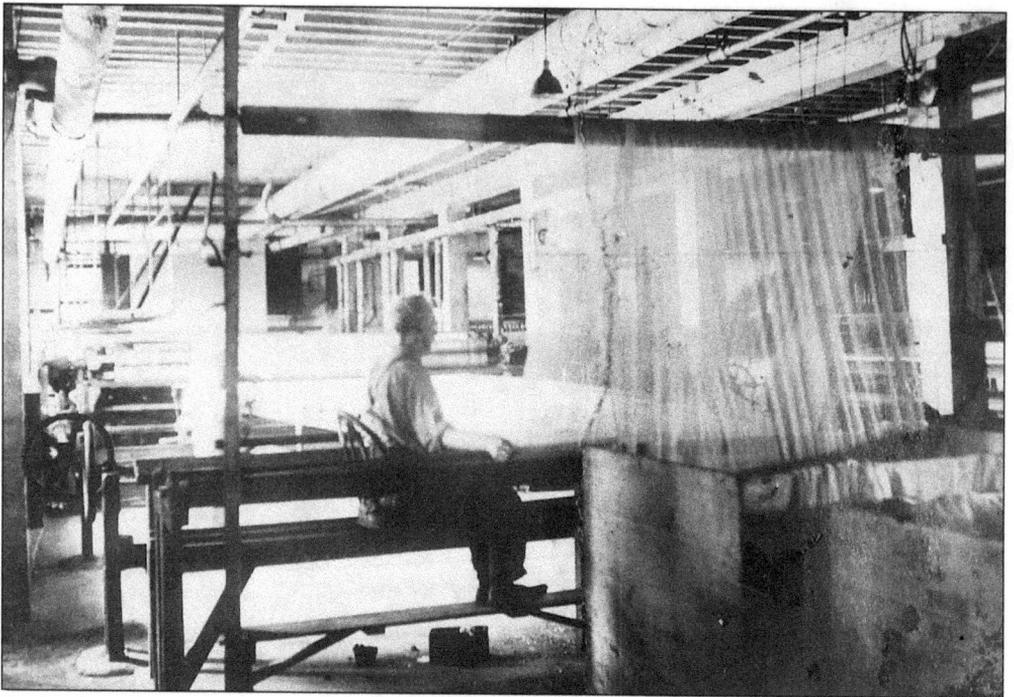

In this large heated room a process called "tenting and drying" took place. This would be the final manufacturing step.

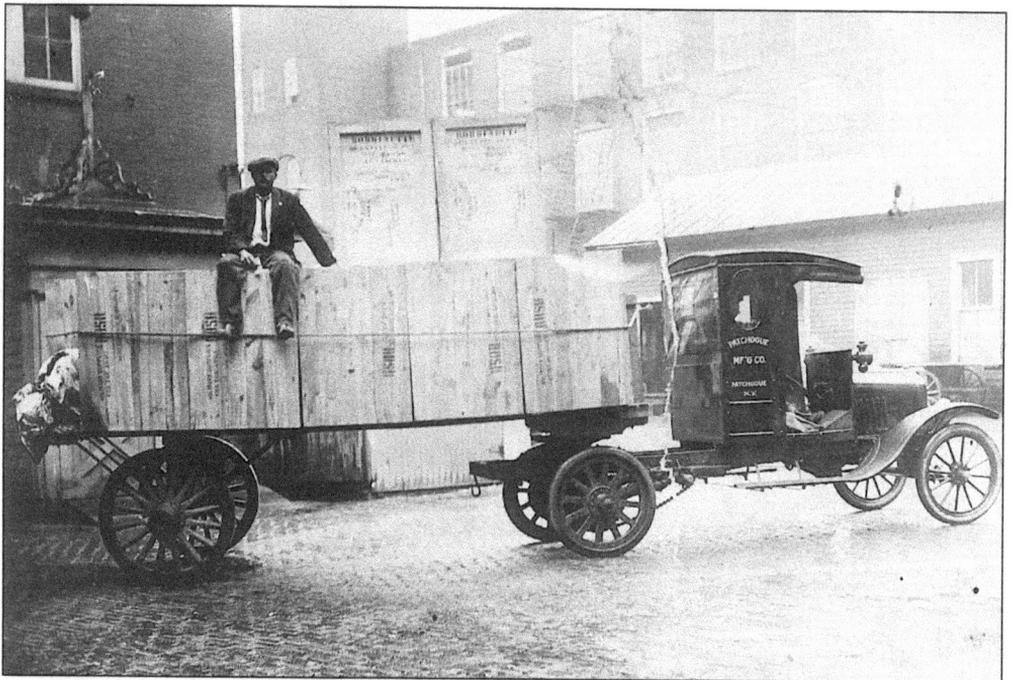

The finished product would be shipped to the railroad station with this truck. The year was 1918.

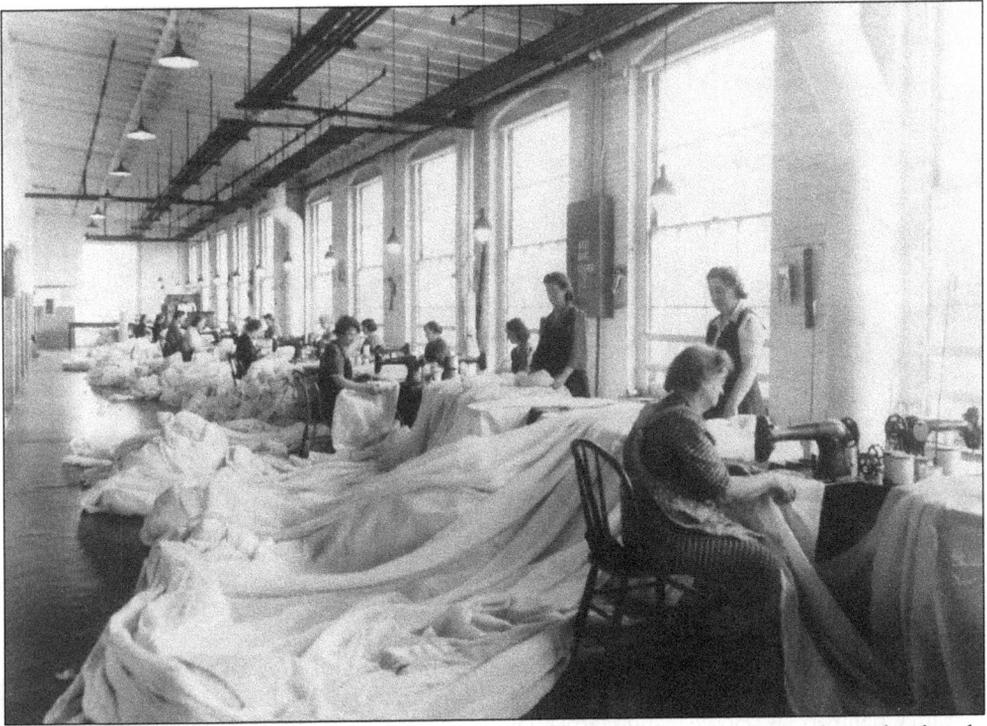

This photograph shows one of the large rooms located on the upper floor where the female workers would sew the finished material. This is a picture from the 1940s.

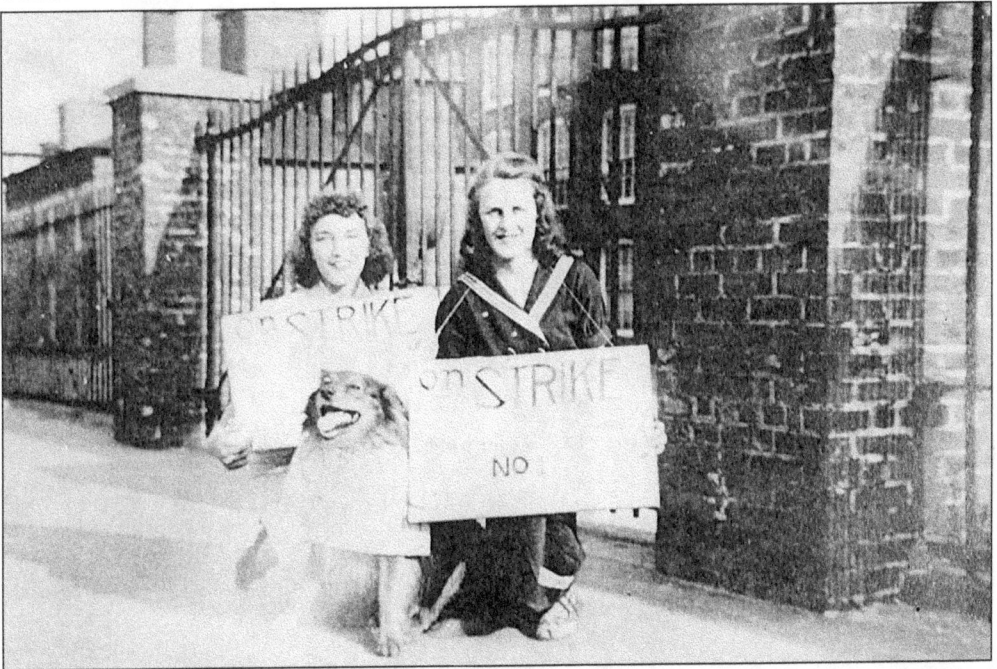

Not everything ran smooth all the time. This picture was taken in 1941 during a strike. Mary Warden Blanding (left) and Adelaide Gazzola pose with their dog "Skippy." We do not know what the dog was striking for—possibly a larger fire hydrant??

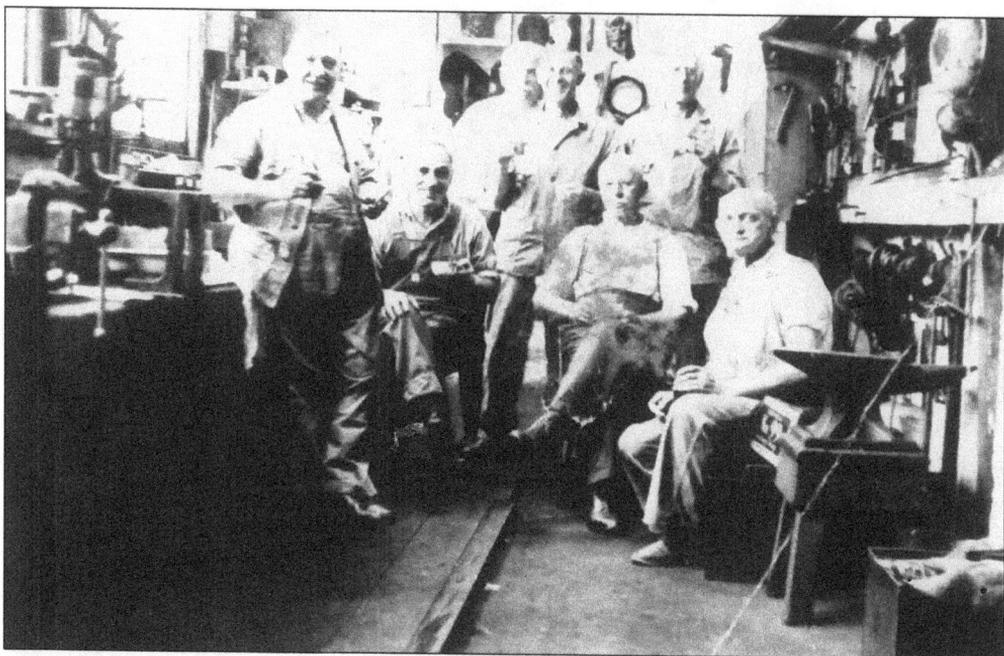

The following pictures of some of the personnel of the Lacemill were taken in the 1940s and 1950s. Listed from left to right are Charles Springhorn, unknown, William Daft, Art Hammond, Edward Chambers, A. Hooley, and Harry Clay.

These Lacemill workers, pictured here c. 1950, are Theodore R. Krimm (left, the machine shop foreman for 47 years), Stanton Edwards (center), and unknown.

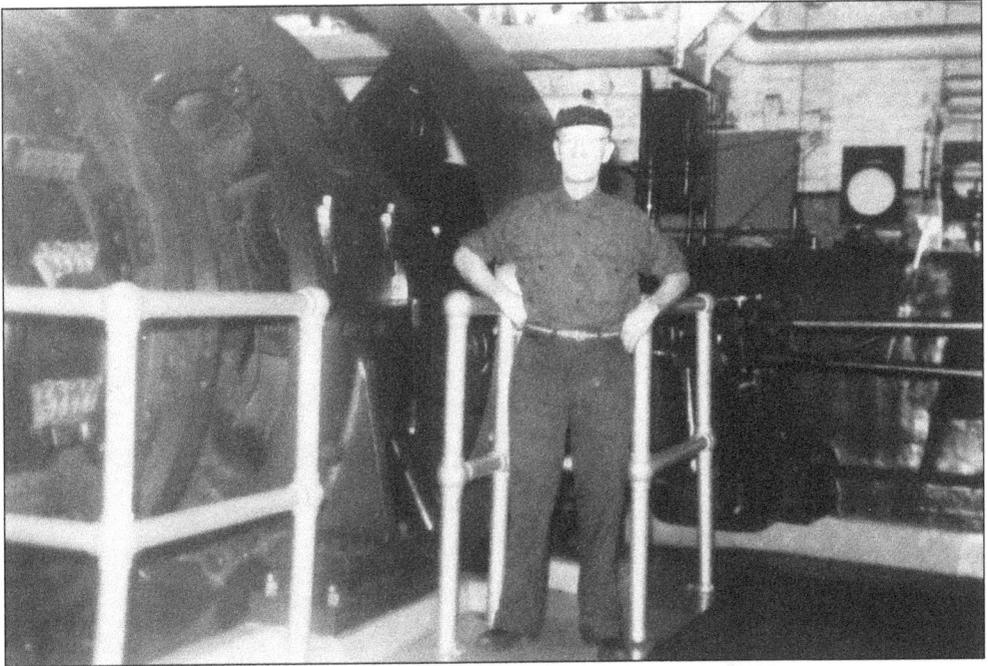

Dave Johnstone, chief engineer, is shown here in his element.

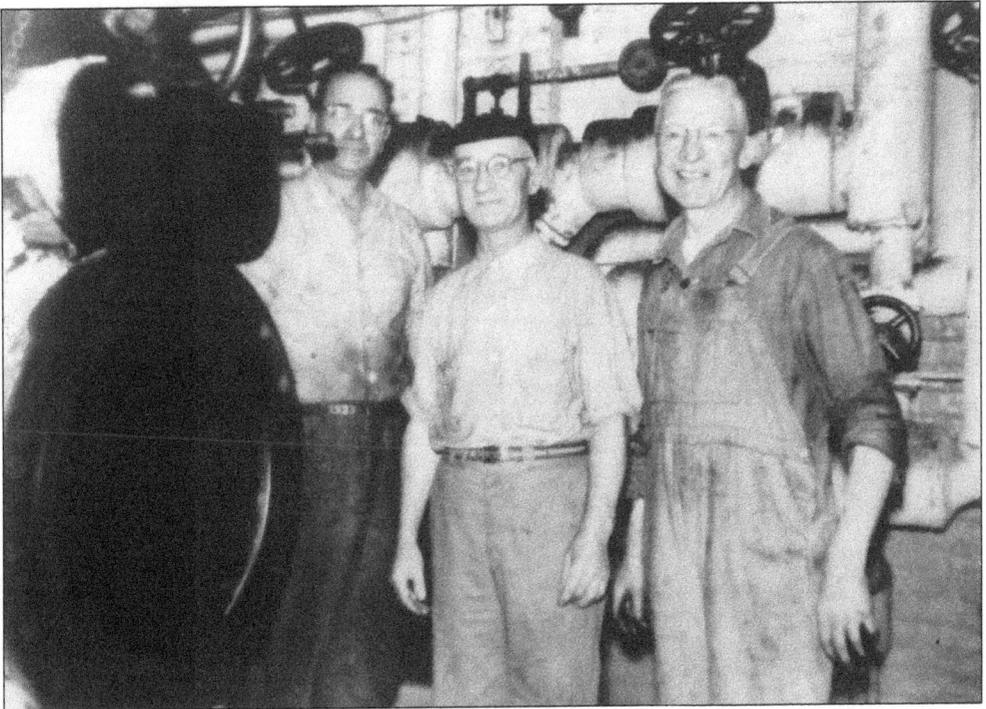

Posing here from left to right are Pete Piel—engineer, Dave Johnstone—chief engineer, and Mr. Paulman, a representative from Erie, Pennsylvania.

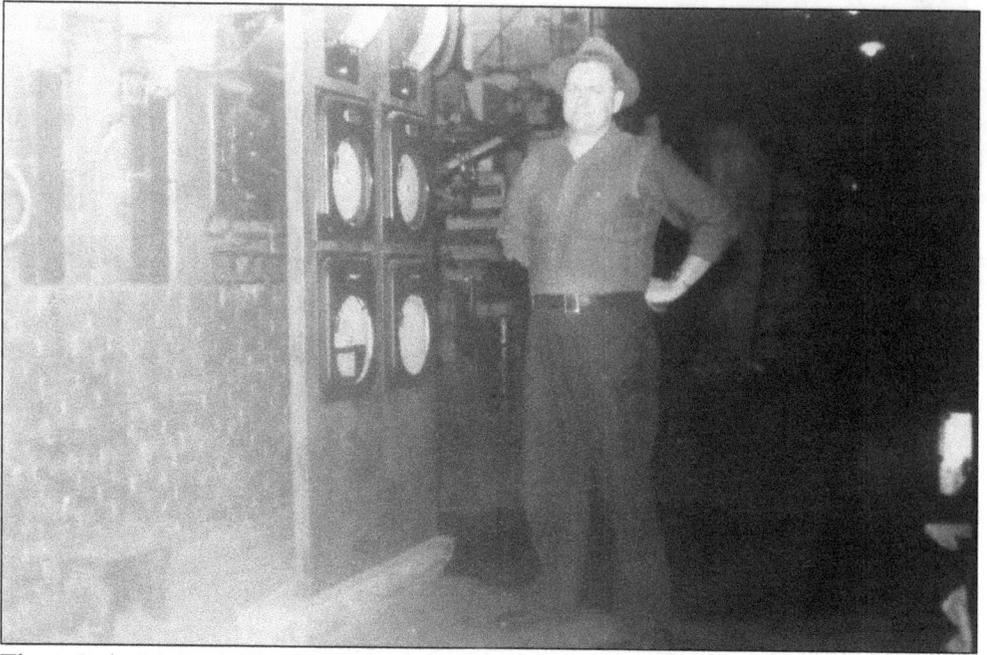

This is Spike McCord, the plant engineer.

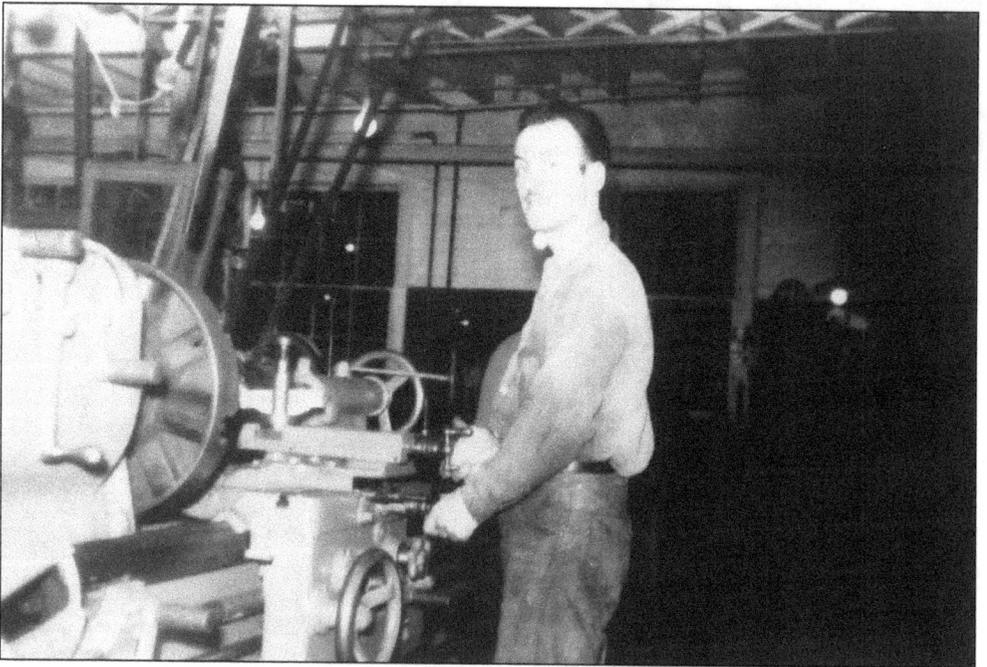

Ed Ackermann, a machinist working in the mill, was photographed at work.

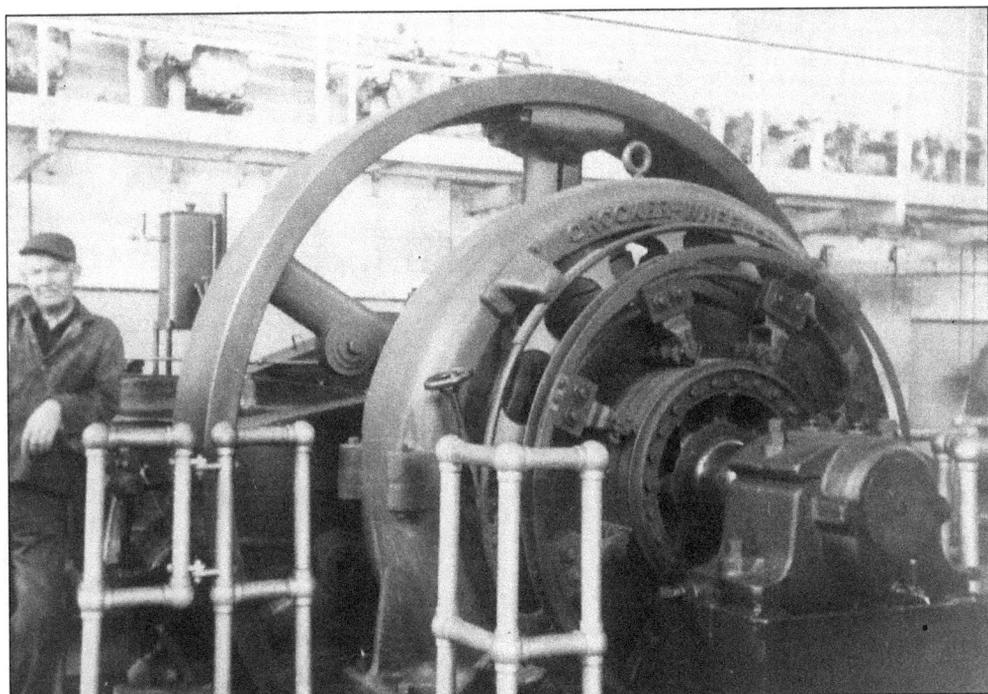

Engineer Fred Benkenstein is shown here in the engine room of the Lacemill in 1950.

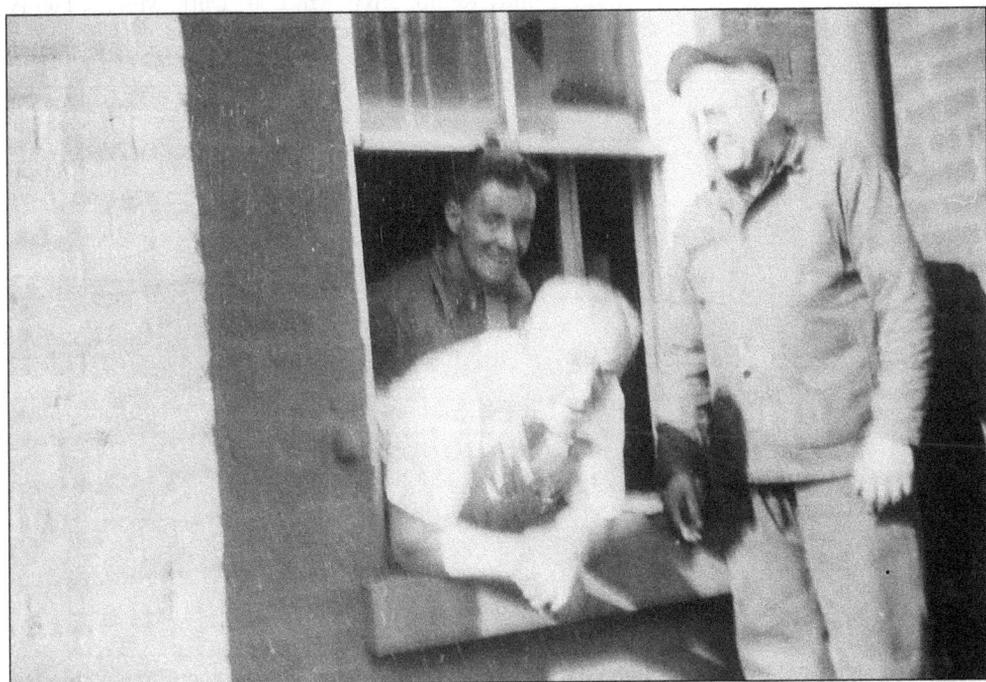

Posing for a quick snapshot are David Johnstone (left), Bill Fitchmer (right), and David Johnstone Jr. (in the rear).

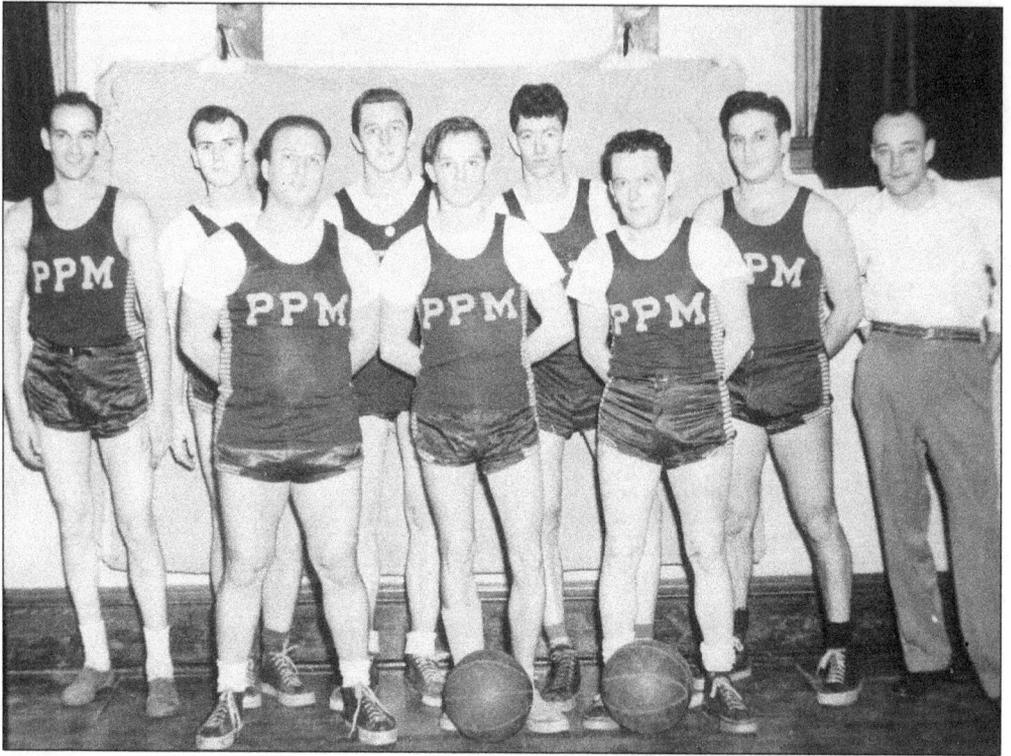

The Plymouth Mills basketball team is pictured here in 1947 at the River Avenue School. Listed from left to right are Pat Littieri, Danny Kemp, unknown, Lou "Dutt" Meyers, Henry Meyer, Ed O'Brian, Howie Van Schaik, Carl DeVito, and coach Charles Keller.

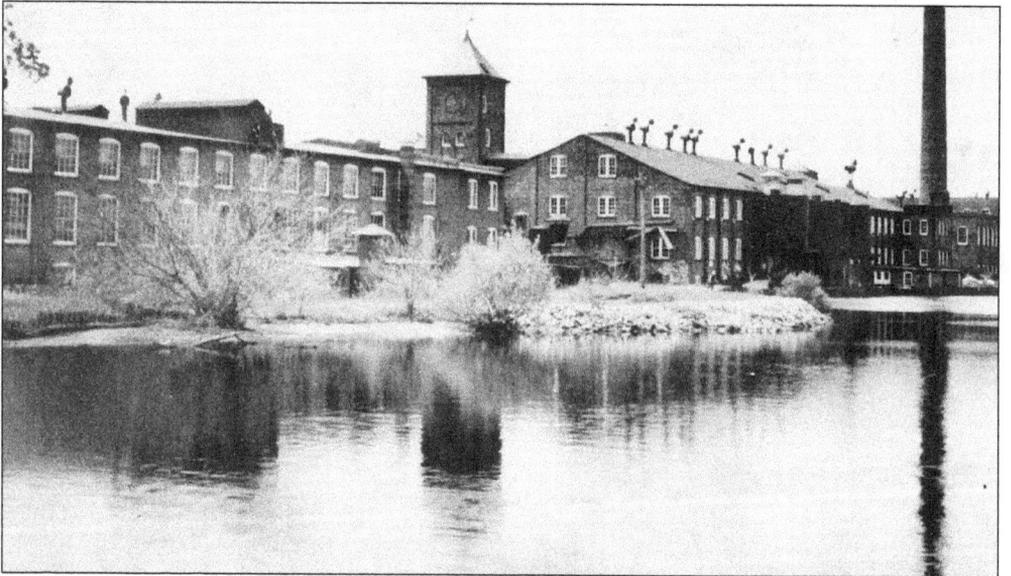

The north side of the Lacemill is pictured here in 1950 before West Avenue was extended and connected to Waverly Avenue. The waters of the lake at that time came close to the mill buildings.

Patchogue-Plymouth Mills Corporation

Patchogue, Long Island, N.Y.

PLYMOUTH LACE CURTAINS, NETS
PLYMOUTH LACE TABLE CLOTHS
DYERS & FINISHERS OF
SYNTHETIC FABRICS
MILLS: PATCHOGUE, L.I., NEW YORK

EXECUTIVE OFFICES
295 FIFTH AVENUE, NEW YORK, 16, N.Y.
PHONE MURRAY HILL 4-6765

WORLD'S LARGEST MANUFACTURERS OF
FIBRE PRODUCTS & PLYMOUTH RUGS
FIBREARS SLIPCOVER MATERIALS
MILLS: LAWRENCE AND HOLYOKE, MASS.
ASHUELOT PAPER COMPANY
HINSDALE, N.H.

October 15, 1954

It has been apparent for some time that the lace curtain and cover business has been steadily diminishing. While our standing in the industry has not changed, our volume has fallen off to roughly one-third of what it was as recently as 1948. During these years five of our competitors have been forced to liquidate their lace plants. Because of the drastic sales decline, we have been suffering sizable losses in this plant for the past six years. With future prospects looking even more unfavorable, we can no longer cope with this situation. It is indeed with great reluctance, that the decision to discontinue our lace operations has finally been forced upon us.

The date for the cessation of our operations will vary from department to department, with the weaving department stopping first, which will be very shortly. Most other work should be completed before the end of the year.

Along with the decline of our lace business, there has been a steady curtailment of employment at the Patchogue mill, and for some time the number of persons regularly working has been extremely small in comparison to the huge size and potentials of this plant. In the final analysis, we believe that this action will prove beneficial to the workers as well as to the community as it will be our purpose to attract other industries to use our plant in Patchogue, which should provide gainful employment to a far greater number of workers than presently employed. However, to accomplish this aim we will require the same full cooperation of the workers, the unions and the community as we have had in the past.

DIRECT REPLY TO
PATCHOGUE, LONG ISLAND, N.Y.

This is a copy of the letter sent to the employees of the Lacemill on October 15, 1954, informing them of the impending closure of the mill.

This picture was taken during one of the last years of the Patchogue Plymouth Mills operation, c. 1954.

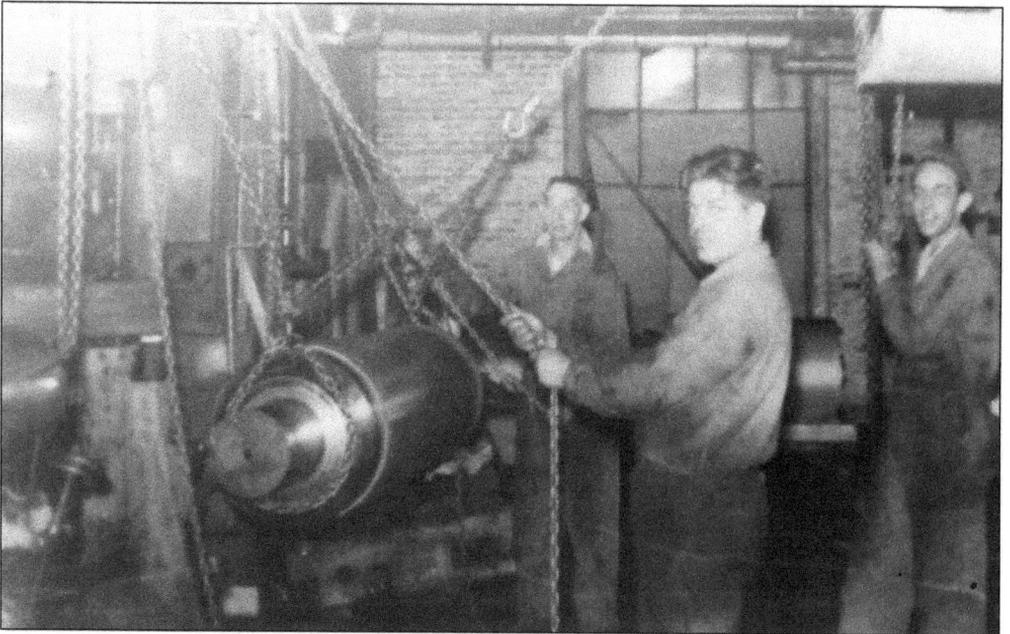

Some of the dismantling of the machinery was done previous to the closing. Stan Edwards, E. Gregory, and A. LeBranch are shown here removing a Perkins Roll from the machinery for packing and shipping. The roll alone weighed 4,400 pounds. This picture was taken on April 22, 1950.

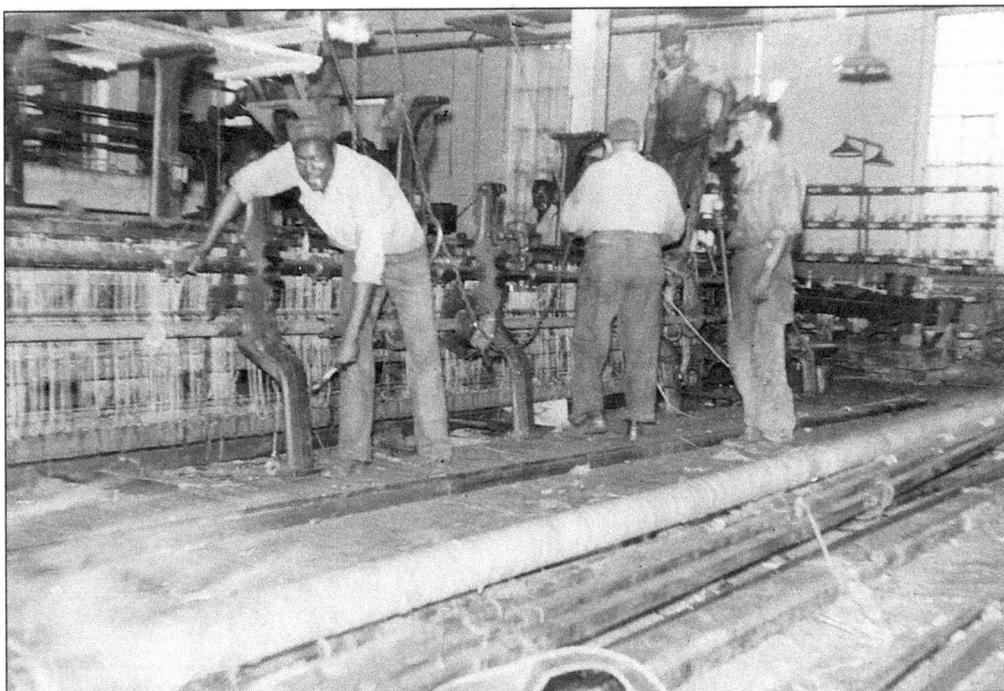

Here weaving machine #27 is dismantled for scrap.

After all the machinery had been removed, all foundations and other obstructions were removed and a new concrete floor was poured. Under the name of Island Industrial Park, these spaces were now offered for rent.

The mill was now ready for rentals. This postcard was sent to prospective rental clients.

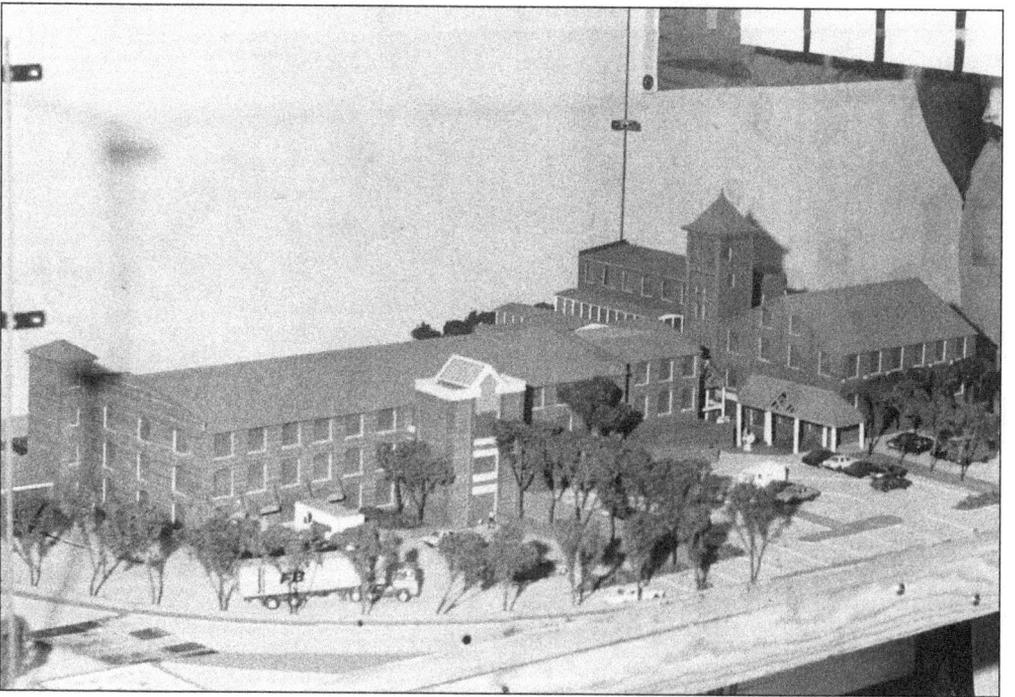

This display model shows a possible mill complex from the 1970s.

Three

Life in Patchogue in the 1930s and 1940s

Patchogue had now transformed into a business community and major shopping center. Over 250 stores and many other businesses provided a large selection of goods and services for a large surrounding area.

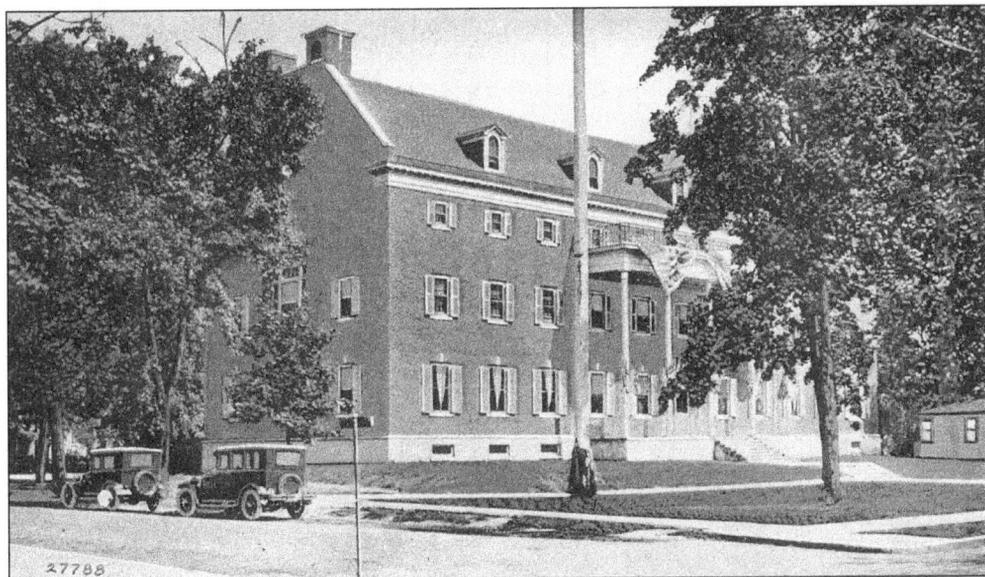

The new Elks Club on East Main Street, opposite the post office, was dedicated on March 4, 1926. It served the Elks until 1936 when it was vacated. The building was not used again until 1941, when it became the Patchogue Hotel. In 1969 the hotel was demolished to make room for an apartment building.

Officers

❖

Exalted Ruler...........Herman J. Schoenfeld
Esteemed Leading Knight........Harry S. Soper
Esteemed Loyal Knight.........Joseph F. Acker
Esteemed Lecturing Knight......Albert S. Dayton
Secretary...................Francis L. Brophy
Treasurer...................A. D. Schoenfeld
Tiler.....................William H. Miller
Inner Guard.................Alfred H. West
Esquire....................Earle M. Turner
Chaplain...................Philip McHugh
Organist...................Louis A. Muench

TRUSTEES

John Donaldson, P. E. R. Alexander G. Blue
John E. Glover, P. E. R. Fred N. Terrell
 Earle L. Holmes, P. E. R.

BUILDING COMMITTEE

Alexander G. Blue................Chairman
G. Sanford Coleman.........Vice-Chairman
Charles N. Butler, Jr................Secretary
William Loughlin August D. Schoenfeld
 Earle L. Holmes

FINANCE COMMITTEE

Samuel Jacoby...................Chairman
E. Agate Foster Edgar A. Sharp
Harry S. Soper William D. Mott
John C. Barrie Herman J. Schoenfeld

HOUSE COMMITTEE

John C. Barrie...................Chairman
Emil Zeugin Leonard Strong
Gustav Brandau John Roe Snedecor
George Link Gustav Schmidt

Program Courtesy Harry Lee Pub. Co., Inc., Riverhead

Patchogue Lodge, 1323, B. P. O. E.

E. MAIN STREET PATCHOGUE, N. Y.

—

Dedication Dinner

at the

NEW HOME

Wednesday, March 24th

1926

This menu was for the the dedication dinner of the new home of the Elks Lodge on March 24, 1926.

88

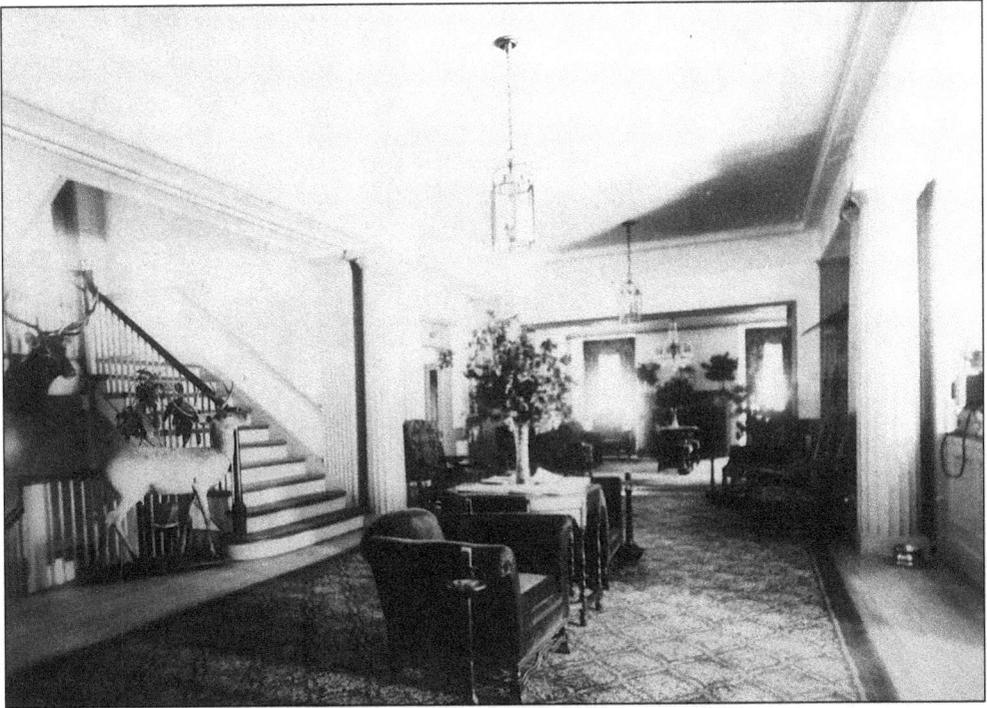

Pictured here is the foyer of the Elks Club.

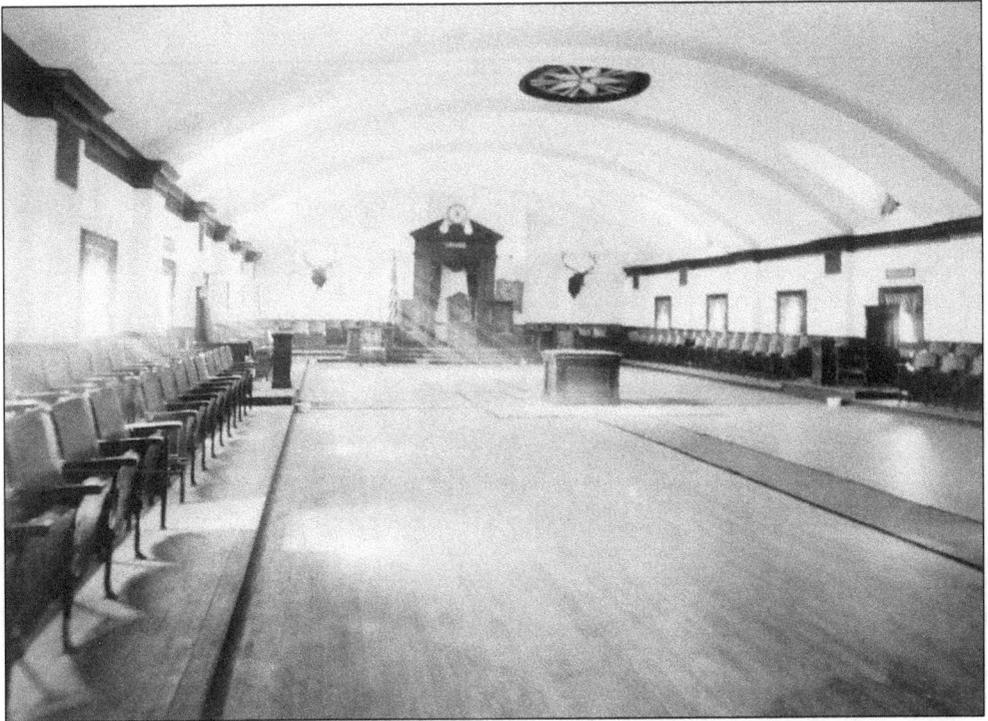

The third floor of the Elks Club was one large hall. During the time of the Patchogue Hotel it was used to host many meetings and social events for the people of Patchogue.

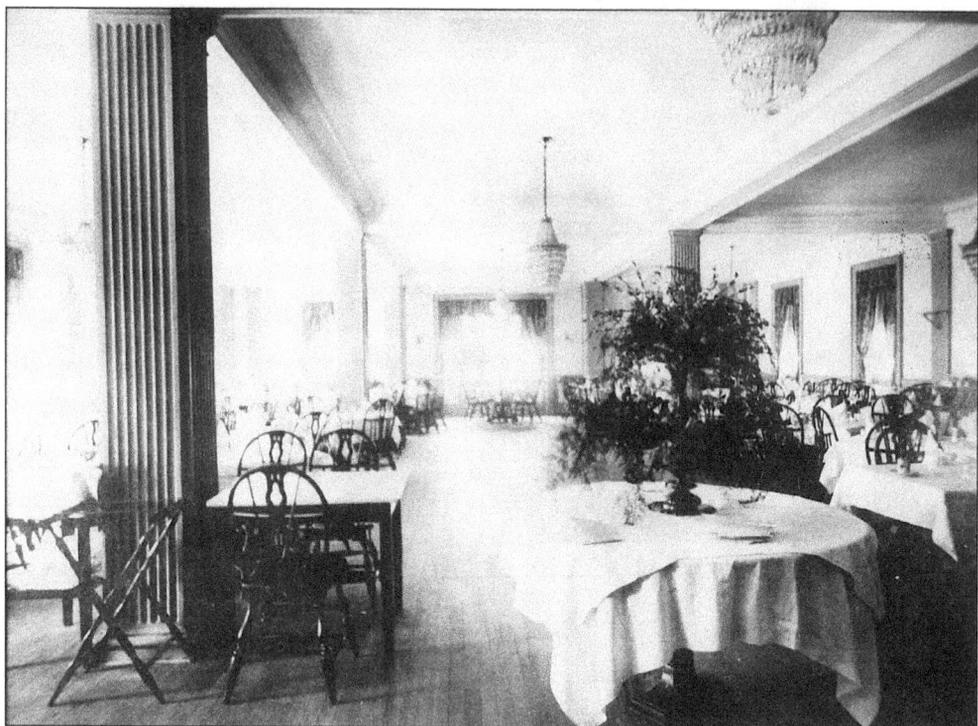

This is the spacious dining room located on the ground floor of the Elks Club. During the Patchogue Hotel days it became a popular restaurant.

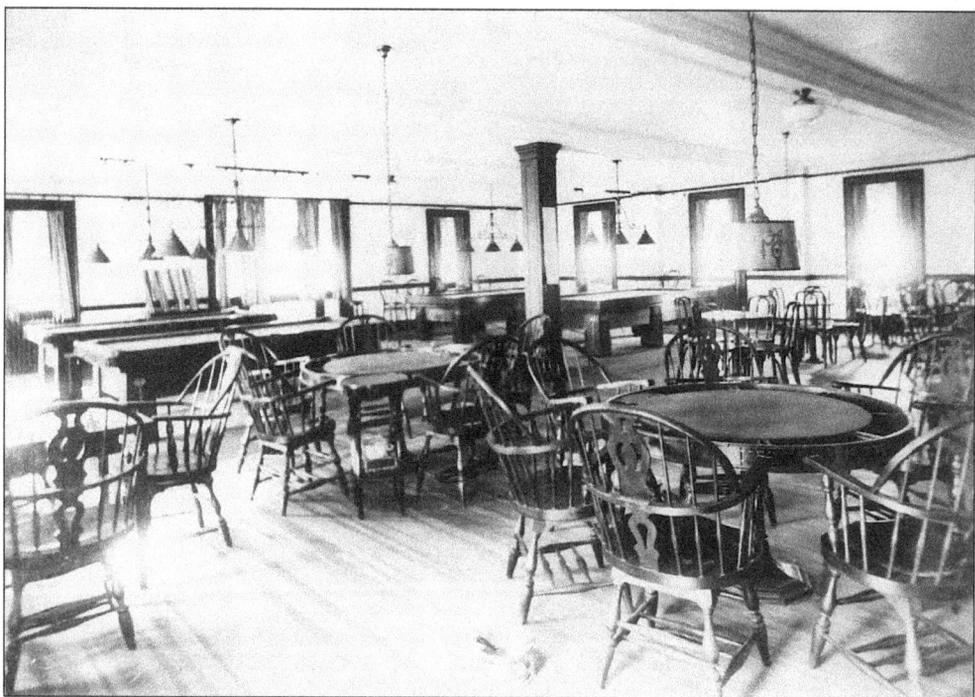

Pictured above is the game room of the Elks Clubhouse.

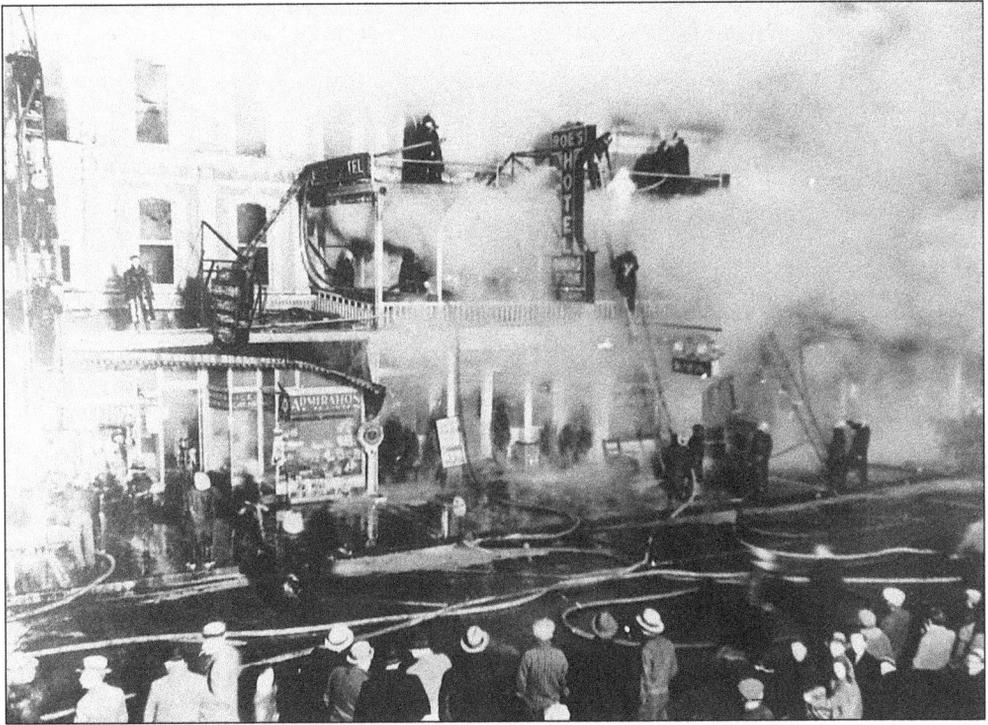

On March 7, 1934, a large fire destroyed most of Roe's Hotel at a loss of $100,000. Forty guests and a dozen employees working at that time managed to escape unharmed.

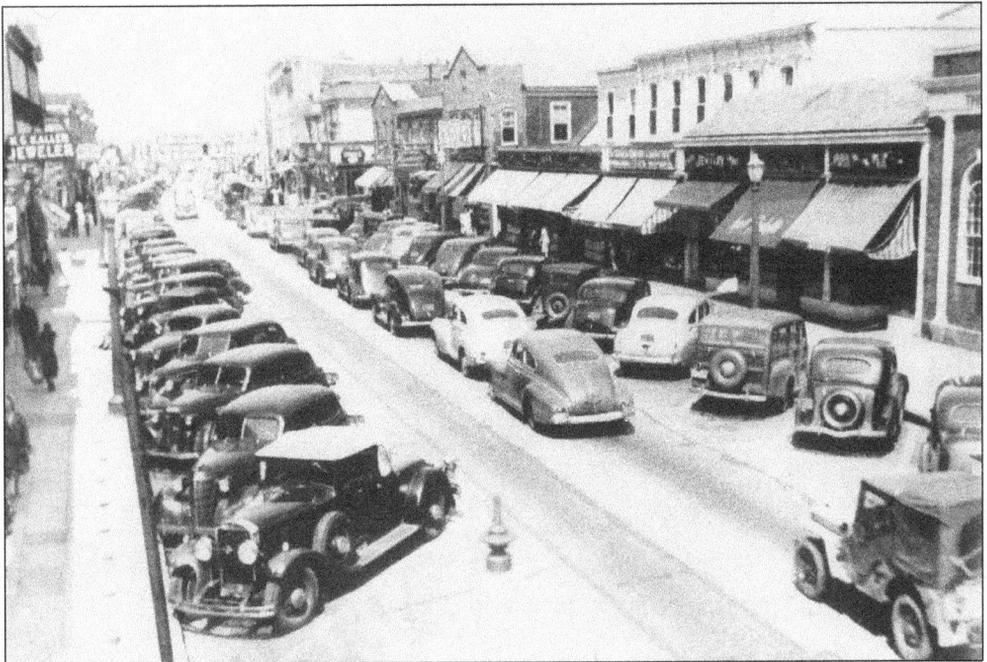

This 1940s photograph of Main Street shows the portions of Roe's Hotel that survived the 1934 fire. Another fire on April 23, 1959, destroyed this section also, which was at the time occupied by Pergament's.

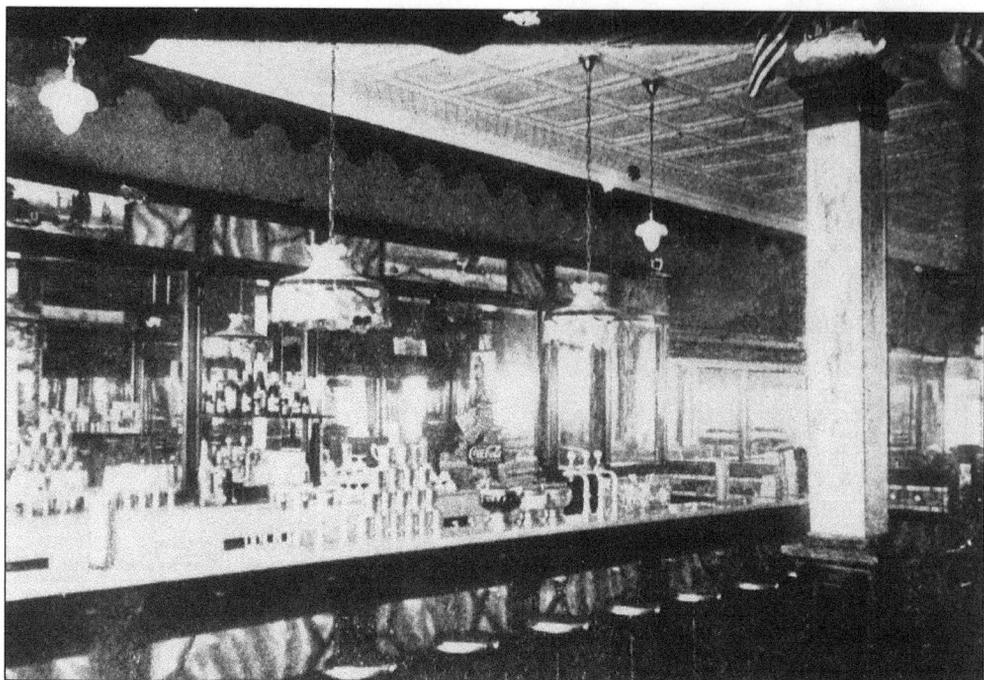

This is a 1917 picture of the Olympia Confectionery Store and Ice Cream Parlor, located at 32 South Ocean Avenue. It was a favored place for young and old alike. The store was in the old Ackerly building on the west side of South Ocean Avenue, where today the entrance to the parking lot is located. Clarence Lagumis was the manager in 1926.

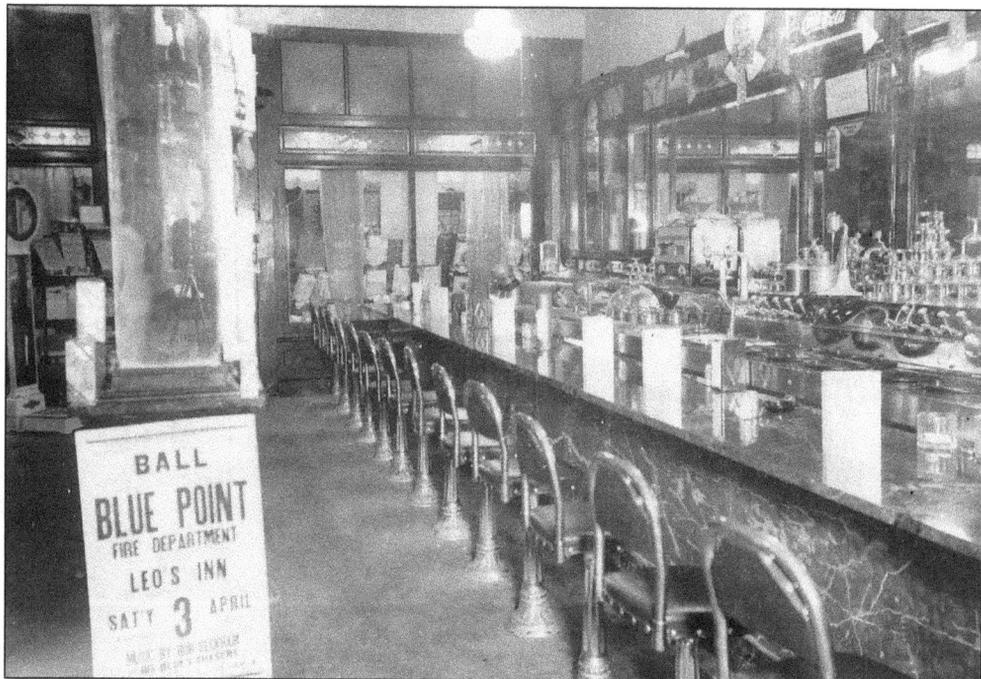

This is another interior photograph of the Olympia taken in the 1940s. The store was lost to fire on December 28, 1953.

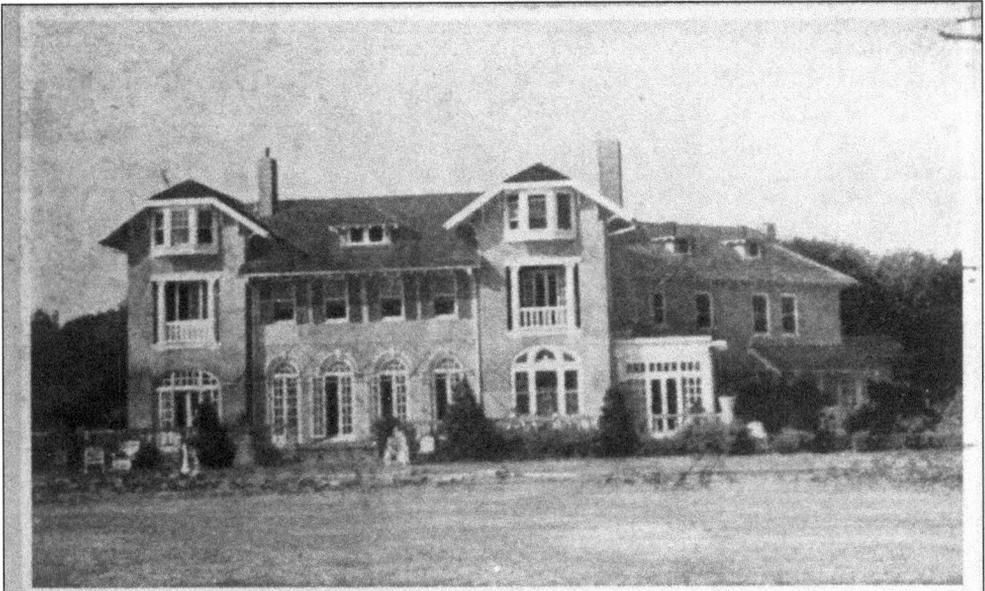

LOCATED ON GREAT SOUTH BAY AT EAST PATCHOGUE, LONG ISLAND, NEW YORK

In a private community for the discriminating

Patchogue Shores Country Club

1946

The Patchogue Shore's Country Club in East Patchogue was the former "Jackwill Farms" estate, the residence of Ruth Litt.

APPETIZERS

Shrimp Cocktail	.60
Clam Cocktail	.40
Oyster Cocktail	.45
Pickled or Maatjes Herring	.45
Chopped Liver or Egg	.40
Orange, Prune, Grapefruit, Pineapple, Tomato Juices	.20

SOUPS (All soups home made)

Bowl with Crackers	.25
Cup	.20
Bouillon	.20
Clam Broth	.20
Clam Chowder	.30
Oyster Stew	.65

ROASTS (All orders with potatoes, vegetable and salad)

Roast Leg of Lamb	.85
Roast Beef	.85
Roast Fresh Ham	.85
Roast Virginia Ham	.95
Roast Loin of Pork	.75
Roast Maryland Turkey	1.00
Roast Spring Chicken	.85

BOILED MEATS

Beef with Horseradish	.75
Pork Tenderloin	.75
Corned Beef and Cabbage	.75
Spare Ribs and Sauerkraut	.65
Chicken with Cream Sauce	.75

BROILED MEATS (Steaks, Chops, etc.)

Filet Mignon	1.35 & up
Sirloin Steak	1.35
Club Steak	1.35
Porterhouse	1.75 & up
Steak Sandwich	1.00
Pork Chops	.85
Lamb Chops	.85
Veal Chops	.85
Half Chicken	1.00
Liver and Bacon	.75

SPAGHETTI

Spaghetti with Sauce	.55
Spaghetti with Meatballs	.75
Spaghetti with Chicken	1.00
Spaghetti with Sausages	.85

SEA FOOD

Scallops (Fried)	1.00
Shrimp (Fried)	.85
Halibut (Broiled)	.95
Flounder (Broiled)	.65
Blue Fish (Broiled)	.85
Salmon Steak (Broiled)	.95
Mackerel (Broiled)	.70
Lobsters (Boiled or Broiled)	1.25 & up

SALADS

Tuna, Potato or Cole Slaw, and Tomato	.85
Whole Shrimp, with Egg, Cole Slaw, Tomato	1.00
Shrimp Salad with Cole Slaw or Potato, Tomato	.80
Salmon Salad with Cole Slaw or Potato, Tomato	.65
Hard Boiled Eggs, Potato, Cole Slaw, Tomato	.55
Assorted Cold Cuts, Potato, Cole Slaw, Tomato	.65
Chopped Egg Salad, Potato, Cole Slaw, Tomato	.65
Lettuce, Tomato and Cucumber	.50
Sardine, Cucumber, Tomato, Radishes	.50

DESSERTS

Pies	.15
Puddings (with cream 5c extra)	.20
Pie A la mode	.25
Baked Apple (with cream 5c extra)	.20
Fruit Salad	.25

BEVERAGES

Coffee	.10
Tea	.10
Postum	.10
Milk	.10 & .20
Hot Chocolate	.15
All Sodas	.15

May we suggest
to-day

spaghtti &
meat balls

with che

.75

Cocktail s

special's
Port

sherry
or
muscatell

.20

Special
cocktail

Martini

Old Fashioned

Manhattan

40 ¢

May We Suggest

to- day

Roast sirloin oB
beef

potatoes & vegetab

This is a part of the menu of the Patchogue Shore's Country Club. These prices on the 1946 menu sure look good to us today, but in 1946 the average person's salary was certainly much lower too!

94

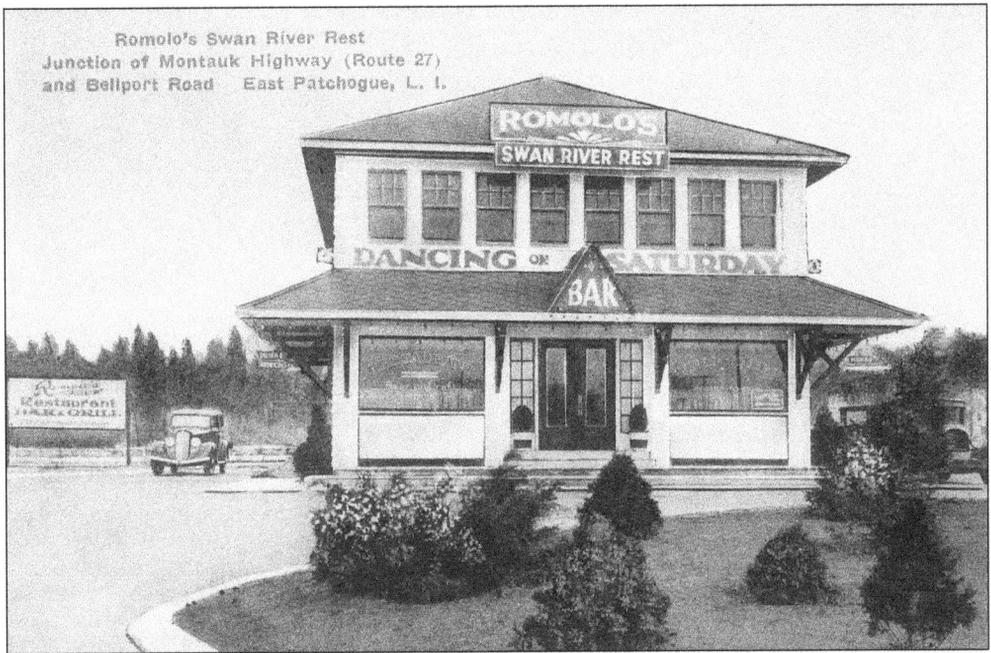

Romolo's Swan River Rest in East Patchogue is pictured here in the 1930s. The occupant of this building today is Swan Cleaners.

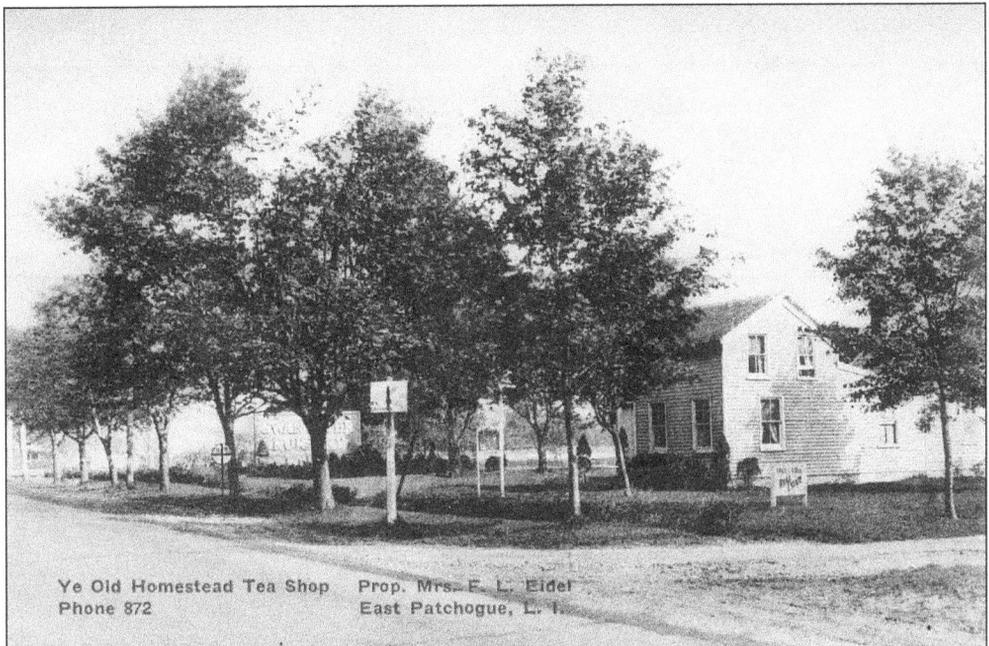

The quaint little "Ye Olde Homestead Tea Shop" on South Country Road stood just east of the Swan River Nurseries in the 1930s and '40s.

The Palm Pines Restaurant address was 347 Grove Avenue in Patchogue. It was the former home of Dr. Charles F. Walter in 1926. By 1946 the building was gone.

An advertising postcard of the Palm Pines Restaurant is seen here. The question seems to indicate an owner of German ancestry.

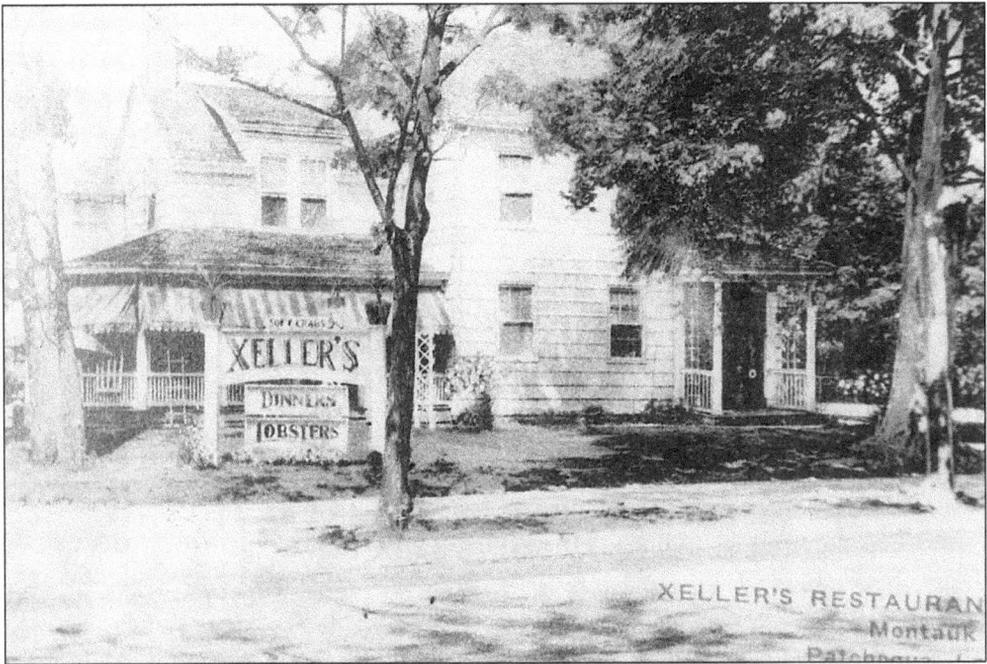

Xeller's Restaurant on East Main Street was located on the northwest corner of Rose Avenue. William Xeller also was the manager of the Elks Club in 1926. By 1939 Xeller's Restaurant had moved to a location opposite Medford Avenue on Main Street.

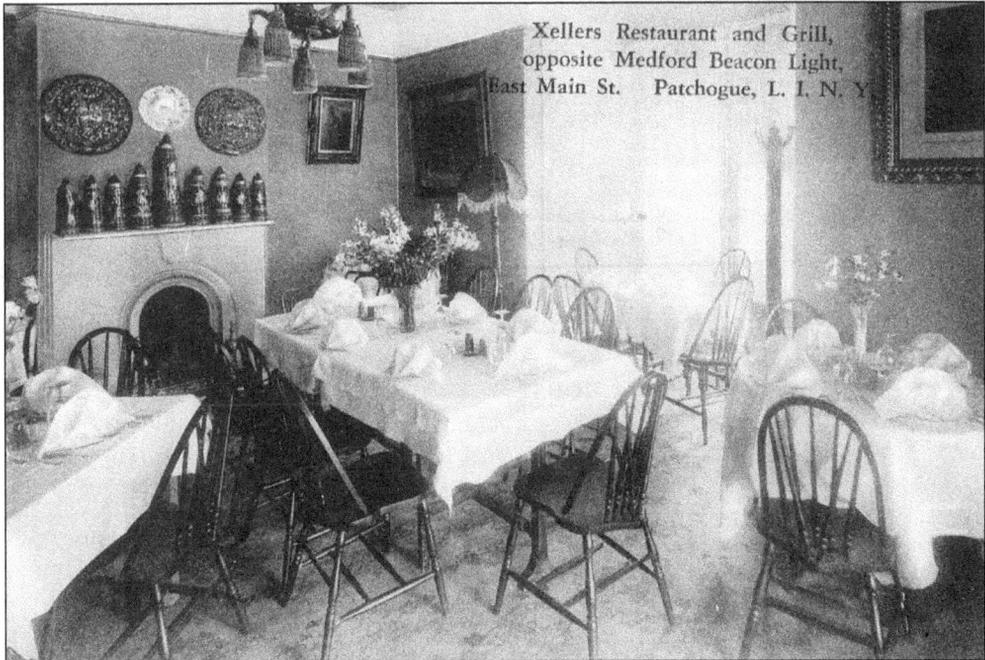

This is the cozy little dining room of Xeller's Restaurant.

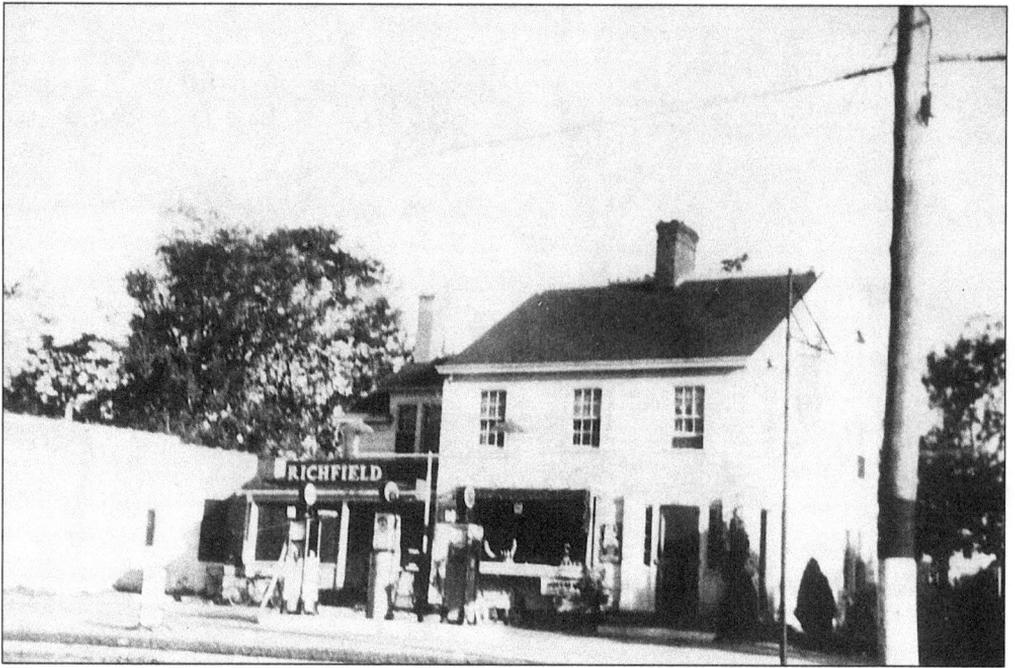

This is the former Xeller Restaurant building in 1939, now Hayman's Service Station.

VIEW OF SWAN RIVER FARM HOUSE

SWAN RIVER FARM HOUSE

is located in one of the prettiest towns on Long Island.

Noted for its domesticity and home-like atmosphere.

Always cool, best of home cooking. A most delightful house.

CATERING TO TOURISTS

STEAK, CHICKEN AND DUCK DINNERS

Eight Course Sunday Dinner, $1.00

The Swan River Farm House, on Swezey Street and the corner of Chapel Avenue, catered to tourists in the 1920s and 1930s. It was the Van Slingerland Home at the turn of the century.

1918

PARADA

UNDER DIRECTION OF CAPT. CHAS. W. EDDY

PALACE THEATRE

WEDNESDAY THURSDAY FRIDAY

MARCH 13 14 15

UNDER THE AUSPICES OF

COMPANY H, 6th BATTALION
INFANTRY N. Y. GUARDS

PATCHOGUE ADVANCE PRESS

This is a 1918 souvenir program of the Star Palace Theater. Many famous personalities performed at the palace. A 1920 newspaper article announced that on May 27 and 28 Charlie Chaplin, newlyweds Mary Pickford and Douglas Fairbanks, Alice Brady, and many other famous performers would parade on stage in the costumes of the characters they made famous.

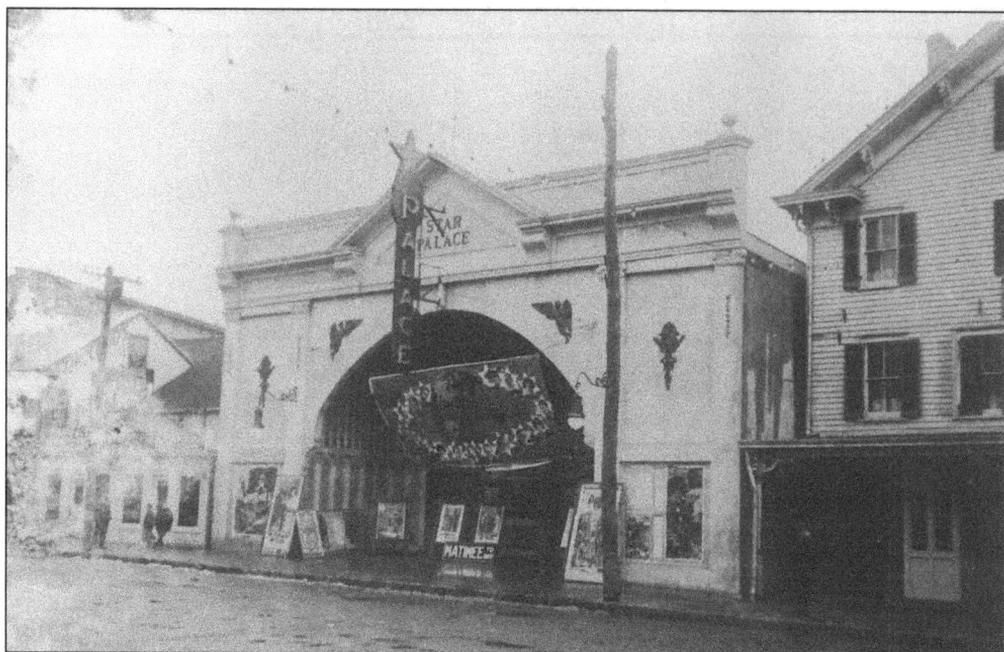

The Star Palace on West Main Street was just 100 feet from the 4 Corners. The building on the right is the Central Hotel.

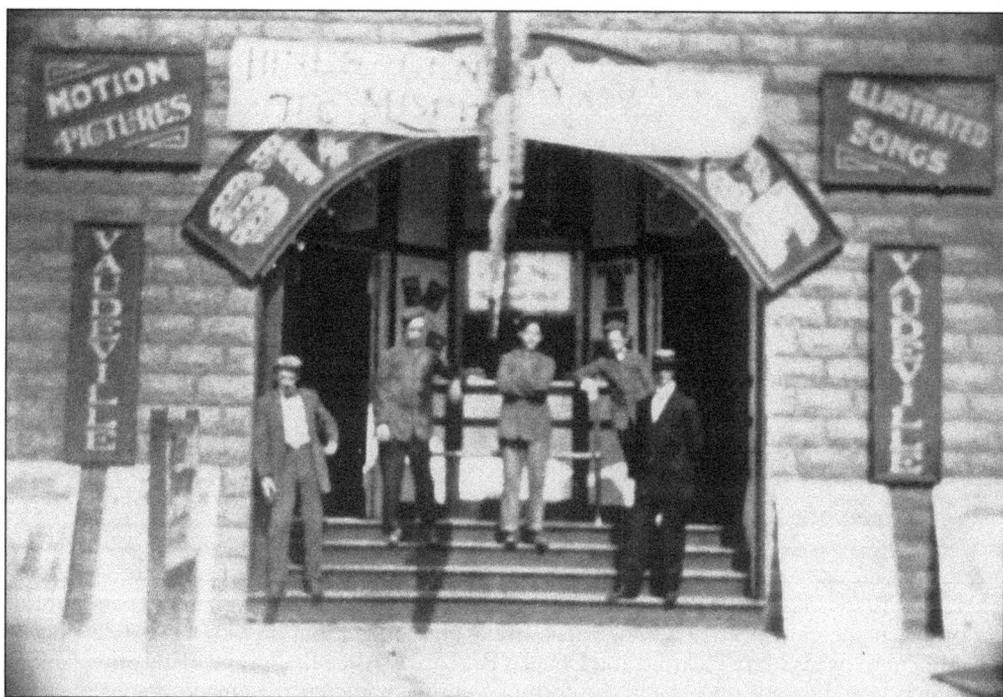

A group of employees were photographed here in front of the Star Palace.

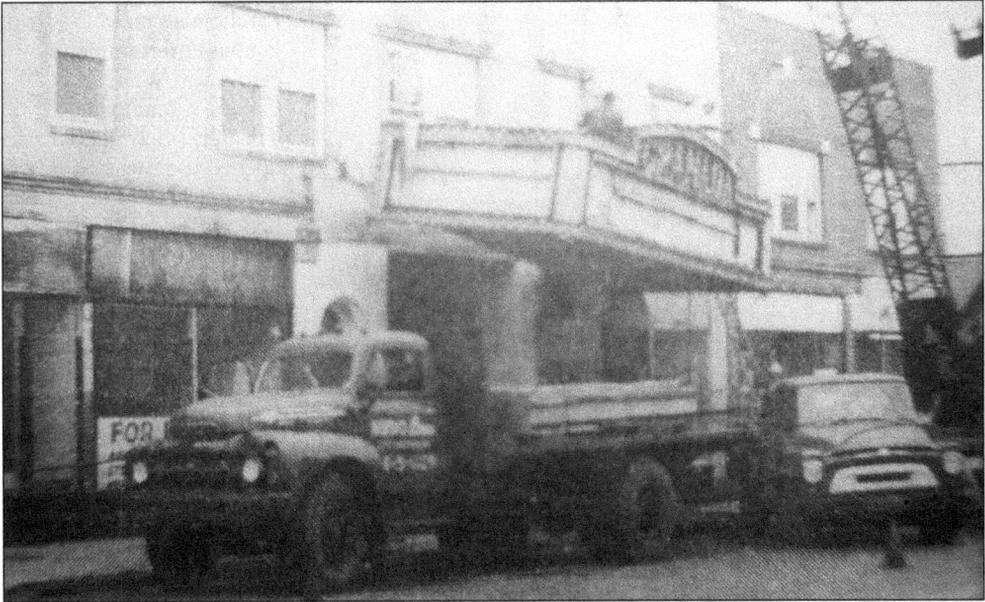

The Granada Theater on West Main Street, halfway between Railroad and West Avenues, was built in 1928 by Samuel Savener. It was a very popular movie house. The Granada closed in 1947. In 1967 the marquee was dismantled and the building became the "Two Guy's" department store.

This is a playbill of the Granada Theater from the 1930s.

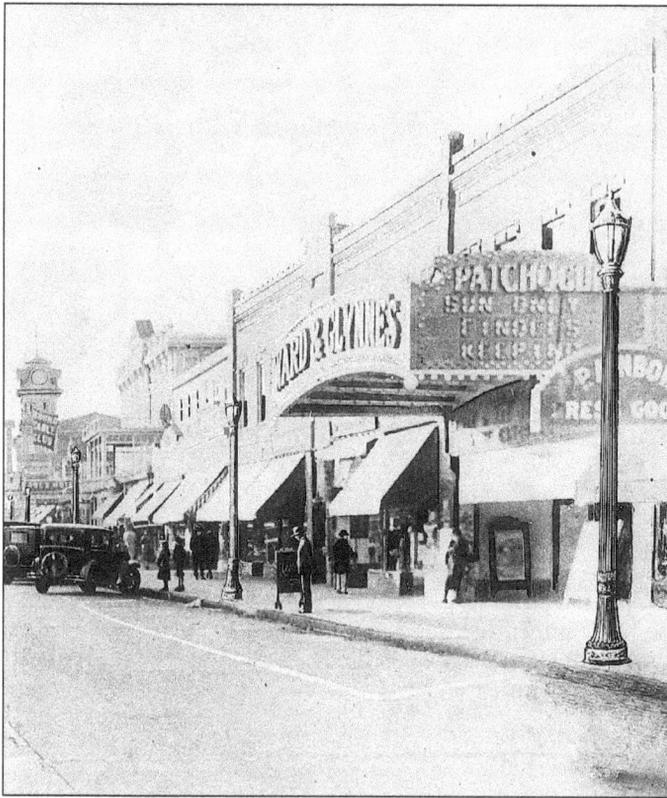

Patchogue's most famous entertainment center was Ward and Glynne's Patchogue Theater. Michael Glynne opened the theater on May 23, 1923. The theater had seating for 1,330 people. The interior was richly decorated and it was one of the most beautiful theaters on Long Island.

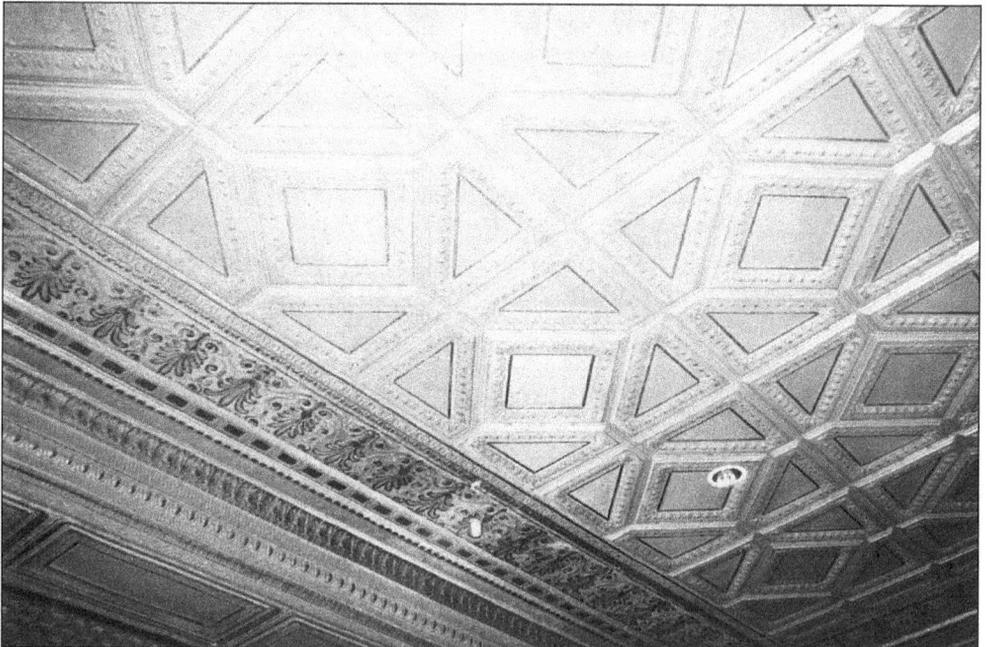

Unfortunately, there seems to be no picture available today of the interior of the original Ward & Glynne's Patchogue Theater. The renovation in progress at the present time will restore the past glory of the theater. This is a view of a section of the ceiling.

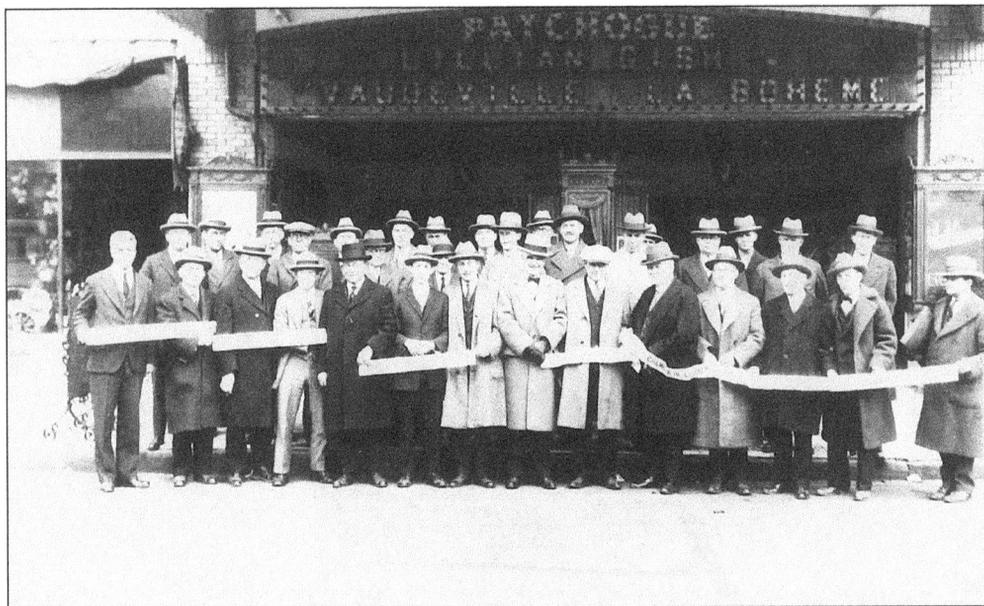

Pictured here is opening day of the Ward and Glynne's Theater on May 23, 1923. The three gentlemen in light coats in the front are, from left to right, John Tuthill Jr., Edgar Sharp, and John Swezey. Behind John Tuthill stands Dave Weissberger and Herb Austin.

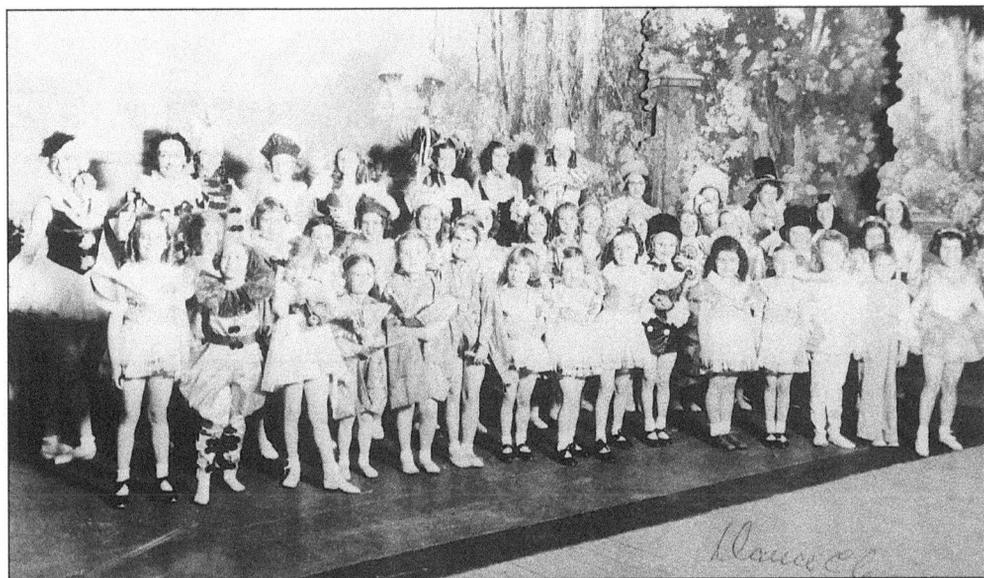

In addition to famous performers, local talent also performed on the stages of Patchogue theater. These are some of the little students of Barbara Maxwell's dance class of 1938. Listed from left to right are as follows: (front row) fourth from left is June Rogers; (middle row) fifth from left is June Vanderborgh, Nance Edwards, Joyce Strong, unknown, Lois Jedlicka, Betty Rhodes, unknown, unknown, Margaret Norton, unknown, unknown, and Anita Palmer; (back row) Joyce Westerbeke, Barbara Maxwell, unknown, Audrey Gordon, Jeane Wells, unknown, Marie Deneuse, and Marjorie O'Grady.

This is the opening announcement of the Patchogue theater on May 23, 1923, as it appeared in the *Patchogue Advance*.

WARD AND GLYNNE'S

PATCHOGUE THEATRE WEEKLY

ISSUED FREE TO PATRONS

WARD AND GLYNNE'S

Vol. 3 PATCHOGUE, L. I., SEPTEMBER 13, 1926 No. 4

"THE GREAT GALEOTO" IN PRODUCTION

Ramon Novarro and Alice Terry Leads

Some of the most elaborate Spanish settings ever seen on a studio lot have been put up at Culver City as a background for the production of "The Great Galeoto," which went into production last Wednesday under John Stahl's direction, with Ramon Novarro and Alice Terry in the leading roles. The distinguished supporting cast includes Edward Martindale, George K. Arthur and Edward Connelly.

CAST COMPLETED

The complete cast of "The Understanding Heart," an adaptation of Peter B. Kyne's new novel now under production for Metro-Goldwyn-Mayer, with Jack Conway directing, includes Joan Crawford, Ralph Bushman, Rockcliffe Fellowes, Richard Carle, Harvey Clark, Carmel Myers and Jerry Miley.

Joan Crawford

AGNES C. JOHNSTON'S "THE NEWLY POORS"

ALICE TERRY

This most regal of screen stars is here seen wearing the magnificent bridal gown from "The Magician," Rex Ingram's (her husband) latest production. This exquisite creation was especially made for Miss Terry by the most expert lace workers in southern France, where Mr. Ingram has his studios. It is entirely plain, except for a single ornament in front, but the long train is of the most elaborate hand made lace.

Christine Johnston, widely known

HUGHES TO PLAY OPPOSITE MAE MURRAY IN "VALENCIA"

Lloyd Hughes has been chosen to play opposite Mae Murray in a picturization of the song hit, "Valencia," which will be her next starring vehicle and the first film to be directed under his new contract by Dimitri Buchowetski. Hughes will play the role of a young sailor who falls in love with a Spanish dancer (Miss Murray). Roy D'Arc has the role of the heavy.

Lloyd Hughes

"SPRING FEVER," BROADWAY SUCCESS

"Spring Fever," the dramatic hit by Vincent Lawrence, which A. H. Woods produced in the Maxine Elliott Theatre last year, will be turned into a motion picture. No director or player has been selected. James Rennie and Marion Coakley

The *Patchogue Theater Weekly* issue from September 13, 1926, is pictured above. Many famous stars and personalities made their appearance on this stage. Some of those stars included Rudolph Valentino, Sophie Tucker, Pat Rooney, Paul Whiteman, Gloria Swanson, and Pola Negri. Many of these actors stayed at the Heinroth House on Terry Street while in Patchogue. The leader of the orchestra was Ben Nelson.

WARD & GLYNNE'S PATCHOGUE THEATRE

Evening Program

Sousa and His Band

Lieut. Com. John Philip Sousa, Conductor
Harry Askin, Manager

MISS MARJORIE MOODY	Soprano
MR. JOHN DOLAN	Cornet
MR. J. W. BELL	Piccolo
MISS WINIFRED BAMBRICK	Harp

1. Overture, "My Old Stable Jacket" - - - - - Bilton

2. Cornet solo, "La Favorita" - - - - - Hartman
 ### MR. JOHN DOLAN

3. Suite, "Looking Upwards" - - - - Sousa
 - (a) "By the Light of the Polar Star"
 - (b) "Under the Southern Cross"
 - (c) "Mars and Venus"

4. Vocal solo, "Polonaise-Mignon" - - - - - Thomas
 ### MISS MARJORIE MOODY

5. Symphonic poem, "Don Juan" - - - - - Strauss

—INTERVAL—

6. Fantasia, "Music of the Minute" (new) - - - - Sousa

7. (a) Xylophone solo, "Liebesfreud" - - - - Kreisler
 ### MR. HOWARD GOULDEN
 (b) March, "Ancient and Honorable Artillery Company - Sousa
 (new)

8. Harp solo, "Fantasia" - - - - - - - Alvares
 ### MISS WINNIE BAMBRICK

9. Mountain Dances - - - - - Transcribed by Orem

Another famous personality, Philip Sousa, performed here with his band during the time of Ward and Glynne's. In 1929 the theater was sold to the Prudential Theater chain. In the early 1930s vaudeville was discontinued.

106

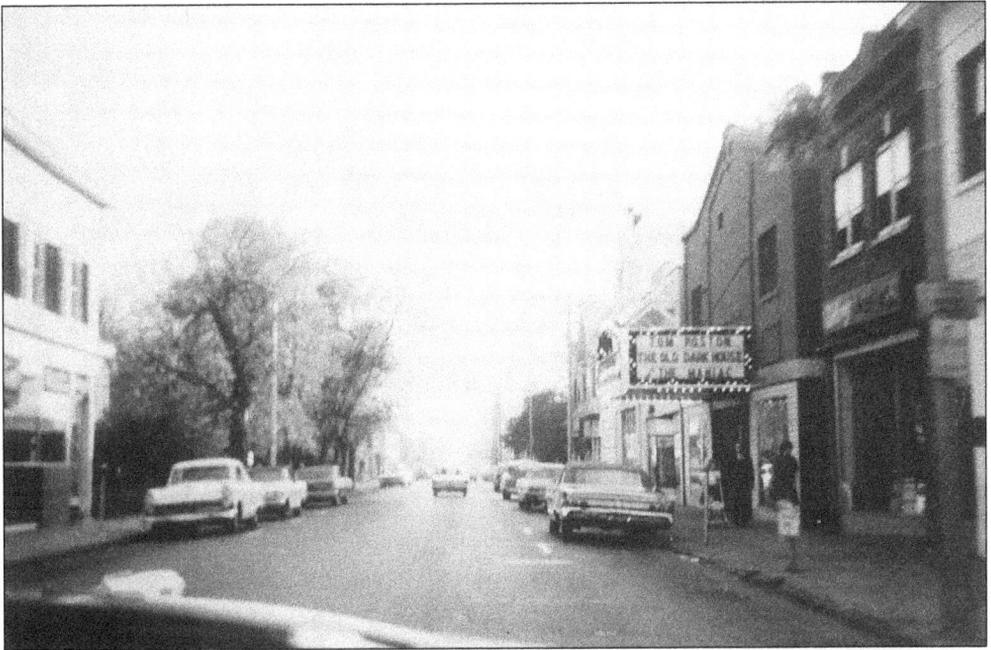
The Rialto Theater, shown here in 1963, was another popular theater among moviegoers.

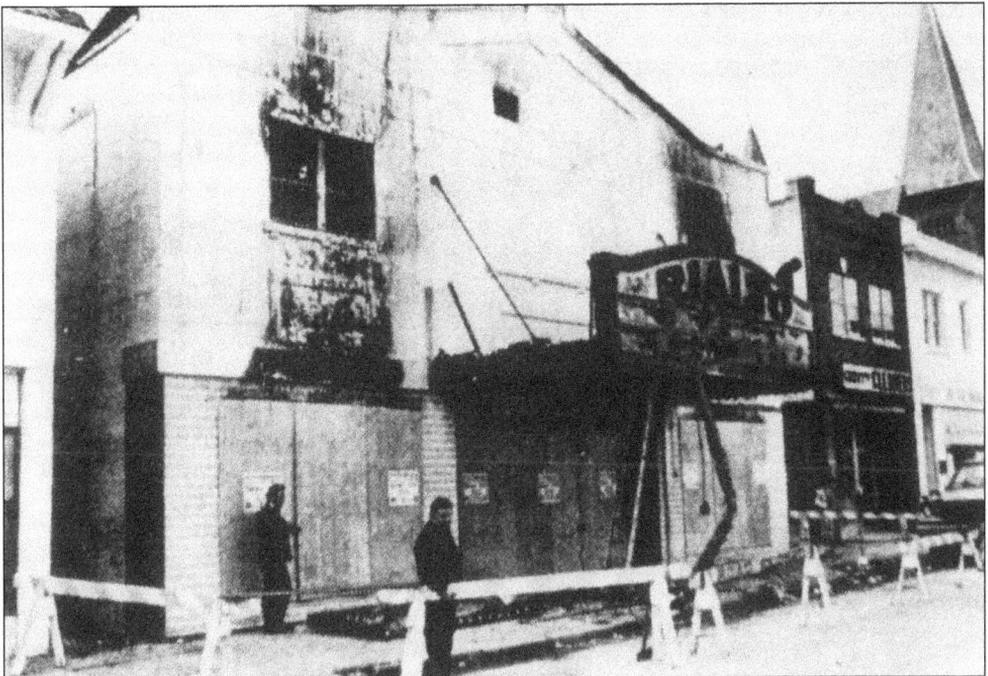
On February 16, 1978, men removing snow from the street spotted a fire in the Rialto. By the time firemen arrived at the scene, the building was completely engulfed in flames. They spent eight hours at the scene fighting the fire but the building was a total loss.

The Sunray Furnishing Company occupied the large brick building on the west side of West Lake, next to John Belzak's Bar and Grille. The following pictures were all taken in the 1930s and 1940s.

On the south side of Main Street, opposite John's Belzak's Bar and Grille, a used furniture store operated in the long building that later became Flaxman's Furniture store.

Joe and Frank's Market conducted their business from a small roadside building on West Main Street, next to today's car wash. For many years prior, John Sosinski Sr. sold candy, groceries, and tobacco products from this little store.

The corner of Waverly Avenue and Main Street is pictured here c. 1940. The large building on the right had just recently burned and Felice's Gas Station would be built here in the future. Mount Carmel church is across the street and the rectory is barely visible to the right of it.

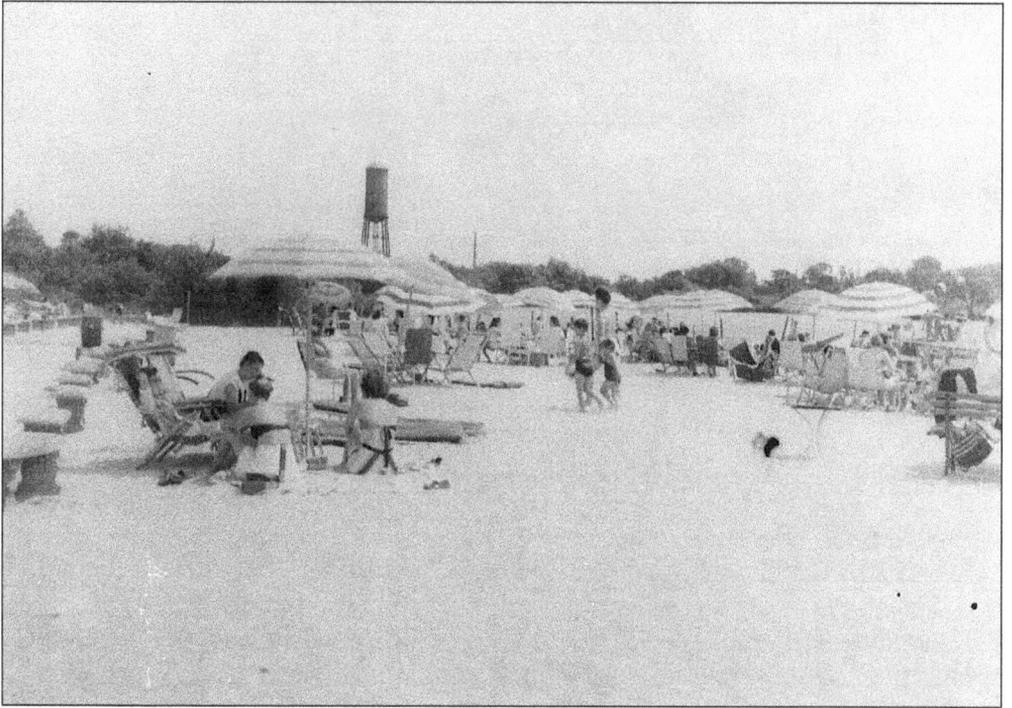

Many people do not remember this nice beach. It is the Mount Carmel beach on the upper east side of the West Lake. It was established by Father Cyrus Tortora, the well-known and loved pastor of Our Lady of Mount Carmel in the 1940s.

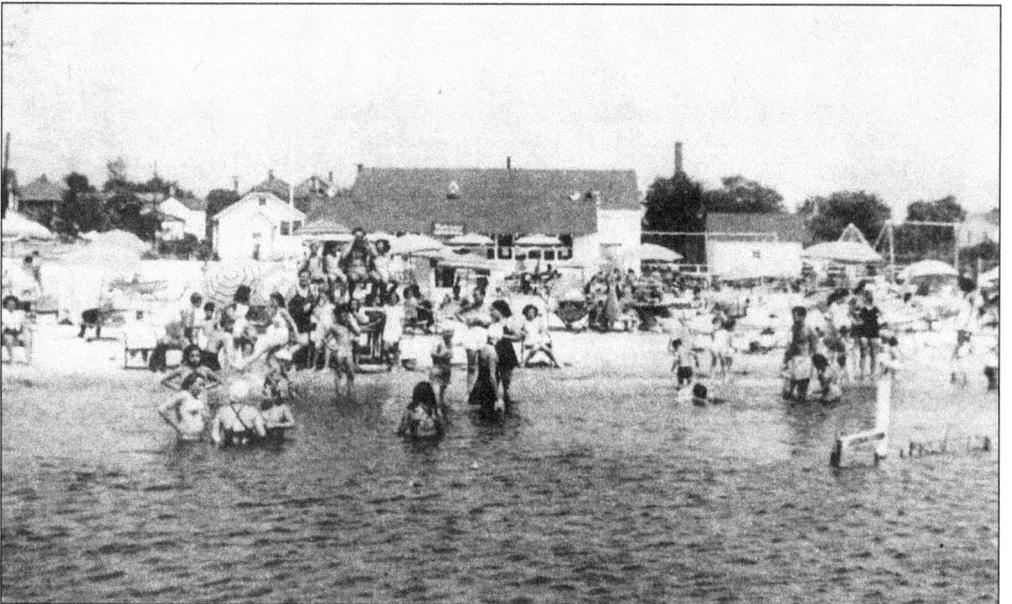

It certainly was a pleasant and very busy beach although it existed for only a few years in the 1940s and no trace of it remains today.

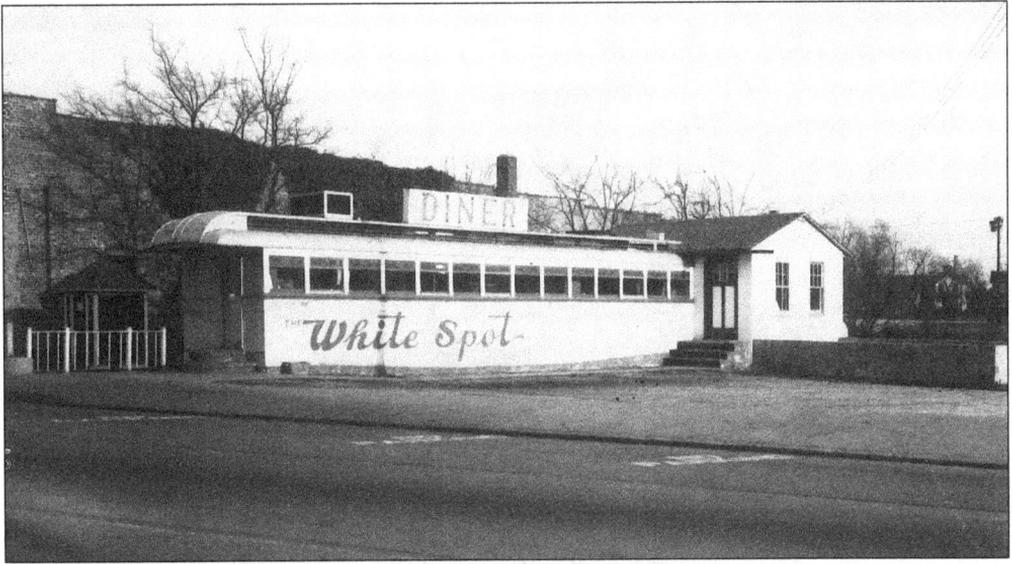

The White Spot Diner across from the Lacemill, alongside the little stream, is pictured here. Sal Vignato was the diner's owner.

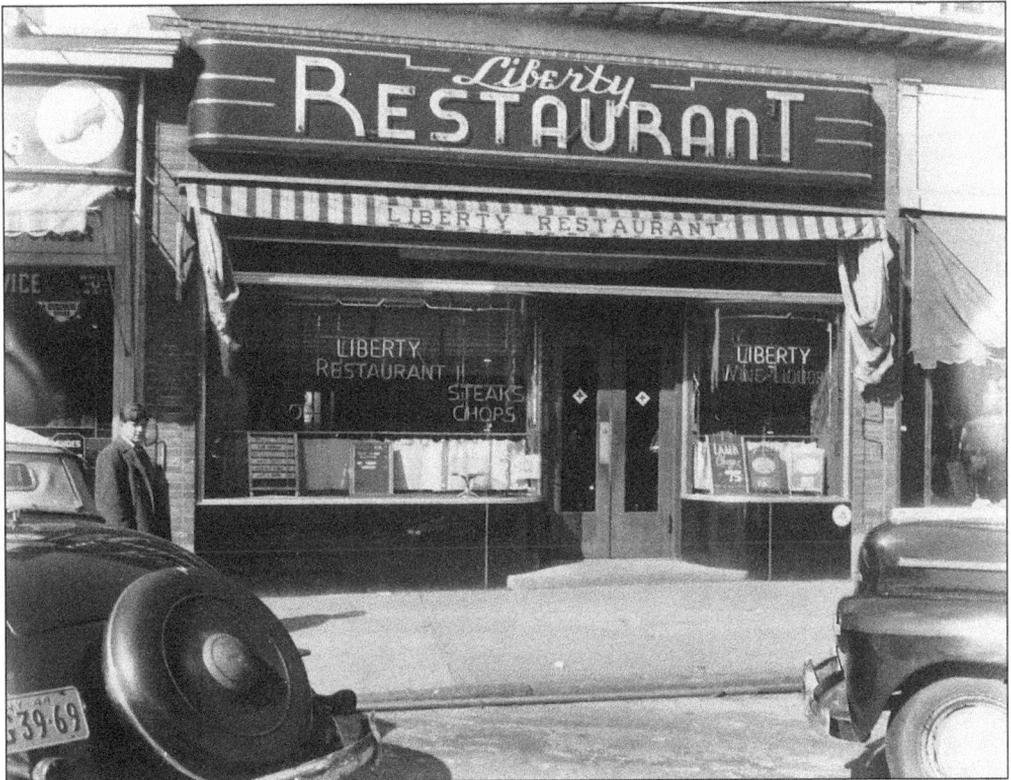

A well-known eatery in Patchogue was the Liberty Restaurant next to Swezey's. John Petropulos was the proprietor.

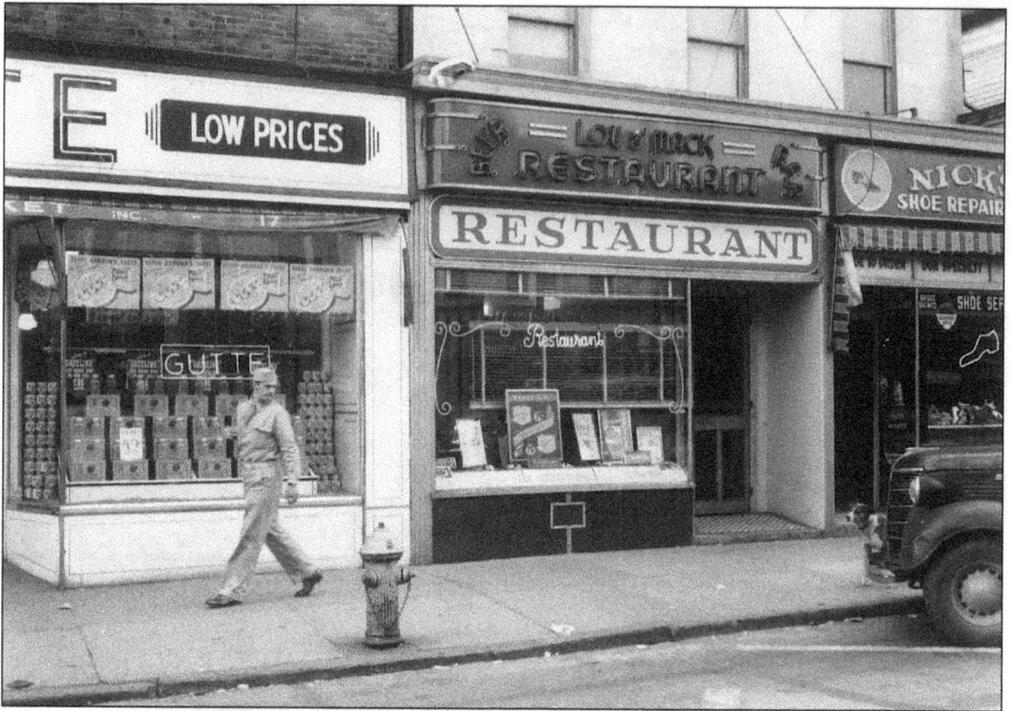

Lou & Mack's Restaurant was owned by the Dorr brothers, William and Hermann. The restaurant was to the east of Gutte's, which at that time was a grocery store. Nick's Shoe Repair was in the next building to the east and then came the Liberty. "Duke" is standing behind the car.

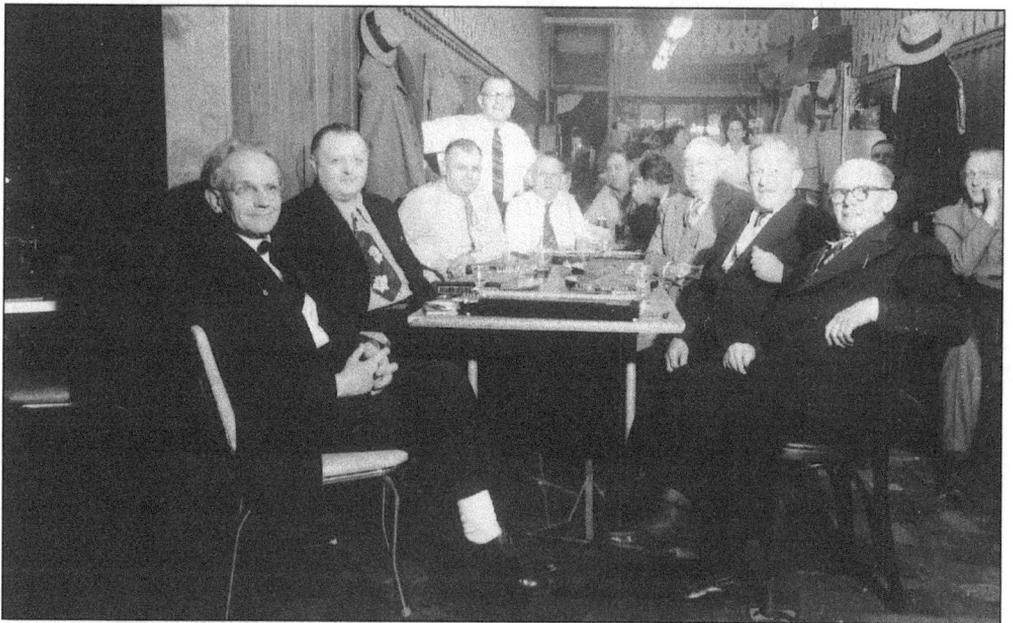

This interior view is of Lou & Mack's and its patrons. Behind the table stands Willie Dorr; the gentleman in the white shirt behind the table is Gus Moos, a well-known expert local zither player. The five zithers on the table indicate that this is the local Zither Club.

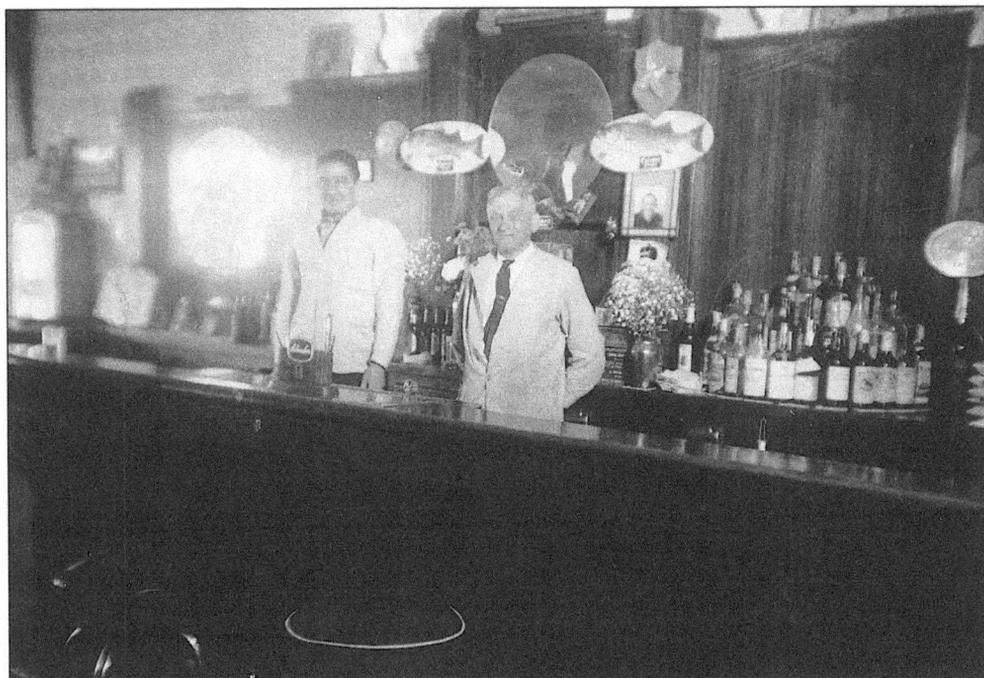

Hermann Dorr is pictured here behind the bar of Lou & Mack's Restaurant.

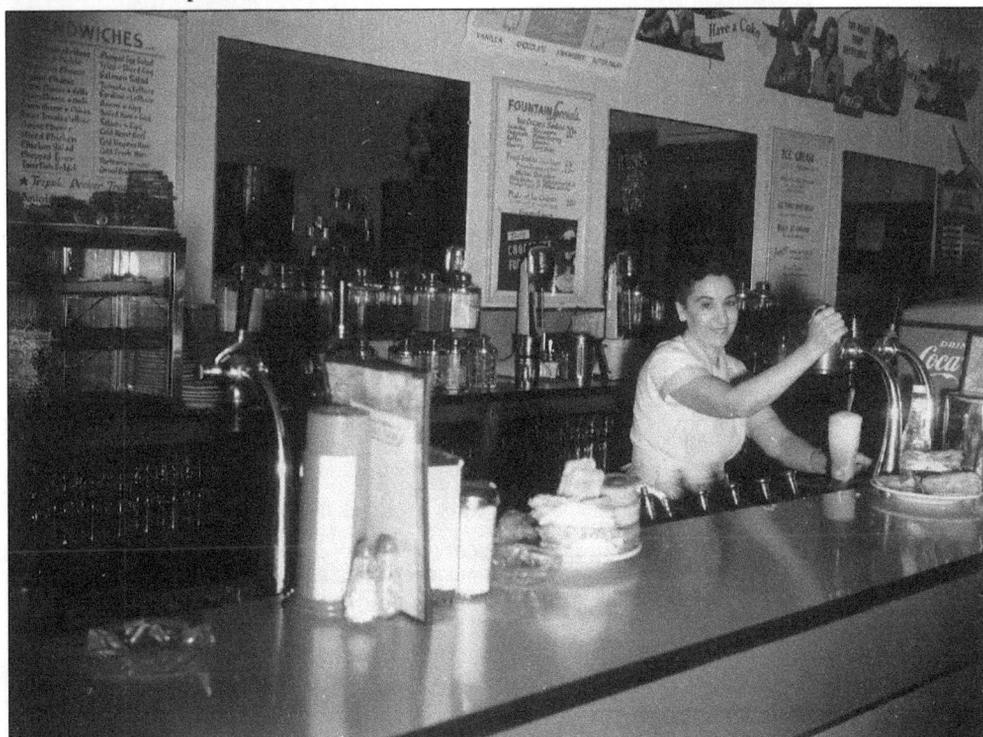

This is the counter of Jimmy Doukas's Confectionery and Luncheonette on South Ocean Avenue. Not far from either the high school or the Rialto, it was a favored place to have a soda or lunch, especially for the young crowd.

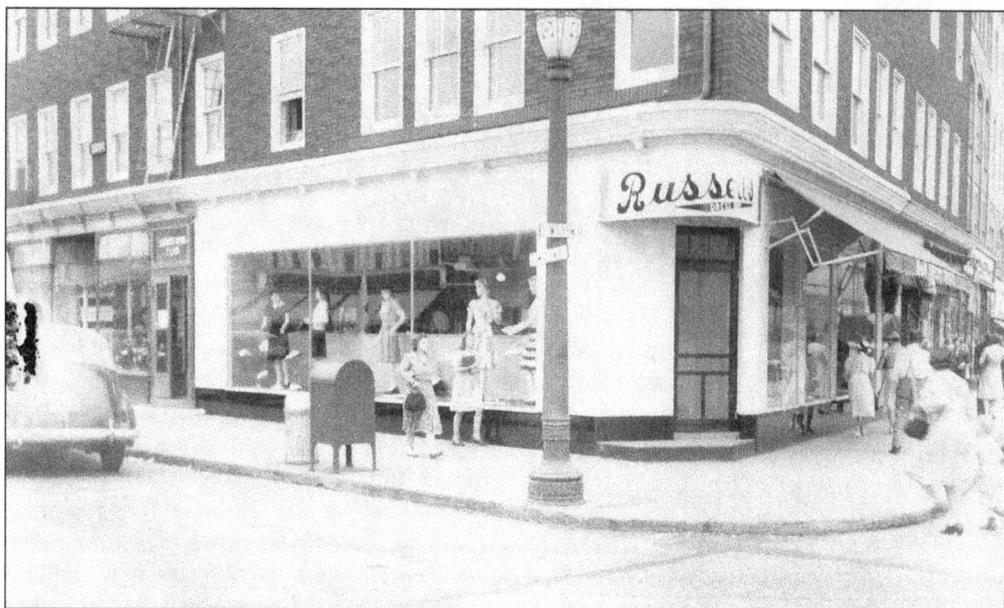

The old Mills building on the corner of Main and Ocean Avenue sports a new brick facade and housed Russell's Dress Shop in this 1947 picture.

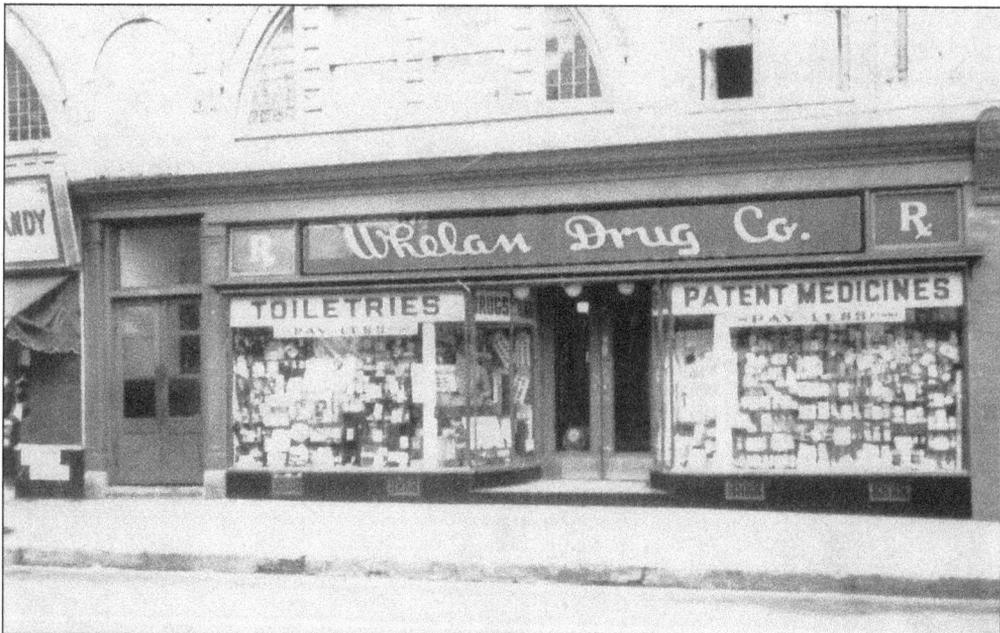

The Whelan's Drug Co. conducted their business for a few years around 1945 from the Arcade building on South Ocean Avenue, which was part of the Mills building complex. The Mills building complex, built in three separate sections, extended 93 feet on East Main Street and 190 feet on South Ocean Avenue.

114

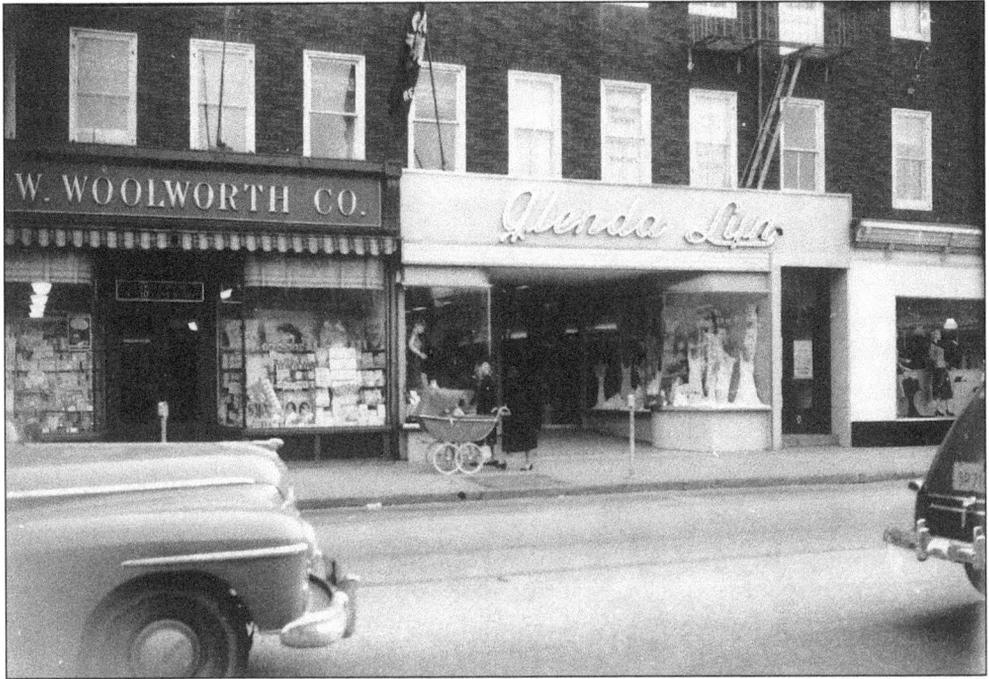

The Glenda Lyn store, specializing in ladies apparel, was located in the East Main Street section of the Mills building. In this 1940s photograph, the Woolworth store is on the east of Glenda Lyn and Russell's is to the west. Woolworth had a walk through from Main Street to Ocean Avenue, which later still existed when Max Kavner's Men's store occupied this location for many years.

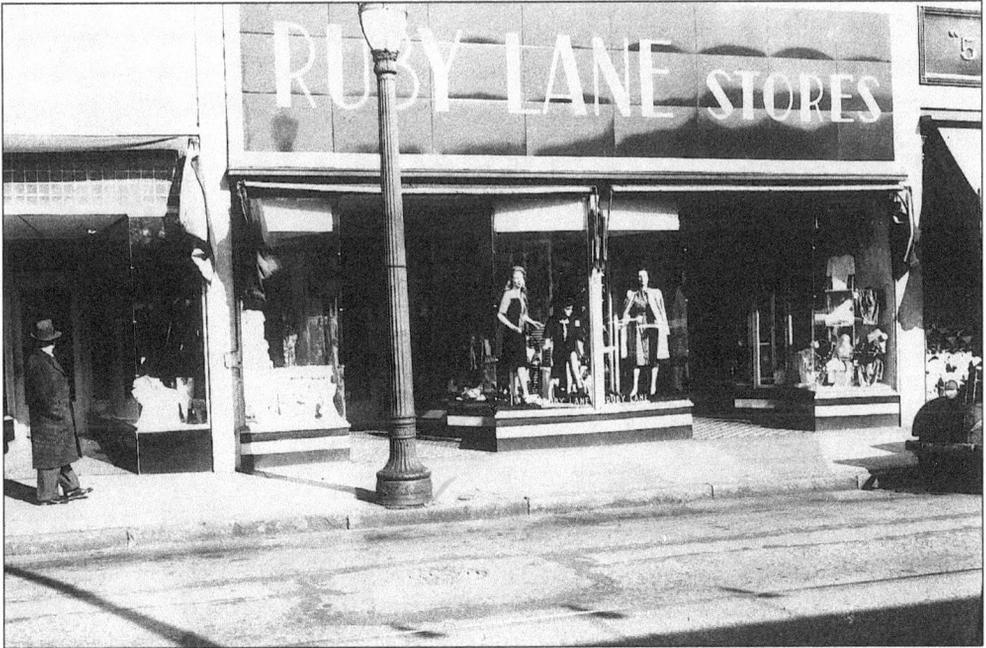

The Ruby Lane store for women on South Ocean Avenue was bordered on the south by Kresge's 5&10 store, and on the north by the Audrey Shop.

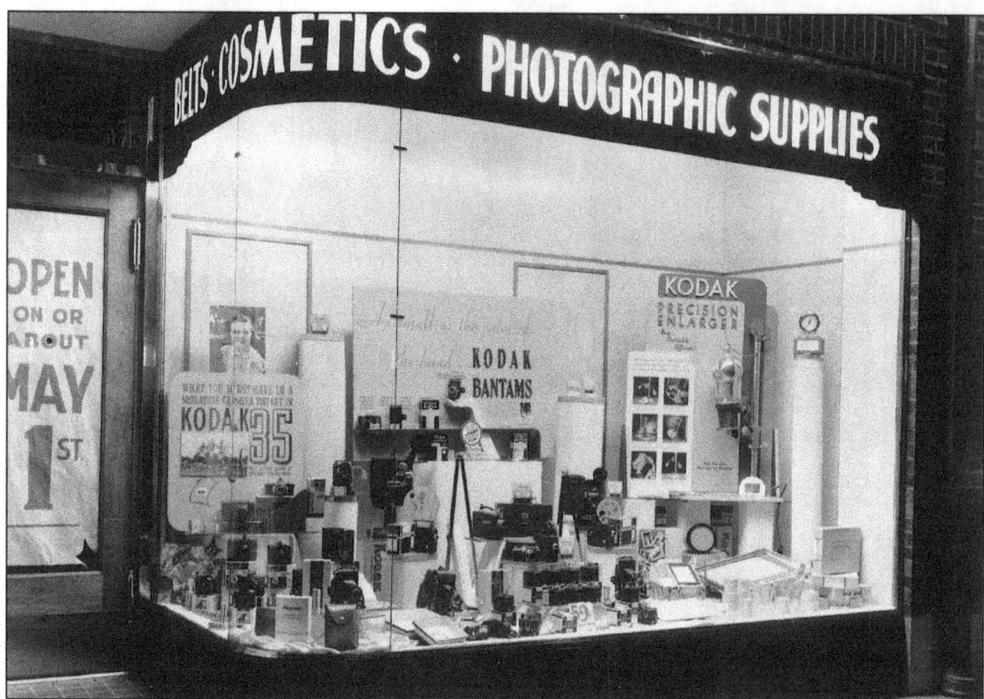

Hyman Steiner, the owner of the Economy Pharmacy on South Ocean Avenue, had been in business in Patchogue since 1931. His store was next to the Olympia. The date of this picture is approximately 1944.

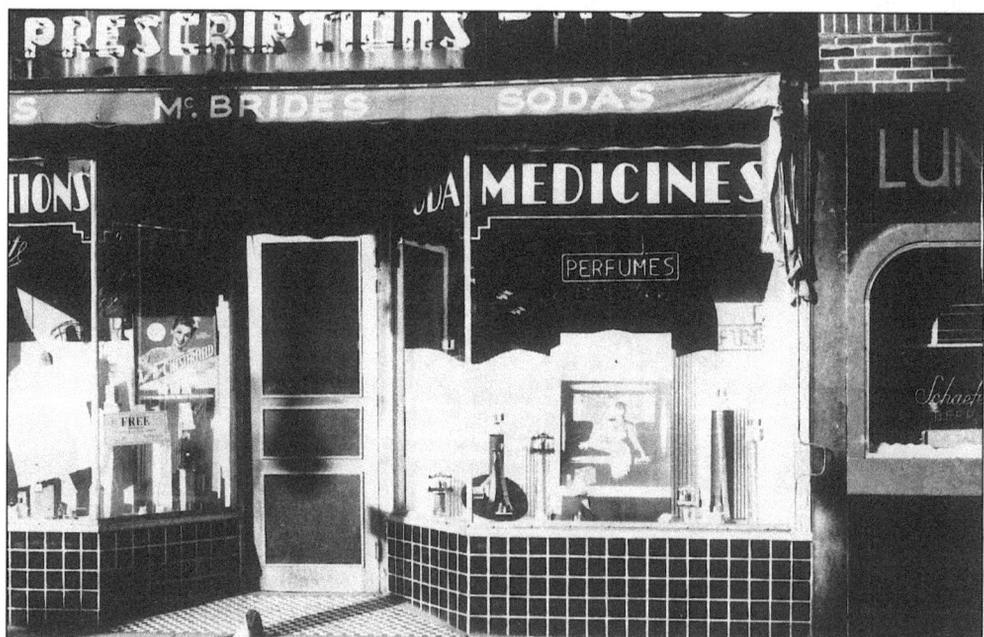

Nelson McBride's drugstore on the northeast corner of Main Street and Ocean Avenue was one of the oldest businesses in Patchogue and started well before the turn of the century. This 1945 photograph shows also a small part of the adjacent Lagumis Restaurant.

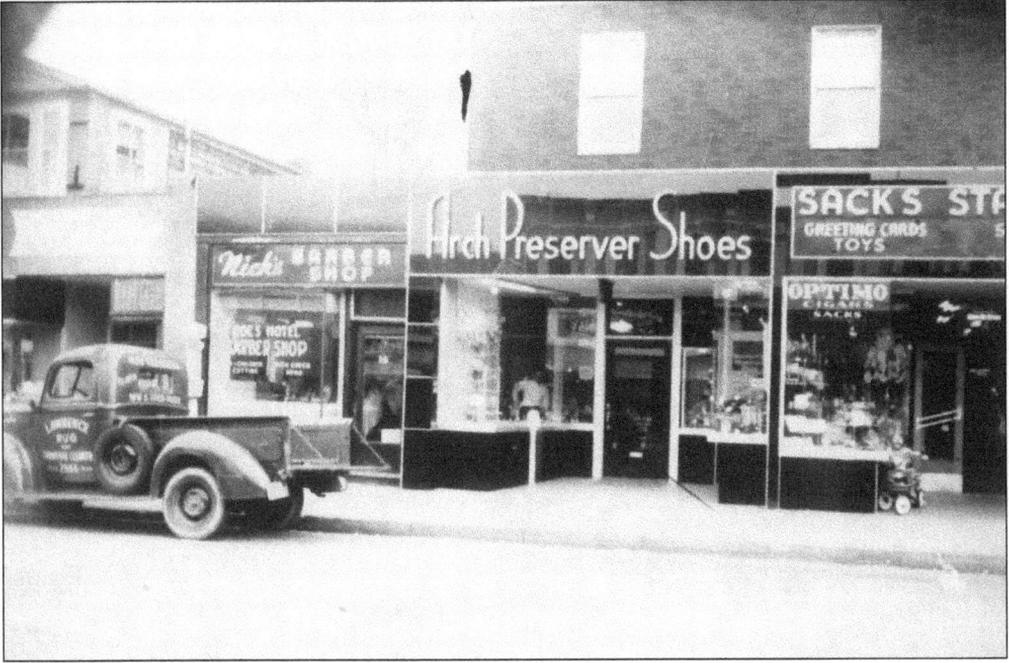

Thanks to the efforts of Adolph Morge, a Patchogue Village patrolman and amateur photographer, we have all these Patchogue views of the 1940s and 1950s preserved. A 1949 photograph shows this row of stores on the south side of East Main Street: Kaller's Jewelry store on the left, Nick's Barber Shop, Mike Weiner's Shoe store, and Sacks Stationary.

This 1950s view shows the Rex Bar and Grille and part of the Jack & Jerry store to the right on East Main Street.

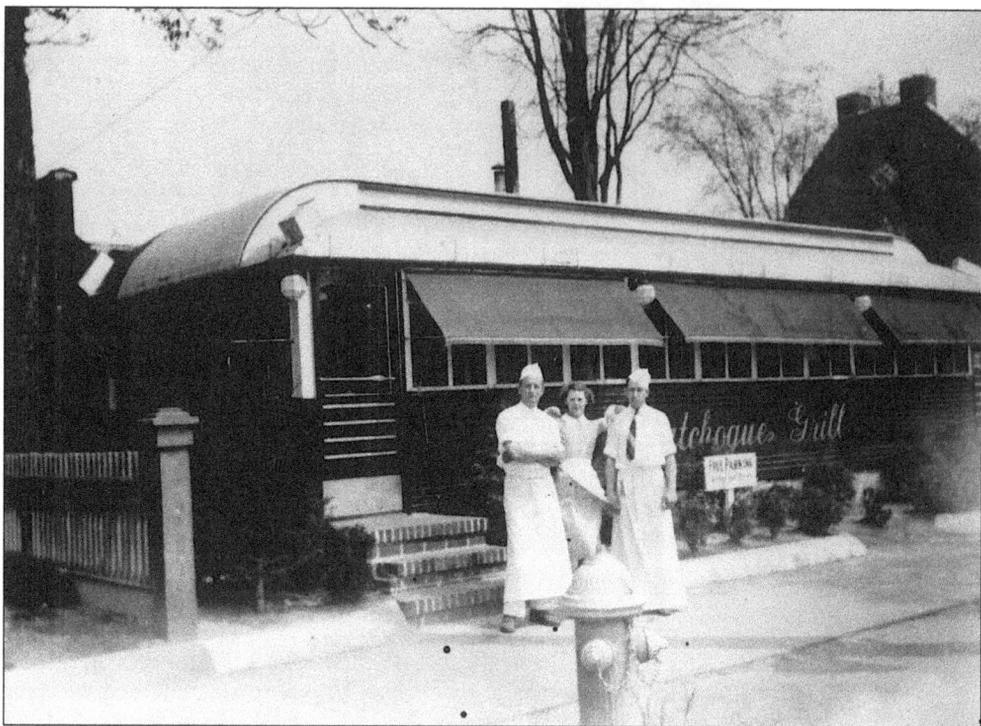

The Patchogue Grill on Main Street, just west of Maple Avenue, is pictured here. The large building in the background is the Patchogue Hotel.

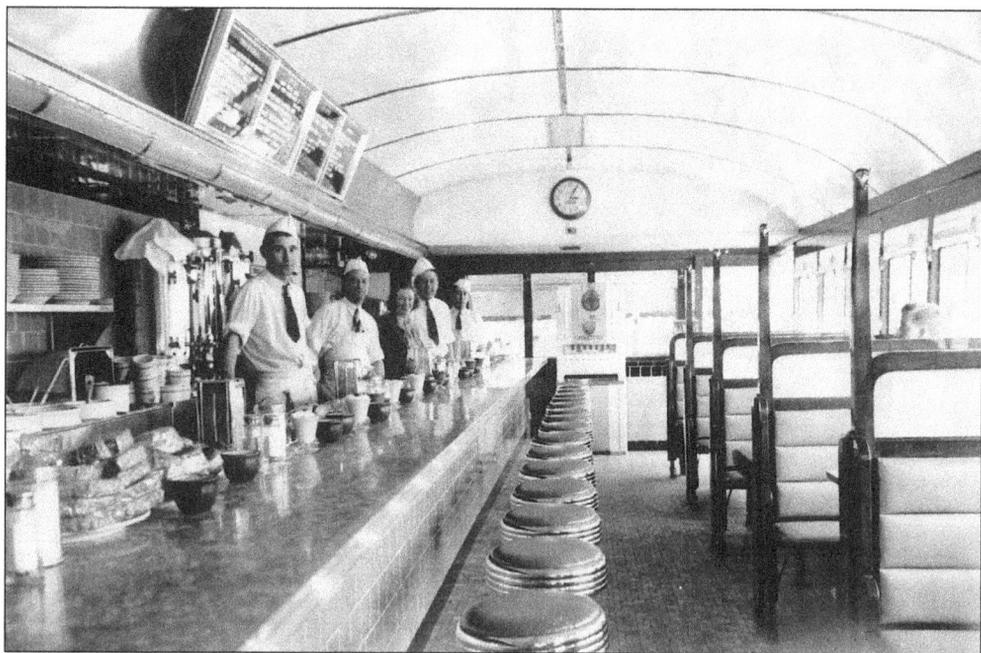

This is the interior of the Patchogue Grill.

118

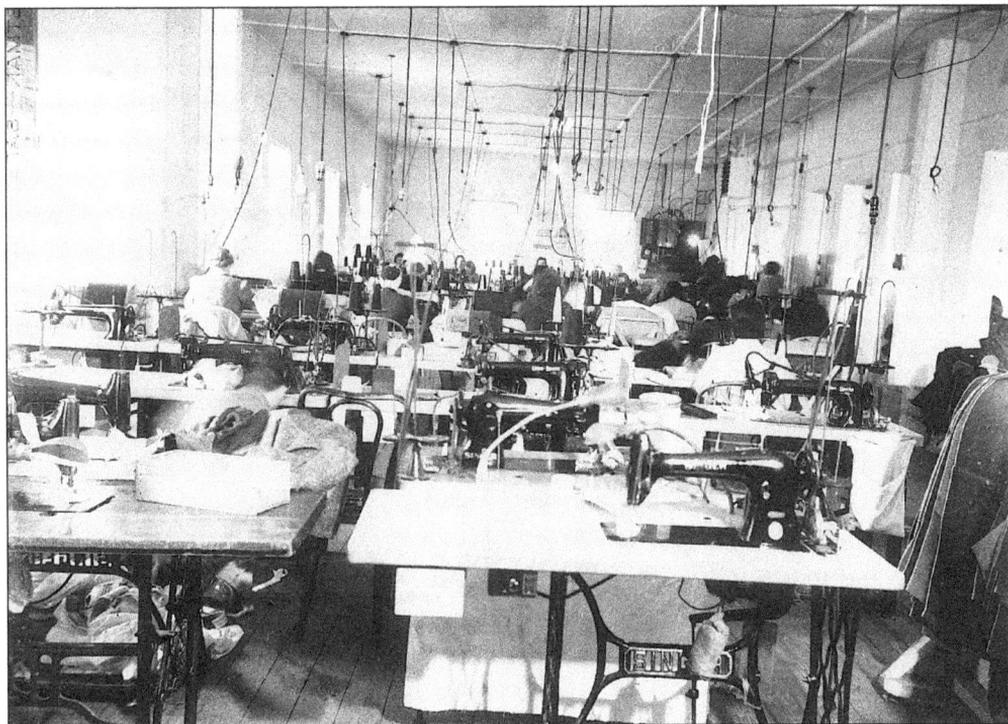

During the years of World War II, this factory on South Street produced clothing items for the armed forces. Navy overalls and white leggings were some of the items produced. The foreman was Mr. Le Pore.

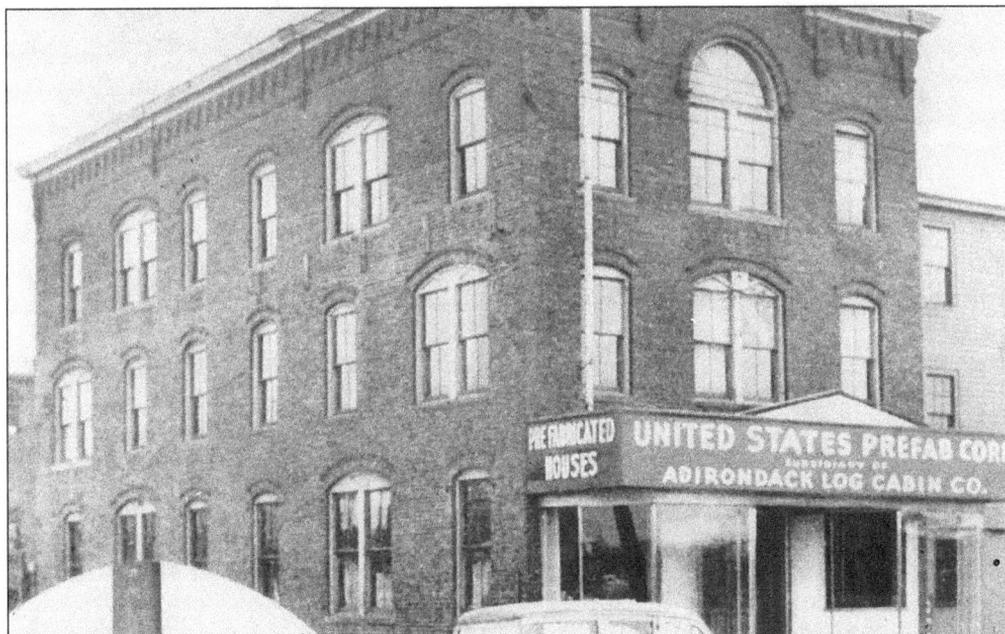

The United States Prefab Corporation manufactured pre-fabricated houses and log cabins on the site of the former Bailey's mill. This is the former Bailey's office building on the corner of Division Street and West Avenue.

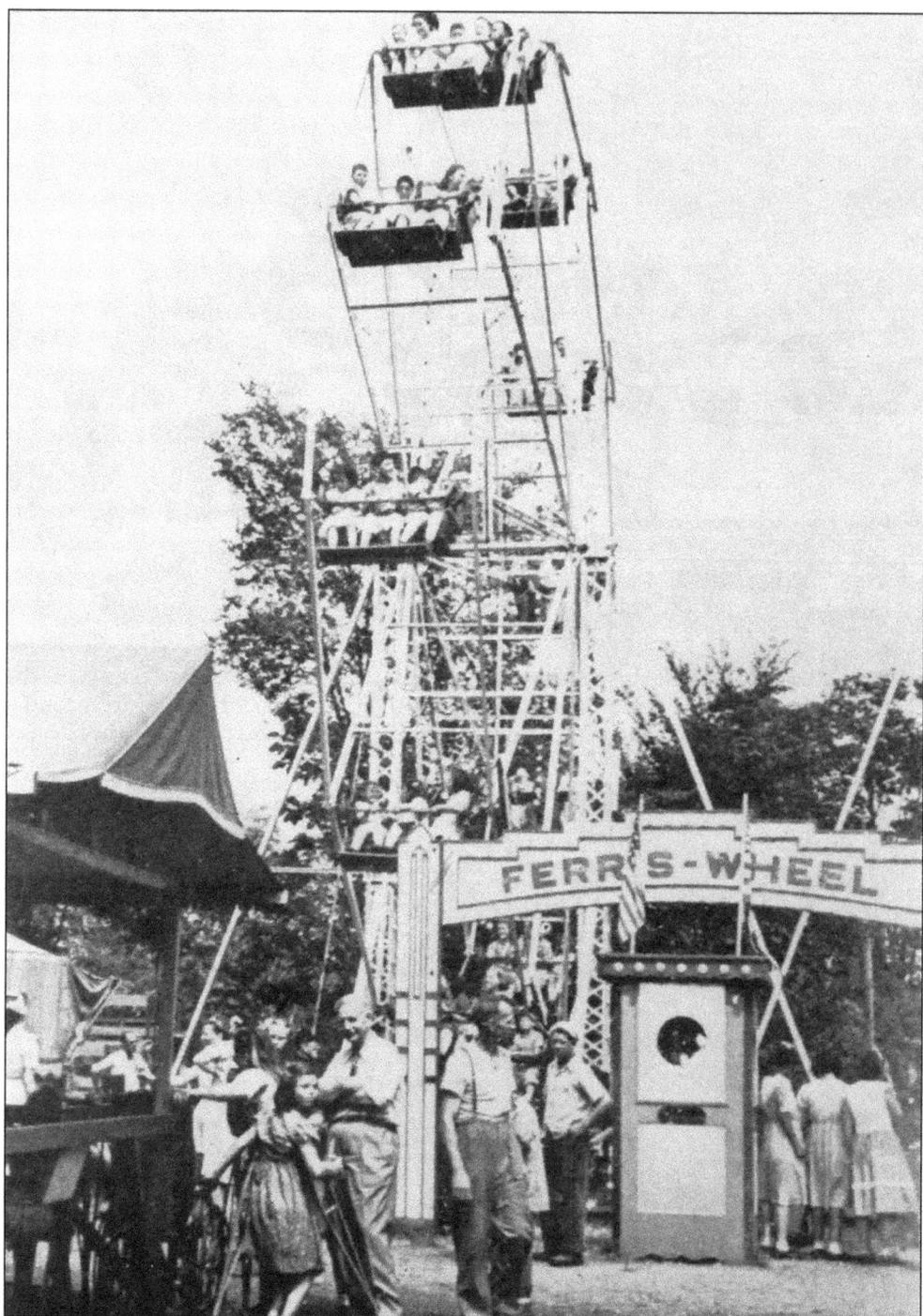

A carnival at Swan Lake is pictured here in the 1940s. Mike Prudent's carnival, based in Patchogue, traveled all over Long Island. A Ferris wheel, merry-go-round, and other rides and booths provided fun for young and old alike. Under the name Island Amusement Shows, this carnival had its beginnings in the 1890s and continued on well into the second half of the century.

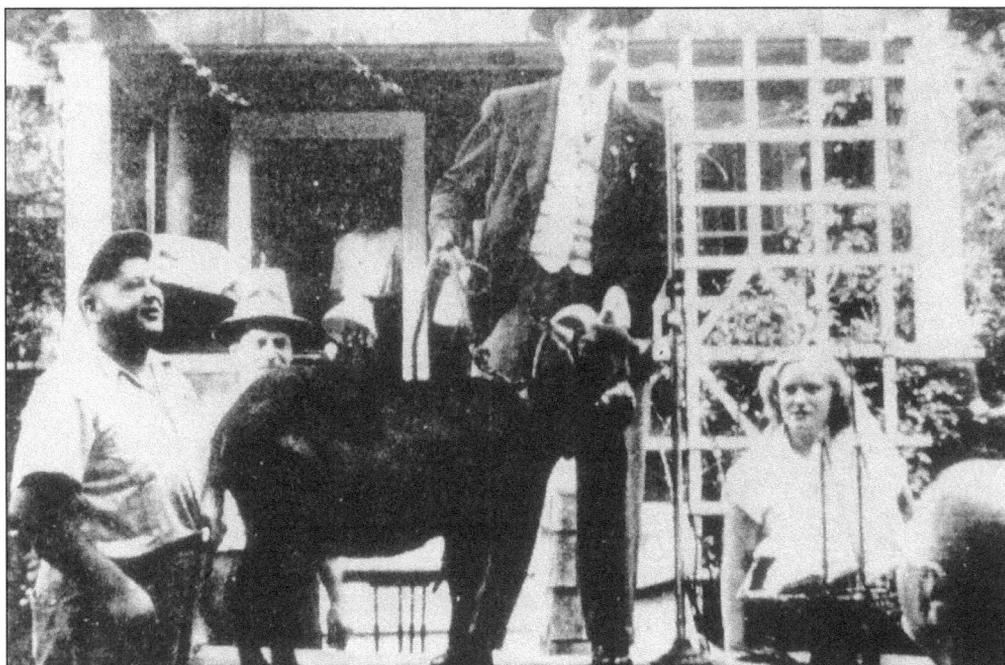

William B. "Bill" Sinn was one of the unforgettable Patchogue characters. He served for many years as a deputy county clerk, a news correspondent, and as an enthusiastic volunteer fireman. He served for two of his department years, 1936 and 1937, as chief of the Patchogue Fire Department. His favored off-duty activity was that of an auctioneer. Here he is seeking a bid on a goat.

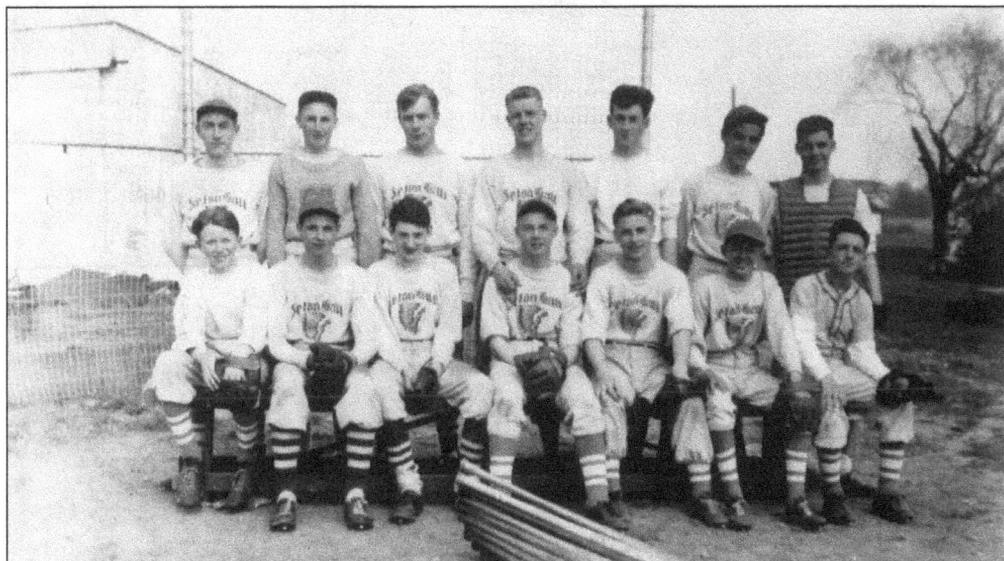

The Seton Hall baseball team of 1943 is pictured here. From left to right they are as follows: (front row) John Masem, Richard Hoffmann, John Murphy, Ken Hughes, Charles Gutman, Frank Johnston, and Jay Merkel; (back row) Marty Murphy, Al Kattan, Bob Douglas, James Broere, Ray Kenneth, Charles Benjamin, and Ed Hughes.

Patchogue always tried to be a progressive town, but here the new meaning of "drive-in" restaurant seemed to have been misunderstood. It is safe to assume that the owner of this automobile had to go hungry for a while longer. The scene is the Hofbrau Haus on the southwest corner of Main Street and Railroad Avenue.

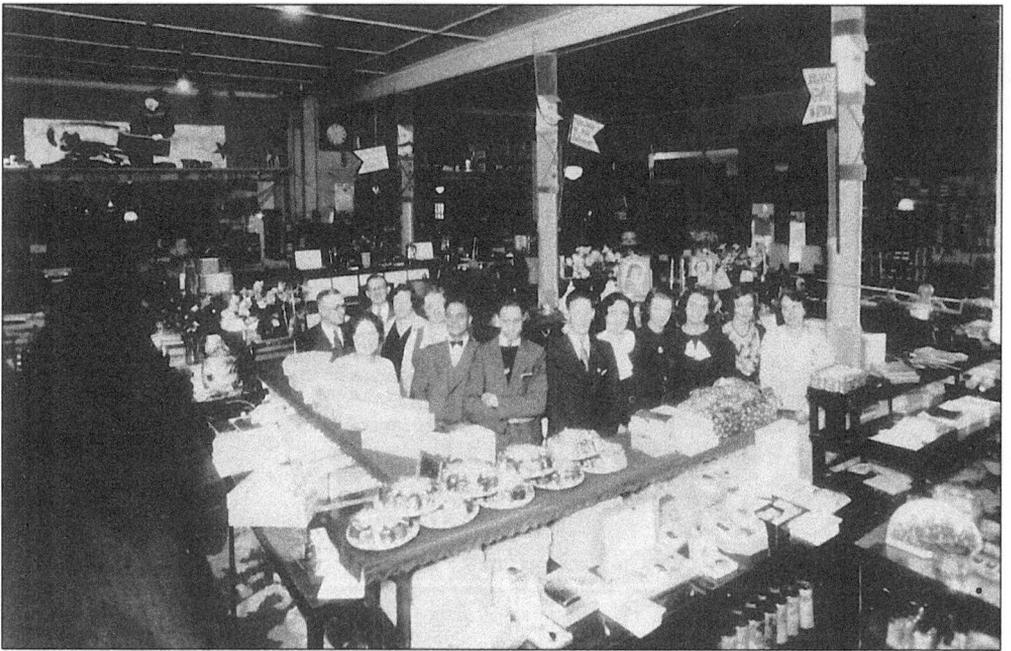

Unfortunately not many pictures of Swezey & Newin's have survived to this day. Here is a rare image of Swezey & Newin's personnel and interior in the 1930s.

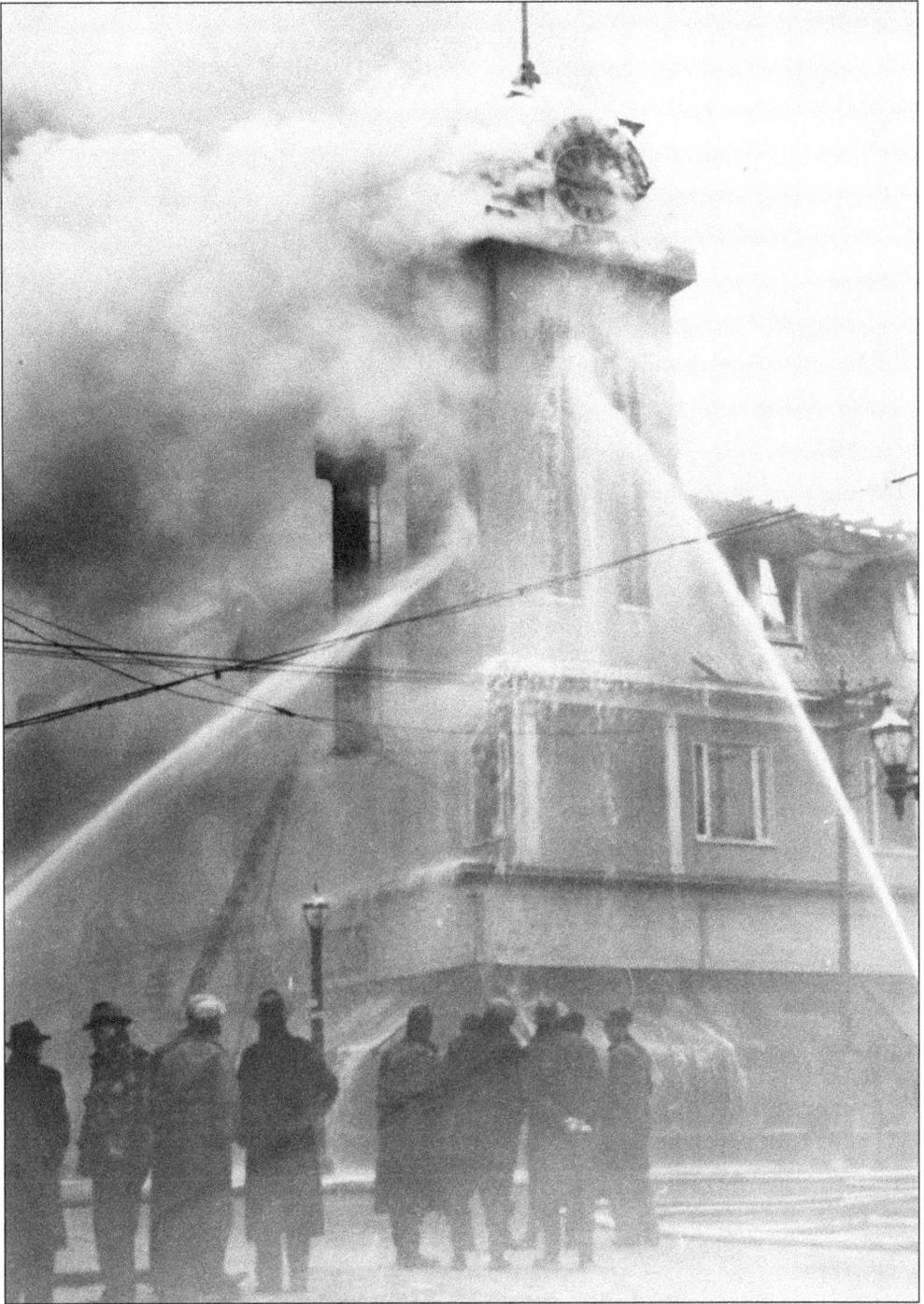

In January 1946, a short circuit in the wall of the tower stairway almost made a total loss of Swezey & Newin's department store. The fire in the tower was hard to fight because the stucco applied to the tower in a 1930s modernization kept much of the water from reaching the fire. The tower and the upper floor were a total loss. The heavy 6-ton Swedish clock, with dials on all four sides of the tower, was greatly missed by Patchogue residents.

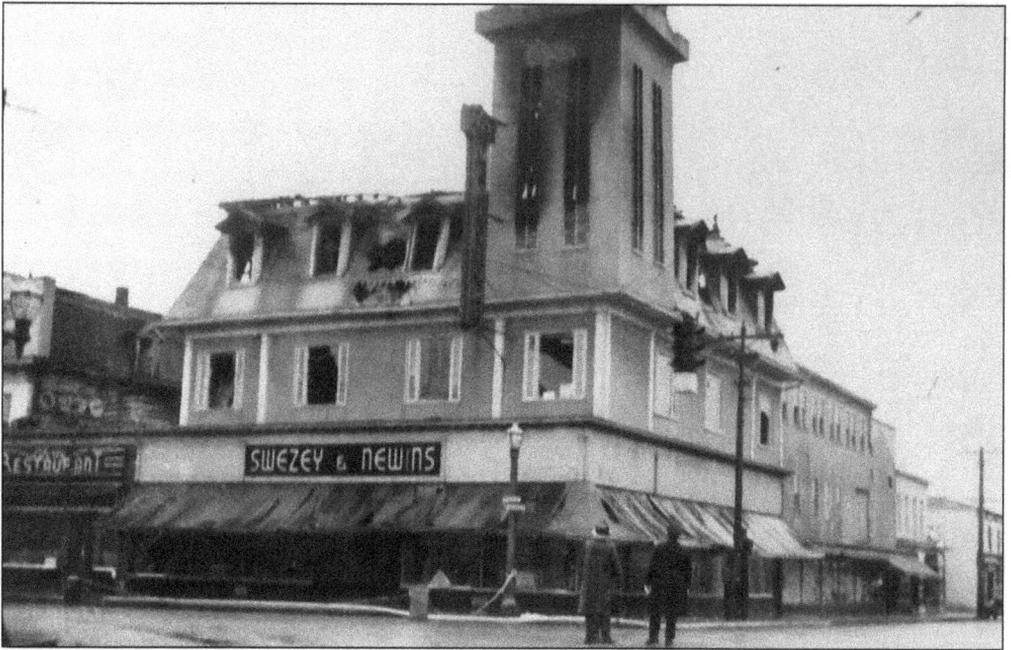

The Swezey & Newin's building is pictured here after it was ravaged by the fire.

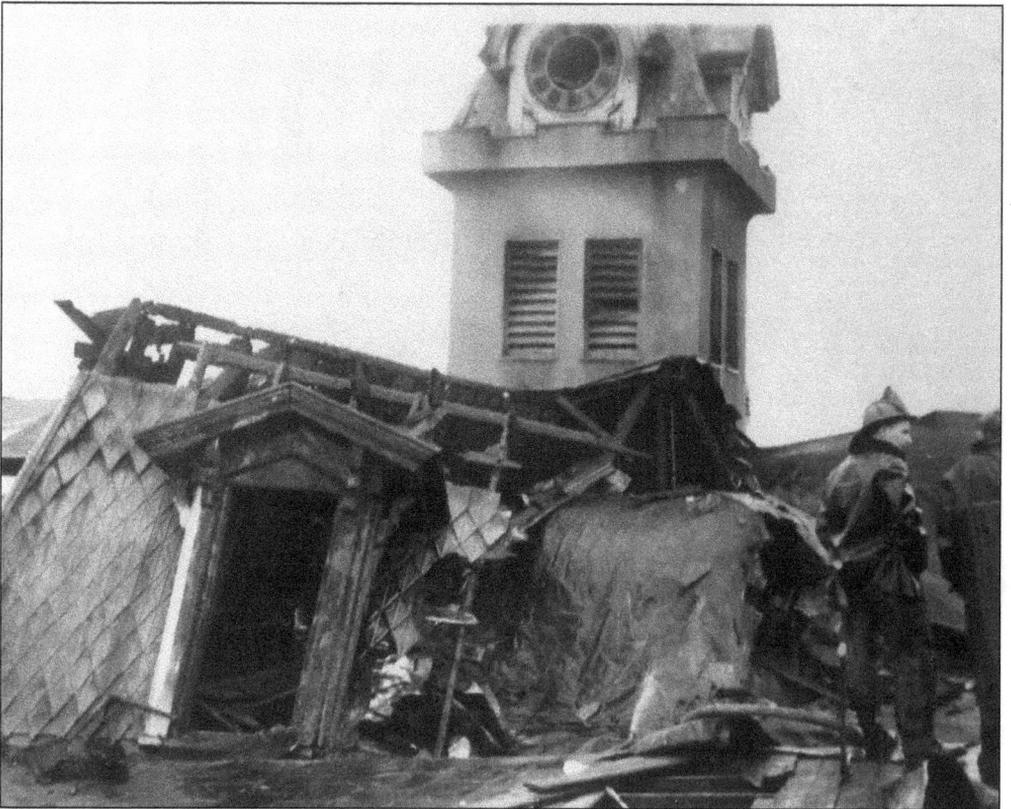

This view shows the damage to the tower and upper floor of the building.

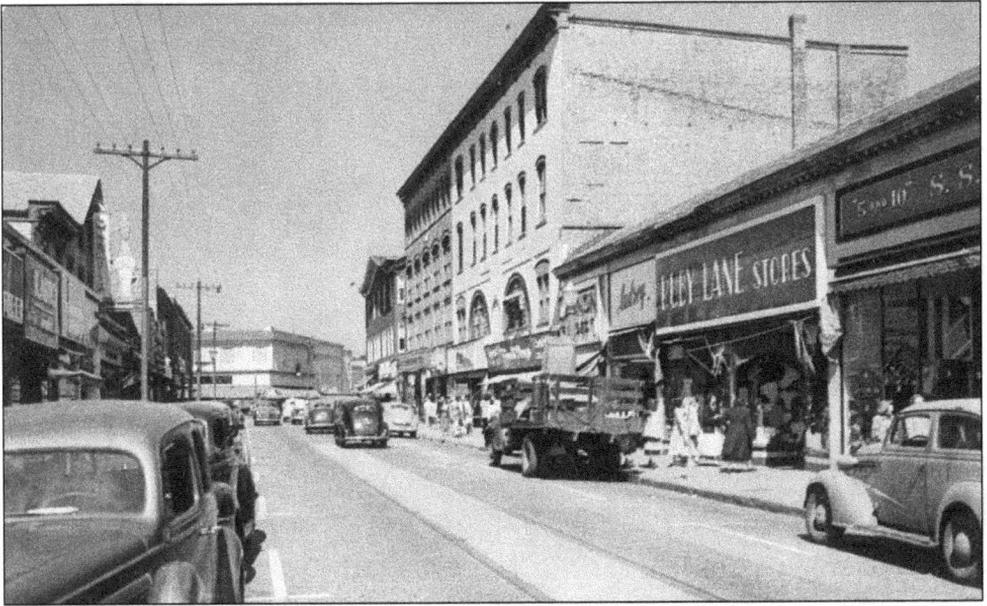

South Ocean Avenue in 1950 shows, from a good advantage point, the large three- and four-story complex of the Mills building, which became a total loss due to fire on February 10, 1956.

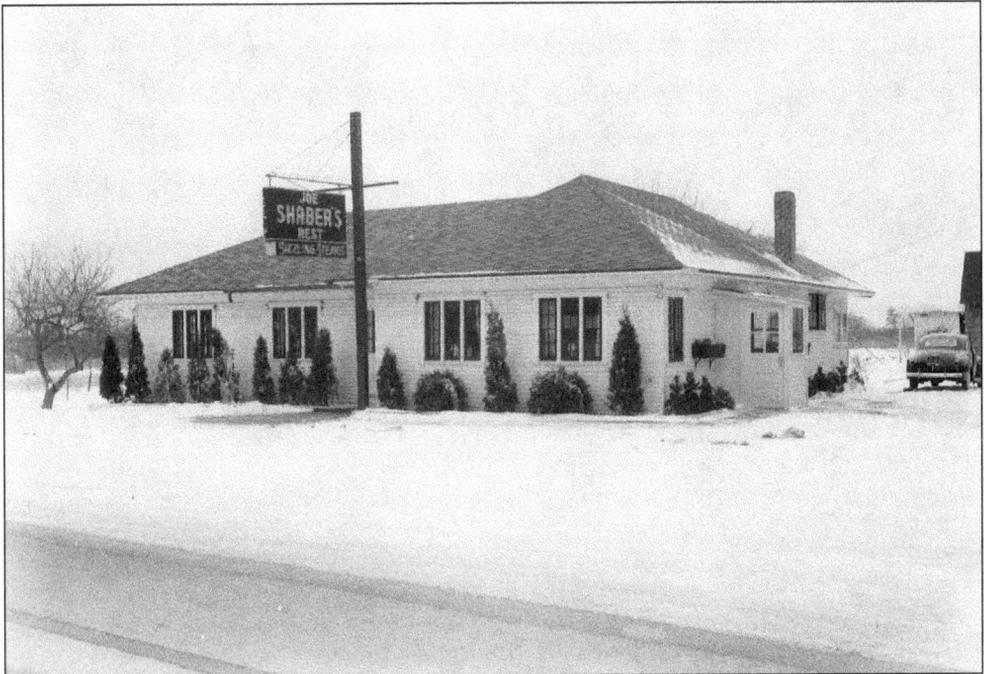

The restaurant Shabers Rest is fondly remembered by many local people. The location was on Route 112 and Shaber Road.

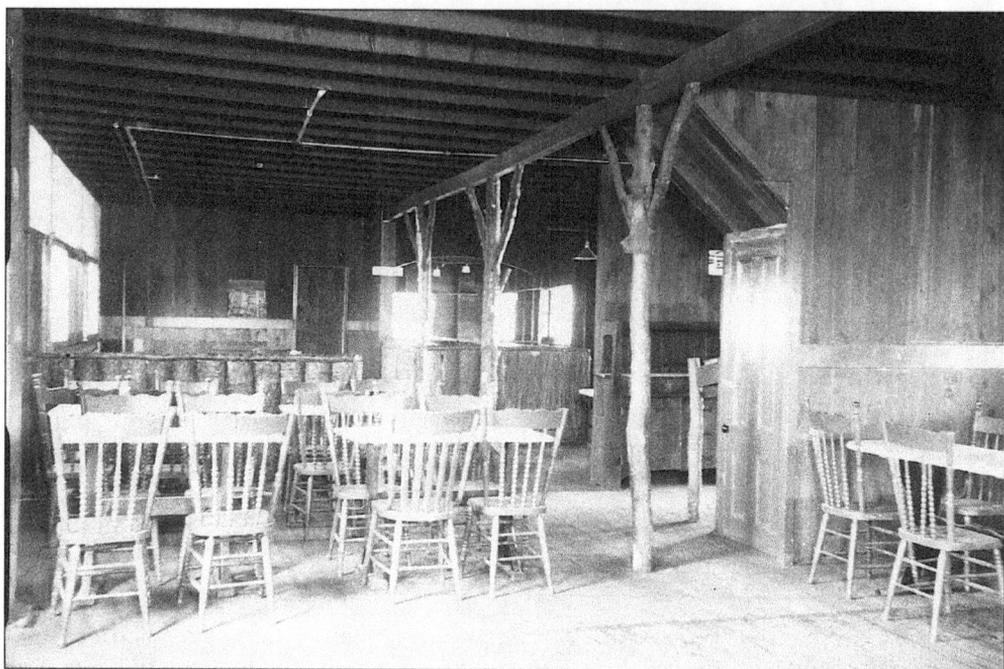

The Pine Grove Inn in East Patchogue was also a popular restaurant during the time of these 1940s pictures, as it is still today! The rustic decor of the interior is a far cry from today's appearance.

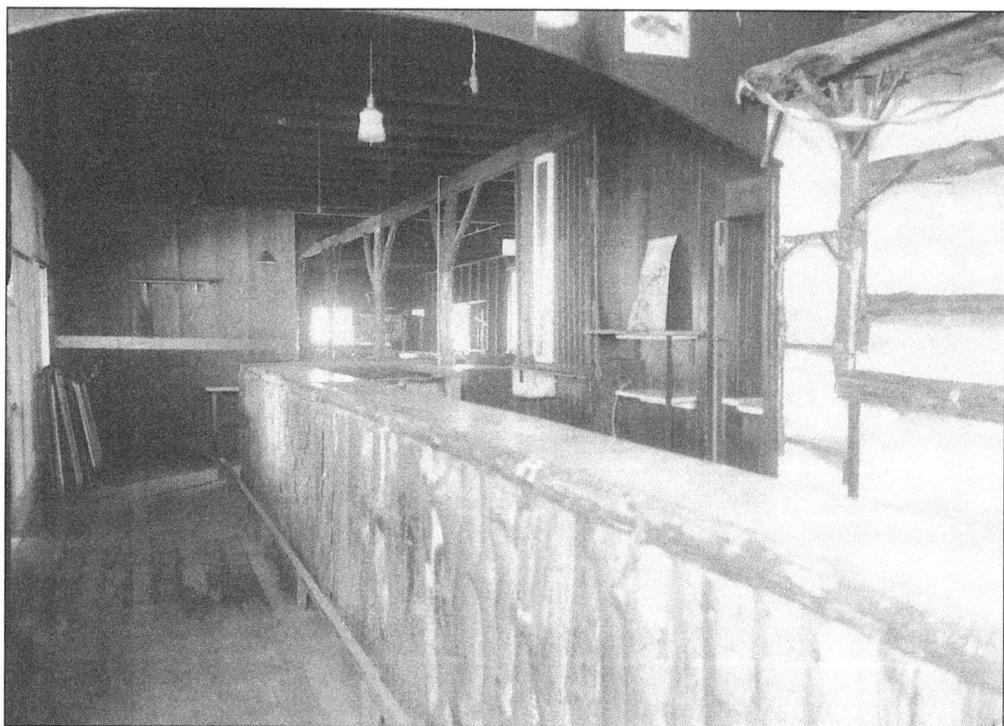

This picture of the bar of the Pine Grove Inn was taken by Adolph Morge before the bar's opening.

LUMBER
GLASS
HARDWARE
SASH
BLINDS
DOORS, ETC.
COAL - WOOD

Telephones
250 PATCHOGUE
500 SAYVILLE
600 BABYLON
1300 ISLIP

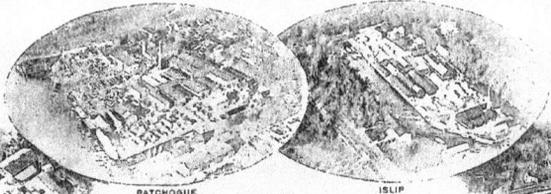

PATCHOGUE ISLIP

ESTABLISHED 1870

SAYVILLE **E. BAILEY & SONS, INC.** BABYLON

ARCHITECTURAL WOODWORK

PLANING AND MOULDING MILLS

REFER TO PATCHOGUE, L.I. August 10, 1927

The **BEE HIVE STORE** Patchogue's Shopping Center NEW YORK OFFICE: 1344 FIRST AVENUE

A Complete Department Store

TELEPHONE PATCHOGUE 1700 2 5 E A S T M A I N S T R E E T
PATCHOGUE · NEW YORK

GRACE A. AVERY, Owner
HUMPHREY R. AVERY, Manager Established 1893
Telephone 1200

SWAN RIVER NURSERY

TERMS CASH
ALL CLAIMS MUST BE MADE
IMMEDIATELY UPON
RECEIPT OF GOODS 615 East Main Street
PATCHOGUE, L. I., N. Y. EVERGREENS, TREES
SHRUBS, VINES, ROSES
and FRUIT TREES

Sold to SOUTH SIDE SPORTMAN'S CLUB,
Great River, L. I. Amount $ 11.40.

Please detach and retain lower portion of this statement.

Three letter heads of well-known Patchogue businesses in the 1920s and 1930s appear above.

T. & S. LUMBER & SUPPLY CO., INC.

LUMBER & MASONS' SUPPLIES

HAYMAN TELLMAN, PRESIDENT
JOSEPH SILVERMAN, VICE PRES.
FRANK SILVERMAN, SEC'Y & TREAS.

SASH · DOORS · TRIM · LATHS · STUCCO · ROOFING MATERIALS · CEMENT · HARDWARE
PAINTS · FLUES · BRICK · GYPSUM WALLBOARD

RIVERHEAD YARD
ROANOKE AVE. & RAILROAD ST.
RIVERHEAD, LONG ISLAND
TELEPHONE RIVERHEAD 7430

392 E. MAIN ST. COR. GROVE AVE.

PATCHOGUE, N.Y.

ADOLPH VORGE
6 CEDAR AVE
PATCHOGUE N Y

Telephone, Patchogue 496

"Our Coal Makes Warm Friends"

Snedecor Coal and Feed Co., Inc.

COAL and FEED

Office and Yard
118 West Avenue

PATCHOGUE, N. Y.

June 08, 1931,

PAINT	MEMBER NEW YORK STATE HARDWARE AND PAINT DEALERS' ASSOCIATION	A PAINT FOR
VARNISH	**Gus Schmidt**	EVERY PURPOSE
WALL PAPER	**17 NORTH OCEAN AVENUE**	
	PATCHOGUE, N. Y.	
HARDWARE	MAIN PAINT AND HARDWARE STORE	PATCHOGUE 219

PATCHOGUE LODGE, No. 1323
B. P. O. ELKS

FRANCIS L. BROPHY
SECRETARY

ALBERT S. DAYTON
EXALTED RULER

PATCHOGUE, NEW YORK

April 10, 1937

Shown here are various 1930s letterhead of the 1930s from the T&S Lumber Company, the Snedecor Coal and Feed Company, the Schmidt Paint Store, and the Patchogue Elks Lodge.

www.ingramcontent.com/pod-product-compliance
Lightning Source LLC
Chambersburg PA
CBHW080905100426
42812CB00007B/2160